THE PM'S BEIRUT MANSION

THE PM'S BEIRUT MANSION

If walls could speak...

Nayla el-Solh

UNICORN

Published in 2021 by
Unicorn, an imprint of Unicorn Publishing Group
5 Newburgh Street
London
W1F 7RG
www.unicornpublishing.org

ISBN 978-1-913491-39-0

10 9 8 7 6 5 4 3 2 1

Design: Nadine Hajjar, Communica Design, New York City

Printed in Europe by Finetone

INTRODUCTION

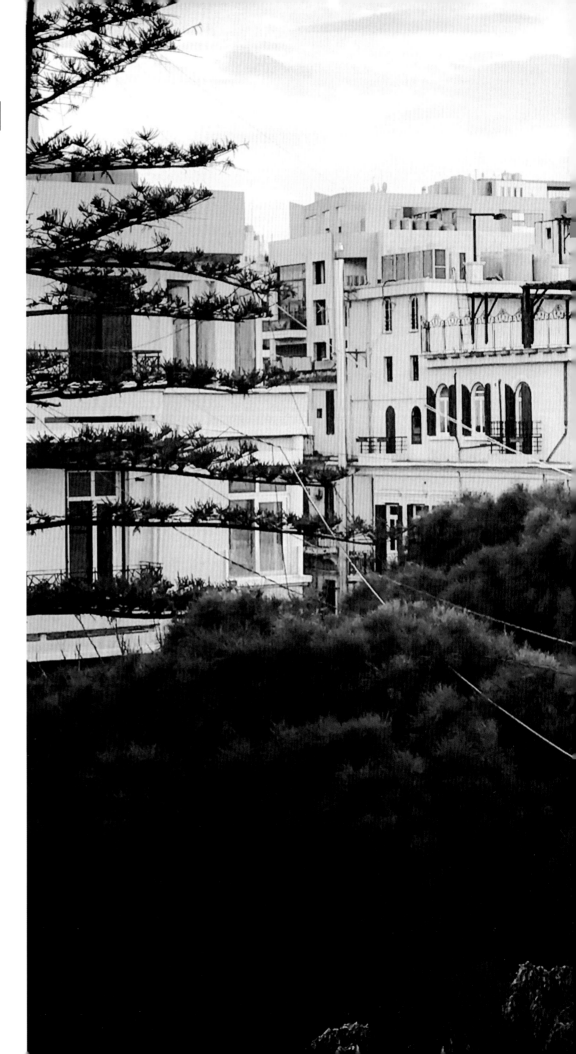

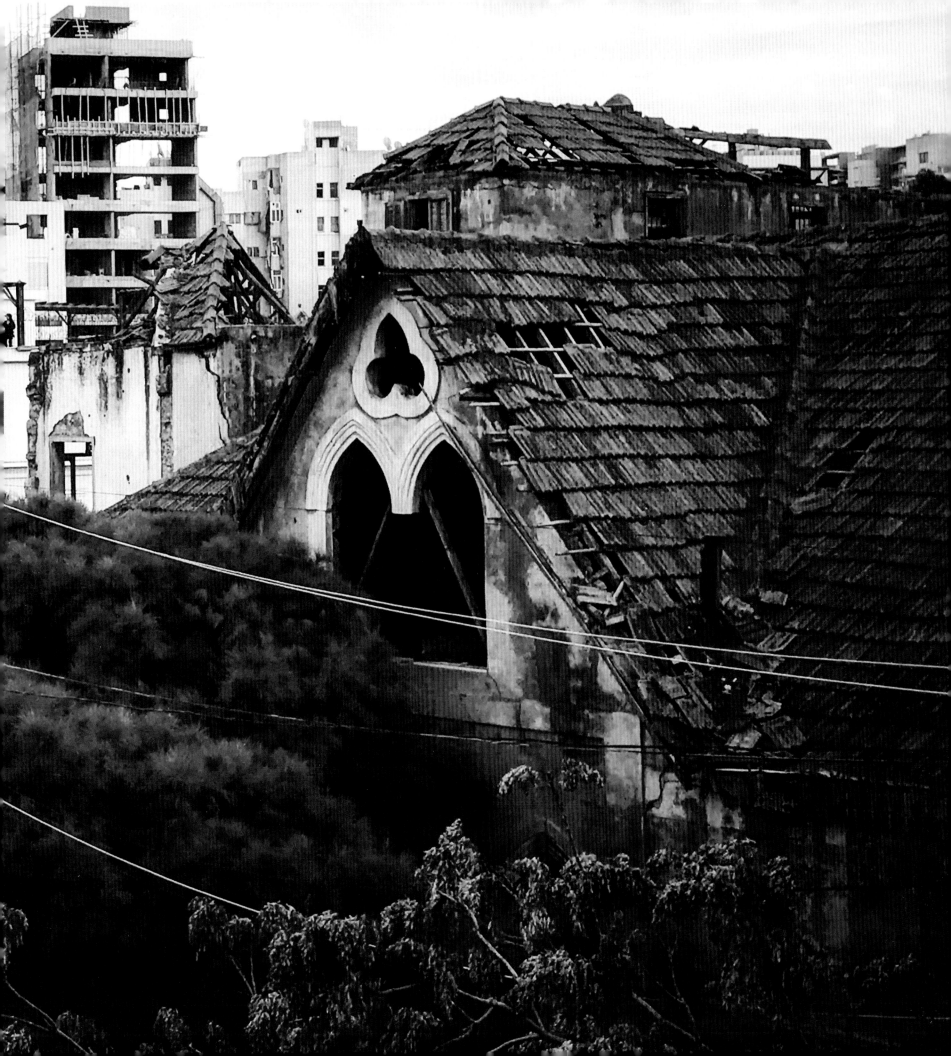

PREFACE

This book depicts the abandoned, decaying and crumbling mansion in Beirut where the Prime Minister once resided, and the many lives interwoven into its fabric for over a century. It provides a mixture of old photos of the rich and famous with the house at its opulent best, contrasted with the building's current state. Accompanying essays unravel the intriguing stories knitted into its bricks and mortar, among them political betrayals, births, deaths, marriages, wars, murders and above all determination.

The mansion has been witness to the best and worst moments in people's lives: tragedy and hope, sadness and laughter, love and disappointment.

The building itself is explored in the first chapter, as a typical example of Ottoman architecture from the second half of the nineteenth century, a spacious two-storey mansion with red-tiled roofs and large central halls featuring soaring triple-arched windows, as well as a three-storey annexe attached. A short summary of four other buildings offers some context to the neighbourhood.

The next four chapters delve into the heart of the four families associated with the mansion, set against the political and social events unfolding around them and involving them. Years of litigation and squabbling between the owners, compounded by the death of the PM, have left the property empty of legal inhabitants. The mansion has become derelict and hosts various squatters. The last chapter reflects this decline, while the final section shows a collection of coloured photographs of the abandoned house in its current state, from the exterior to the interior, exploring it floor by floor. The conclusion ties the chapters together and offers some final reflections.

The mansion was once occupied by Takieddine el-Solh, the former Lebanese Prime Minister (1973-74 and briefly in 1980), and his wife Fadwa al Barazi. It is situated in the Kantari district of Beirut, very close to the downtown area where street battles ignited the Civil War that began in April 1975 and ended in 1990. Many of the residents fled their houses at the beginning of the war, never to inhabit them again.

The mansion, in fact, partly belongs to Fadwa al Barazi and several other heirs and has been the subject of litigation for decades. It belonged to Fadwa's first husband, the politician Mohammad al Abboud, from Akkar in Northern Lebanon, and the finance minister (1947-48) in Riad el-Solh's and Bechara el Khoury's government. They lived together in the mansion until he was tragically gunned down on the steps of the presidential palace in 1953, after only six years of marriage to Fadwa. After his death, her father-in-law, Abboud Abdel Razzak, tried to evict her from the house. However, she refused to leave, as her husband's deathbed wish was for his father to look after his wife and his daughter Elham from a previous marriage.

Fadwa did not want to return to Hama in Syria, from where she had escaped through her marriage at the age of seventeen to Mohammad, twenty-five years her senior. Fadwa was considered a beauty, fair-skinned with blue eyes, from a prominent landowning and political Syrian family. Her cousin Muhsin al Barazi was prime minister of Syria in 1949 and Adib Shishakli, president 1953-54, was her maternal first

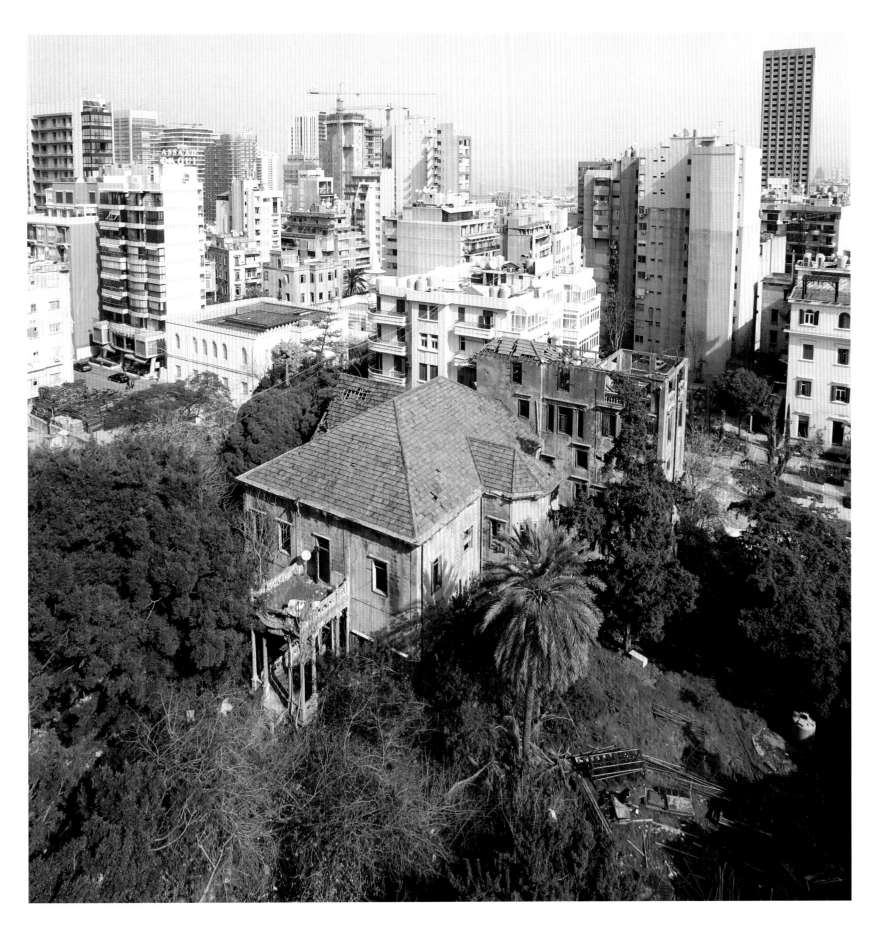

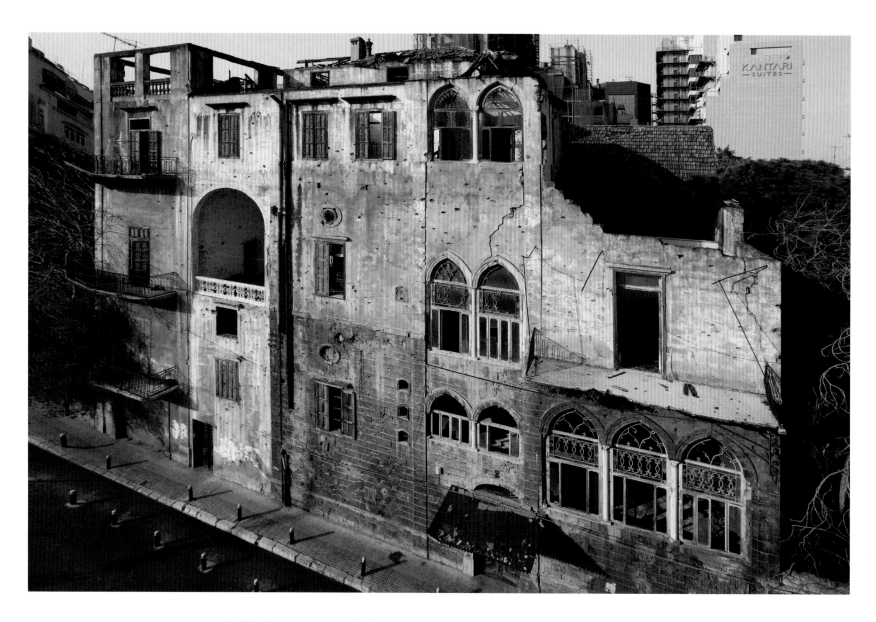

cousin. She had now acquired a taste for independence from her strict patriarchal and very traditional family. She was part of Beirut society, attending operas, cinemas and social functions, and accompanying her husband on foreign trips around the world.

Her father-in-law, having lost his only child, remarried for a third time at the ripe old age of over seventy. He fathered a further three children, who are also heirs and involved in the litigation. The heirs have been unable to agree on a sale, or on renovating the property, for decades. A preservation order was also put on it which prevents its demolition. This was because an influential politician had

lived in it, namely the PM, Takieddine el-Solh, and it is therefore of historical significance.

Meanwhile the mansion crumbles a bit more every day. People unaware of its complicated background wonder why such a once beautiful, opulent and grand house, which has borne witness to countless important events and housed many prominent residents, has been allowed to fall into wrack and ruin.

The house itself has an interesting and chequered history. Its first owners were the Naamani family, rich and politically influential, who were mainly in the textiles business, led by Aref Naamani. They were

forced to sell the house after their financial situation deteriorated. Abboud Abdel Razzak then bought the house from them for his son. Mohammad al Abboud lived in the house with his first wife, then his second and finally with Fadwa in 1947, occupying the first floor. They entertained many local and foreign dignitaries there.

The ground floor of the mansion was rented to another political family, the Ammouns. Daoud, his wife Victorine (Chiha) and their children Charles and Blanche lived there for around fifty years.

There were many visitors to the mansion during Takieddine el-Solh's residence. He helped to establish The National Call Party (hizb al-nida' al-qawmi), which addressed national aspirations and ambitions. The mansion was an 'open house' frequented by a socio-political and cultural crowd, often gathering in the large garden. When the Civil War broke out, Takieddine, especially, was reluctant to leave the house, though they were forced to live elsewhere occasionally, depending on the location of the fighting and the severity of the dangers. Takieddine left for Paris in 1988 in self-imposed exile because of the threats he faced in his country. He passed away shortly afterwards, in November 1988. His body was flown back to Beirut and his funeral was held at the mansion.

In 2002 a contractor was employed to demolish the mansion after a court ruling gave permission to the collective owners to do so. He agreed not to be paid if he could dismantle and take any valuable, recoverable parts of the house, such as the fountain, the wrought iron, the marble floors, the antique wash-basins and the colourful tiles. He began to gut the mansion of its valuable fixtures and fittings but was spotted by a journalist and conservationist, May Abiakl, who gathered support by publishing an article in one of Lebanon's leading daily newspapers about the legality of what was happening. She managed to put a halt to the demolition, gaining a vital reprieve for the mansion.

Since then, various squatters, including refugees and foreign workers, have inhabited the abandoned property, taking the opportunity to stay there. A murder took place in the house in April 2014 among a group of squatters. The police swooped on the property, where they found the body of a taxi driver buried in one of the rooms on the ground floor. They arrested a suspect and evicted the rest. Some of the rooms have an eeriness about them, where everything has been left untouched as though the occupants had to leave in haste, which indeed seems to be the case. The mansion was made secure, for a while anyway, preventing anyone from entering or recovering abandoned possessions. There it sits, scarred, decapitated, watchful, still and calm, surrounded by its protective wall and mutilated, sizeable garden.

The history of the house also reflects the journey, peaks and troughs that the city and the country have experienced during its time span of more than 125 years.

If walls could speak….

Cover: *Doorway with chair*

Pages 6–7: *Tiled roof of the mansion*

Page 9: *View of the mansion and surrounding area*

Opposite: *View of the mansion from May Ziadeh Street*

11

INTRODUCTION

What drew me to this story

The manner in which Lebanon inhabits my thoughts and consciousness, and undoubtedly my subconscious on some levels, is categorised in several stages: before the war (life), during the war (death and destruction/loss), absence (yearning/disconnection), return (hope and reconstruction), visits (disappointment/re-disconnection).

Perhaps I am projecting my war experience of three and a half years at the impressionable age of ten, as well as my love/hate relationship with Lebanon in general, on to a decaying and neglected building. Perhaps it's a metaphor for where I see the Lebanese soul heading, or maybe the world in general. The war was one of my early childhood experiences, which awakened me to the ugliness of humanity, where religion and sectarianism were used as an excuse to inflict unimaginable pain and suffering on fellow human beings. The house is the embodiment, in bricks and mortar, of a decaying society, and yet there is still beauty amid the ruin, in the ordinary and mundane objects, like the teapot, a stove, a random shoe, beautiful tiles. Do we still try to look for beauty amid destruction, as in the delicate flowery wallpaper that is still visible, grasping at straws, at familiarity, in order to keep functioning? Starved yet still searching, we pick at the bones of a stripped carcass in the vain hope that it has the remote possibility of sustaining us.

12

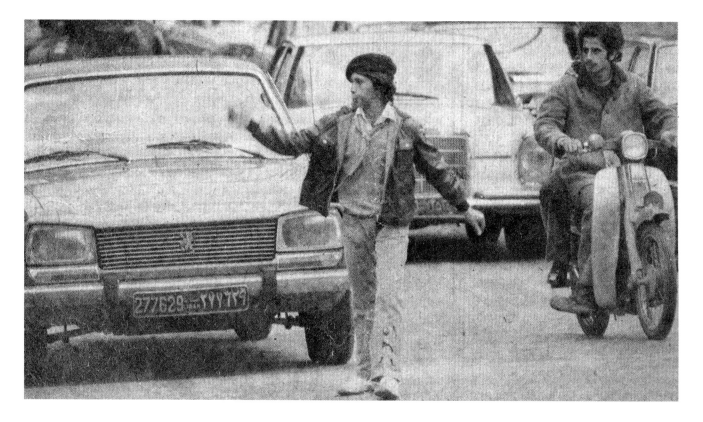

Right: *Yanal el-Solh conducting traffic in Hamra (1973)*

Opposite: *Yanal and Nayla (front row), with the Civil Defence Group (1977)*

© An-Nahar newspaper

Before

Lebanon to me was a more open society, with a cocktail of people co-existing. It was the energetic hub of the Middle East. I am of mixed heritage, with a Lebanese father and an English mother. We had friends from all four corners of the world and all walks of life. I was also aware that in spite of its seeming openness and modernity, Lebanon was still traditional if you scratched just beneath the surface, for the local inhabitants anyway. Tensions erupted occasionally but then returned to normal, until the next time.

War

My life trajectory was transformed when I was ten years old at the outbreak of the 1975 Civil War. Sunday 13 April was my classmate Thierry Van Biesen's birthday party at the Saint Simon beach, where we were gathered with our classmates to celebrate. It was a memorable day, because as the news filtered through of the massacre on the bus at Furn el Shoubak, I was stranded at the beach with no one to collect me – my parents were visiting friends somewhere up in the mountains. As the festivities and the party quickly dispersed, parents hurried to collect their children, and a mother of one of my classmates generously agreed to take me with them. My grandmother's home near the National Museum was deemed too close to the troubles for me to be dropped off, so the mother dropped her own children off at their father's, from whom she was separated, and took me back to her home, near ours. For several hours I felt very anxious and worried for my family. There were of course no mobile phones at that time, so communication was sporadic. My parents eventually collected me and everyone was safe. But life would never be the same.

As a child, perhaps in order to deal with the dark reality, you begin to treat it as yet another adventure, or perhaps my mother tried to lighten the situation for us by trying to make it seem so. The line between reality and fantasy was a bit blurred at times. My brother, our friend Kay and I used to frequent the

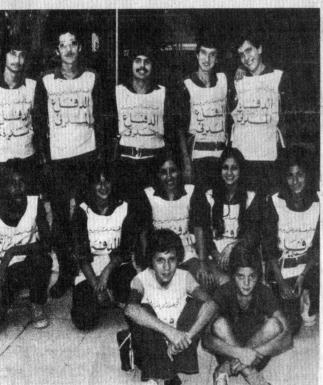

cinema watching war movies and what seemed like quite violent French, Italian, American and English films of the 1970s. The war offered us an opportunity to be in our own live film, in a way. I learnt how to take apart a pistol and a Kalashnikov, clean them and then reassemble them at my uncle's political party headquarters and our local 'neighbourhood watch' group. I was obsessed with firing guns and controlling the recoil. We collected bullets, pieces of shrapnel and used shells. We ate by candlelight, washed from water in a bucket and sometimes slept in the corridor during the worst bouts of shelling. Schools were closed, so my brother and I joined the scouts and helped to clean the streets, distribute food to the elderly and conduct traffic among other things. As part of the civil defence organisation, we were trained in first aid, helped in the hospital and the transportation of the injured. I was eventually deemed a bit too young to be involved with the hospital and ambulance. I chose to help out at our local bicycle and scooter shop, owned by a German man and his Lebanese wife.

I do distinctly remember at the outbreak of the war walking through the Kantari district with the civil defence people and the scouts and discovering looted homes. It felt a bit surreal.

Homes I had visited with my parents or those of schoolfriends, where I was now treading, had been broken into and looted, the inhabitants having fled at the outbreak of war. We reported what we had seen and the buildings were subsequently secured, temporarily anyway. I believe that we visited the mansion, but this had already been protected from looters.

Apart from visiting my great-uncle there, the Kantari area is seared in my memory as a tragic place, as is the mansion, by association, forming part of my haunted images of war. It was an early sign of how the country would be divided along sectarian lines.

Right: *Burnt-out cars in the mansion's grounds*

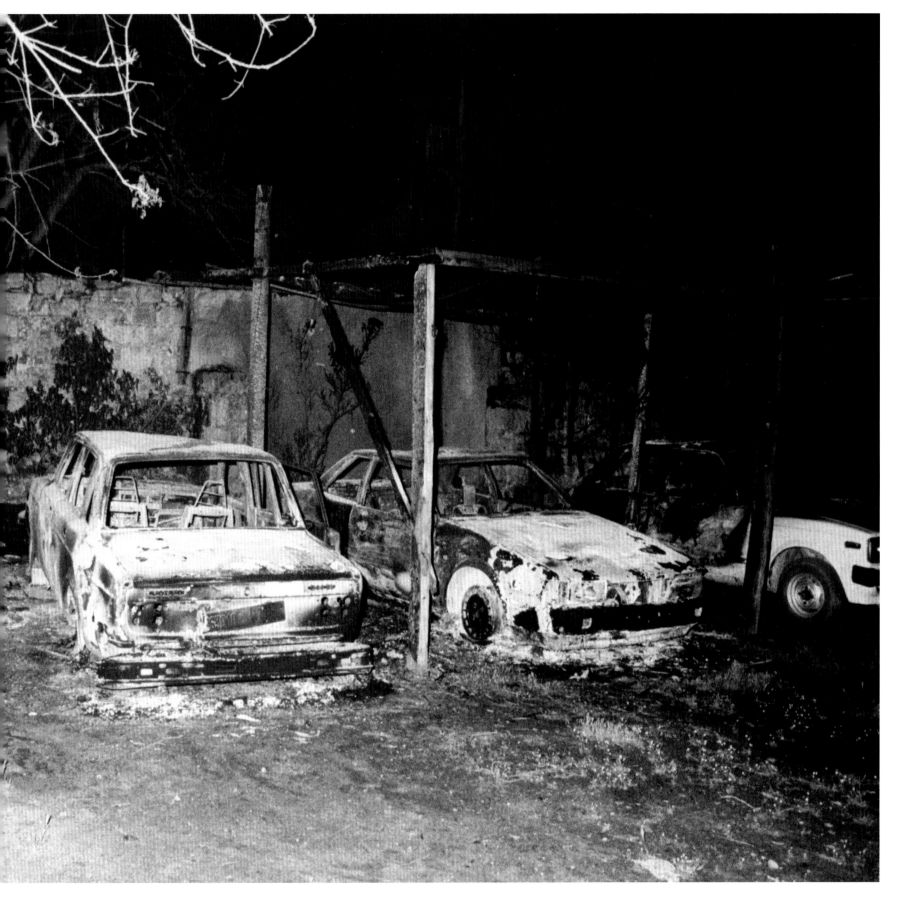

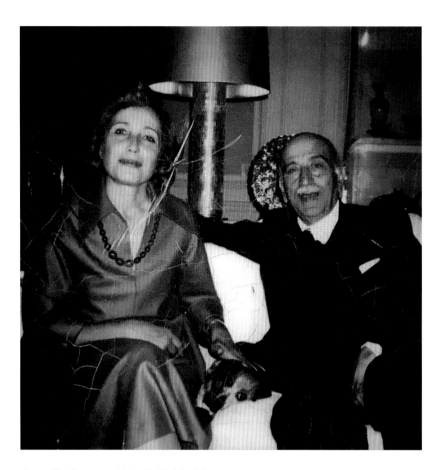

16

Aunt Fadwa and Uncle Takieddine

Takieddine el-Solh

My father was very close to his uncle, having disagreed with his own father upon his marriage to my English mother, after which they never spoke to each other again. Uncle Takieddine became a father figure to him. My brother and I also never spoke to my grandfather, so Uncle Takieddine also became a grandfather figure to us. I remember him as being a very gentle and elegant man with a soft and friendly face, a hint of mischief in his eyes. I also remember being mesmerised by his hands, with long fingers, immaculately clean, peeling an orange, the peel transforming into a perfect orange-coloured snake, with not a single drop of juice wasted.

Fadwa el-Solh (al Barazi)

I have always held Aunt Fadwa up as a beacon of candour in a society that functions on hypocrisy and untruths. Here was a beautiful, strong, forthright woman, of independent means, who spoke her mind and did not suffer fools gladly. My family is actually peppered with strong women, my grandmother Yesser el-Solh being another, though with a different style, and Mounira el-Solh too. These were outspoken women.

I remember several encounters with Aunt Fadwa as a child, one being at the funeral of another greatuncle, Adel el-Solh, mayor of Beirut for several years. She rebuked my brother and me for not knowing the Fatiha. I remember promising her that I would learn it, though I had many doubts about the existence of God even at that age. My English mother (Désirée Mordaunt) was a Catholic who was spiritual but had been put off religion by the nuns at the convent that she had attended in England, with their peddling of the emotion of fear through guilt. My father and our family tended to be humanists and secularists and, therefore, religion was not a large part of our lives from either side, which in a way was somehow apt in a country of such division and sectarianism.

Our encounters with Aunt Fadwa and Uncle Takieddine became more sporadic when we left Lebanon in self-imposed exile in November 1978, after my

father's imprisonment, interrogation and subsequent release a month later by Syrian intelligence. This move was further justified after his brother, my Uncle Raghid, was shot and hospitalised in Beirut in 1975, which also forced him and his wife to seek refuge in England. We saw Aunt Fadwa and Uncle Takieddine in London on a few occasions when they visited the city. I did try to make a point of visiting Aunt Fadwa during my infrequent trips to Lebanon from 1992 onwards.

Recently, Aunt Fadwa visited my Aunt Nawal in hospital and I discovered her storytelling abilities and wicked sense of humour, even going as far as fully fledged re-enactments of humorous situations. Her remarkable zest for life and energy for a woman of her age is astounding. I have always enjoyed the company of older people as they have gone past caring about what others think of them,

I had yet another reason for visiting my Great-Aunt Fadwa. I had been conducting a search for family photos for a website that I was in the midst of constructing, to include my Great-Uncle Takieddine. I visited Aunt Fadwa a few times, hoping to get my hands on these photos but we chatted for hours instead – well, mainly she told me her stories and I listened intrigued. On another visit she actually brought out the photo album of her youth and first marriage, which, although very interesting, was not what I had come for to illustrate my el-Solh family website. But my interest in her life story was deepening.

My visits to Beirut from London became more frequent because of my Aunt Nawal's hospitalisation and eventual passing after nearly five months in hospital. Aunt Fadwa's stories were a welcome distraction and temporary transportation into another era from my feeling of utter helplessness at being unable to alleviate my aunt's pain and witnessing the torment that she was enduring in hospital, followed by the feeling of deep despair at losing her.

As a film-maker, I wanted to capture her tales and the amusing way in which she recounted her stories, weaving a tapestry of images, even sounds and smells, into her tales to such an extent that you could imagine yourself being there, transported in time. The detail with which she described events brought them to life.

I believe her story should and must be told. I felt as though I needed to build up her confidence in me to be able to tell the story, giving it full justice, reflecting her personality and experience. Knowing the mansion has been a symbol of her resistance, I thought of filming it as footage to mix in with her voice-over, together with old photos and footage of her recounting her life. I also started taking photos, with my phone initially and then on subsequent visits with a professional camera, which I also use for filming. When I showed these images to friends and relayed my experience with the storytelling, they suggested that I put it all in a book and a film, perhaps. So this is how the idea took shape.

My cousin Amira el-Solh has accompanied me on this journey of discovery, through which I have got to know her, making the process even more pleasurable. We have visited Aunt Fadwa together on several occasions, receiving life lessons and invaluable advice. We have also been entertained by her intriguing and detailed stories. Aunt Fadwa's dog, Katie, has also provided us with endless hours of delight. While researching the book I have also made friends along the way with members of the different families connected to the mansion, who have been generous with their time, information and kindness, including Arab Abdel Razzak, Bouchra Naamani and Lyne Lohéac. There are many other people without whom this book would not have been possible, including my family, Nayla Razzouk, Rick Whiteman, Christine Morgan, Nadine Hajjar and numerous other friends.

The more I listened to Aunt Fadwa's life stories, the more intrigued I became with her life philosophy and what this woman had witnessed in her life.

Catastrophic explosion 2020

In the 1970s and 1980s Beirut was a byword for war, death and destruction, a metaphor for chaos and the folly of man. The myth of the phoenix rising from the ashes, often linked to Beirut over its 5,000-year history, seemed to apply once more as it wrenched itself to a semblance of normality, through hope and resilience, while papering over its cracks.

In August 2020, all the physical damage of fifteen years of civil war was inflicted on Beirutis in a matter of minutes. One of the largest non-nuclear explosions ever, emanating from the port, ripped through the heart of Beirut, culminating in loss of life, thousands injured, buildings being disembowelled and neighbourhoods devastated, with much of east Beirut no longer habitable. Apocalyptic scenes of eviscerated, ghostly buildings and streets whispering the death of civility have returned to Beirut.

clean out all the ruling elite who have siphoned off much of the country's wealth and provided next to nothing in public services. No matter how the explosion was ignited, there is no escaping the fact that those in power showed negligence by storing such volatile substances in the heart of Beirut, near a densely populated residential area. The clean-up and rebuilding have been left to the people and volunteers to grapple with and outside international aid will probably never reach those in need.

"A nation that has in the past risen to its feet when tragedy forced it to its knees, finds its miraculous capacity for resilience tested once again."
The Guardian *editorial, 5 August 2020*

"A vast crater at the site of the detonation scars the coastline, but deeper still are the wounds to a nation that was already reeling from economic crisis, debilitated by pandemic and weary from political chaos and corruption." *The* Guardian *editorial, 5 August 2020*

Lebanon's rulers, mostly entrenched warlords who swapped their weapons for shiny suits, benefited from citizens' low expectations of the state and the lack of measures ensuring transparency and accountability in the country. After the end of the Civil War in 1990, they brokered a social contract that cast the leaders as patrons and the people as clients rather than citizens. The economy has been exposed as a vast pyramid scheme with services and utilities run as mafia-style racketeering portfolios.

However, decades of endurance have turned to rage after the devastating explosion. Citizens from all walks of life and religions have taken to the streets again, with a central demand of protesters being to

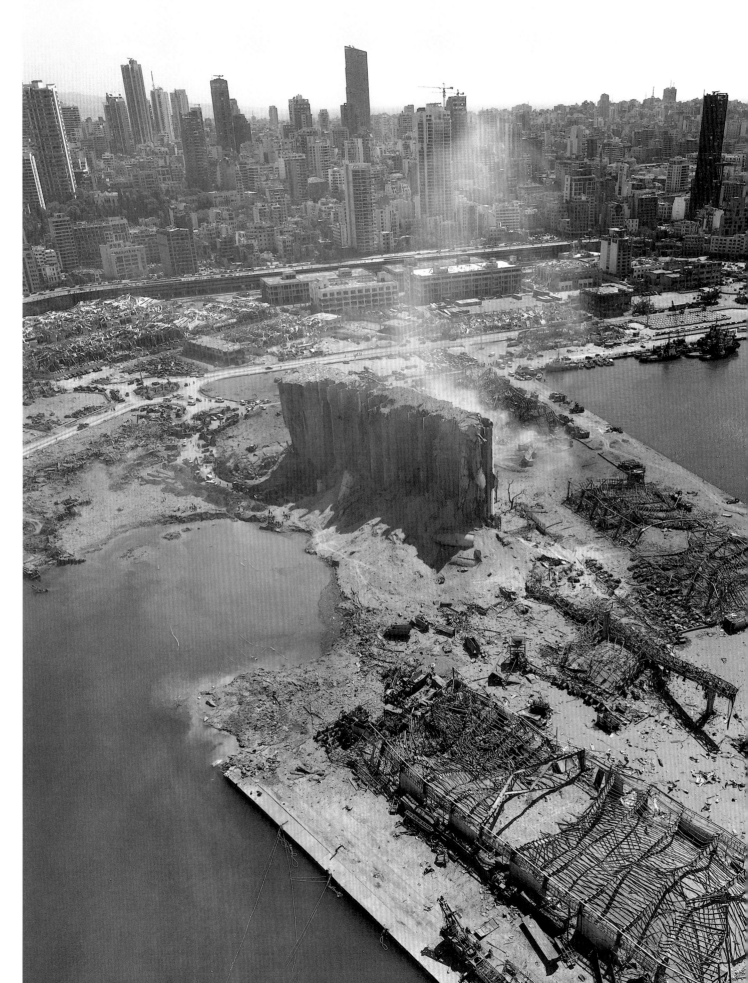

Beirut, shaken after the massive explosion at the port on 4 August, 2020
© P. Elie Korkomaz

TIMELINE OF PERSONAL AND POLITICAL EVENTS

Personal Events

1880's
Hassan Naamani builds the mansion

1920
Daoud Ammoun and his family rent the ground floor

1922
Daoud Ammoun dies; his wife and children remain in the house

1930
Abboud Abdel Razzak buys the house for his son Mohammad al Abboud and his first wife

1940
Mohammad al Abboud marries second wife, Salma Tabal

1942
Mohammad and Salma's daughter Elham is born in the house

1947
Fadwa al Barazi marries Mohammad al Abboud and moves into the house

1953
Fadwa is widowed after her husband Mohammad al Abboud is assassinated

1957
Fadwa marries Takieddine el-Solh

| 1890 | 1920 | 1930 | 1940 | 1950 | 1960 |

Political Events

20

1964-65
Takieddine el-Solh is Interior Minister

1964-68
Takieddine el-Solh is re-elected to parliament (Baalbek)

1958
Civil War in Lebanon

1957-60
Takieddine el-Solh is elected to parliament (Zahle)

1953
Mohammad al Abboud is assassinated

1947-48
Mohammad al Abboud is Finance Minister in Riad el-Solh's government

1946
The French troops leave Lebanon

1943
Lebanon gains independence under Bechara el Khoury as President and Riad el-Solh as Prime Minister

1920
Daoud Ammoun heads the first Lebanese delegation to the Peace Conference in Paris

1920
France grants the mandate for Syria and Lebanon; the State of Greater Lebanon is proclaimed in Beirut

1516-1918
Lebanon part of the Ottoman Empire

1914-18
World War I

1939-45
World war II

1973
Ammoun family asked to
vacate the ground floor
(following Victorine's death,
they used their home
only as a summer house,
spending the majority
of the year in Paris)

1988
Takieddine el-Solh's funeral
is held in the mansion

2005
Mansion set for
demolition but
gains reprieve
after campaign

2014
Murder takes place in mansion by squatters
and body is burried on ground floor

Belongings stored in the mansion cannot
be retrieved as police secure the building

2020
Litigations remain ongoing bet-
ween the inheritors (Mohammad
al Abboud's daughter Elham,
Fadwa al Abboud his third wife
(now Fadwa el-Solh), as well as
Abboud Abdel Razzak's third wife
and her children, Mohammad II,
Arab and Zeina)

1970　　　**1980**　　　**1990**　　　**2000**　　　**2010**　　　**2020**

1988
Takieddine el-Solh goes to
Paris in self-exile; he passes
away a few weeks later

1982
Israeli troops invade Lebanon,
occupying the capital Beirut briefly

1980
Takieddine el-Solh is
chosen again as PM but
is unable to form a governent

1978
Israeli troops invade Lebanon;
UN sets up peacekeeping force

1976
Syrian troops enter Lebanon
forming the majority of an
Arab peace-keeping force

1975-1990
Lebanese Civil War

1973
Takieddine el-Solh is
appointed Prime Minister

2011
Syrian Civil War
spills over into
Lebanon, creating
over a million
refugees, stoking
sectarian violence

2006
Israel bombards Lebanon,
destroying the infrastructure

2005
Syrian troops leave Lebanon
after the assassination of
former PM Rafic Hariri and
mass civil protests

2000
Israel withdraws all troops
from Lebanon

2020
On 4 August, a massive explo-
sion at the port of Beirut leaves
250 dead, 6,000 injured and
an estimated 300,000 homeless.
The explosion, detected by
the United States Geological
Survey as a seismic event of
magnitude 3.3, is considered
one of the most powerful non-
nuclear explosions in history

2019
Anti-corruption protests erupt
in Lebanon amid financial melt-
down and political deadlock

21

THE BUILDING

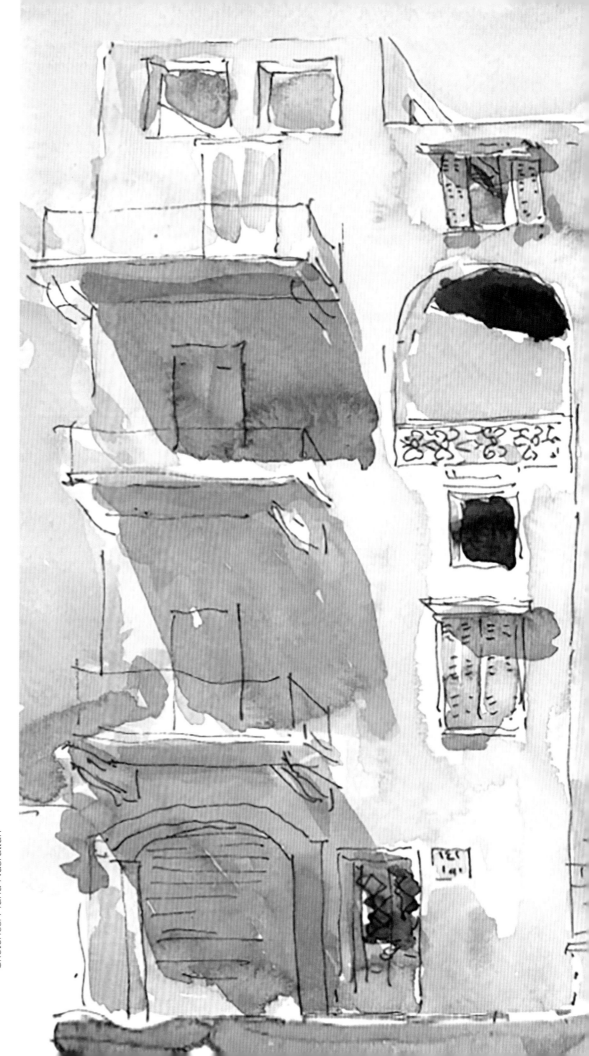

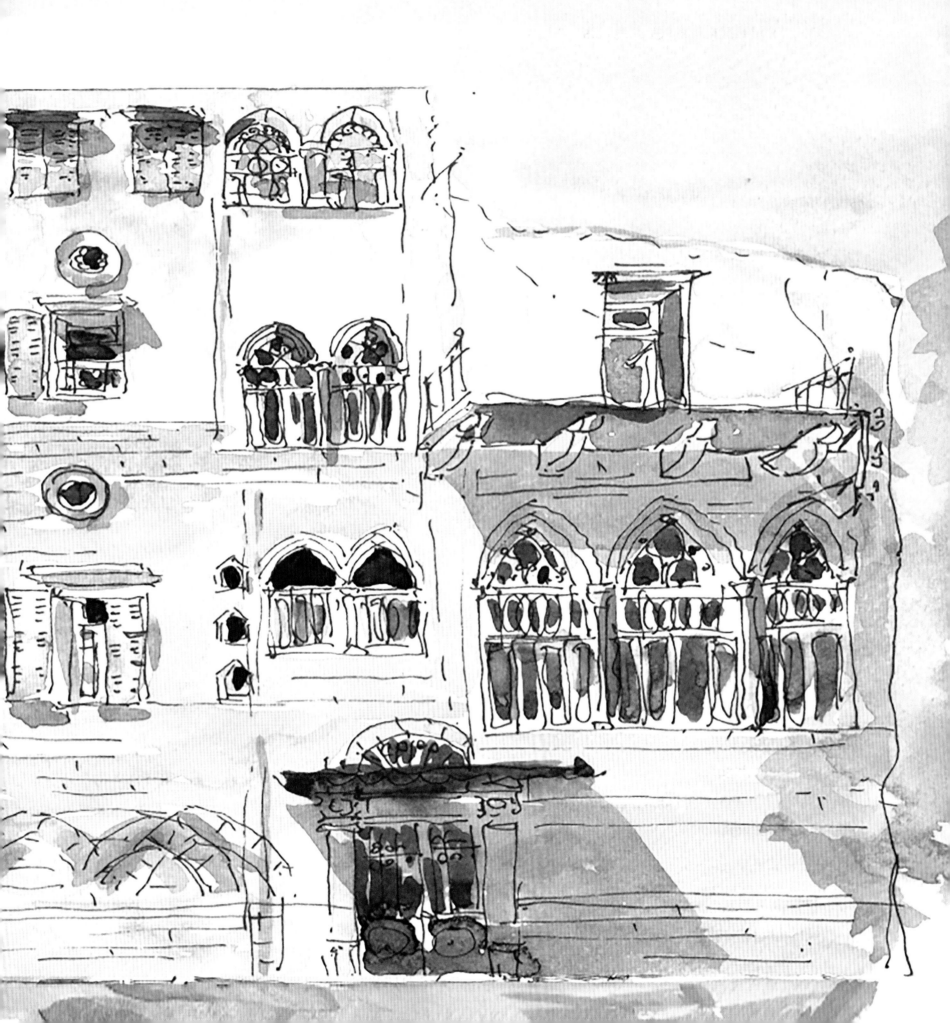

MAPS AND PLANS

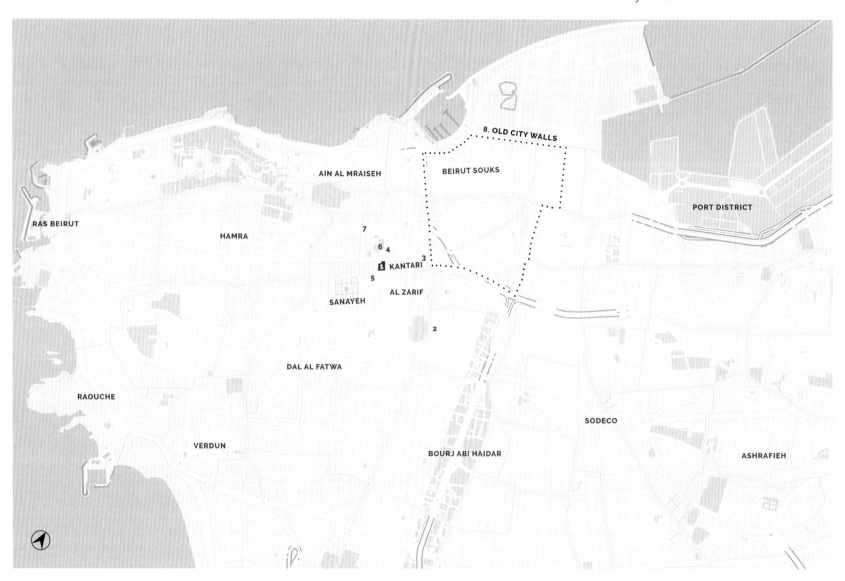

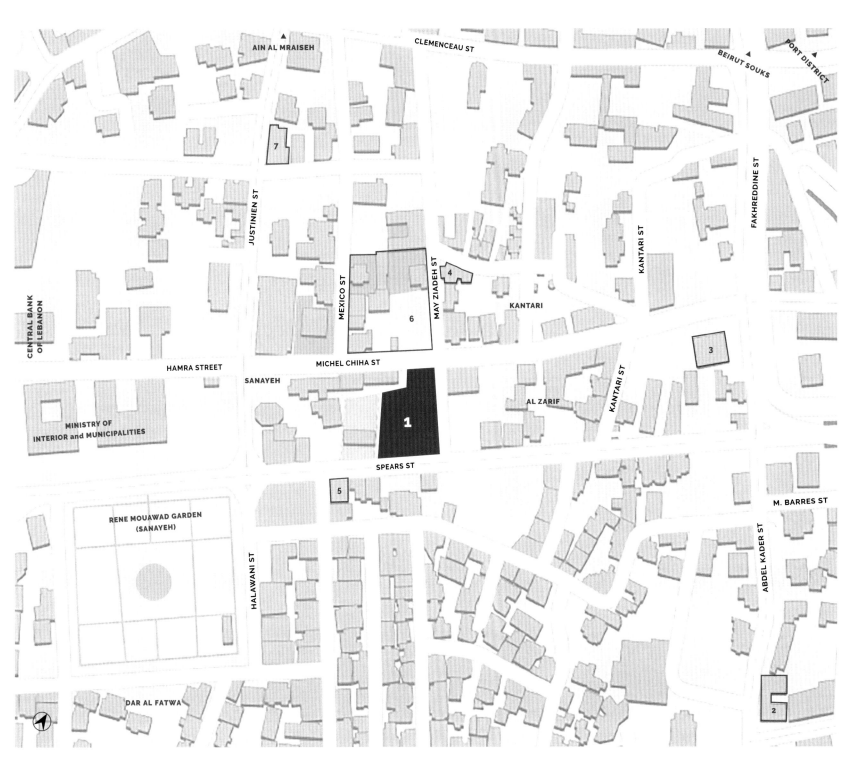

AIN AL MRAISEH

CLEMENCEAU ST

BEIRUT SOUKS

PORT DISTRICT

7

JUSTINIEN ST

MEXICO ST

MAY ZIADEH ST

4

KANTARI

KANTARI ST

FAKHREDDINE ST

CENTRAL BANK
OF LEBANON

6

3

HAMRA STREET

MICHEL CHIHA ST

SANAYEH

AL ZARIF

KANTARI ST

1

MINISTRY OF
INTERIOR and MUNICIPALITIES

SPEARS ST

5

M. BARRES ST

RENE MOUAWAD GARDEN
(SANAYEH)

HALAWANI ST

ABDEL KADER ST

DAR AL FATWA

2

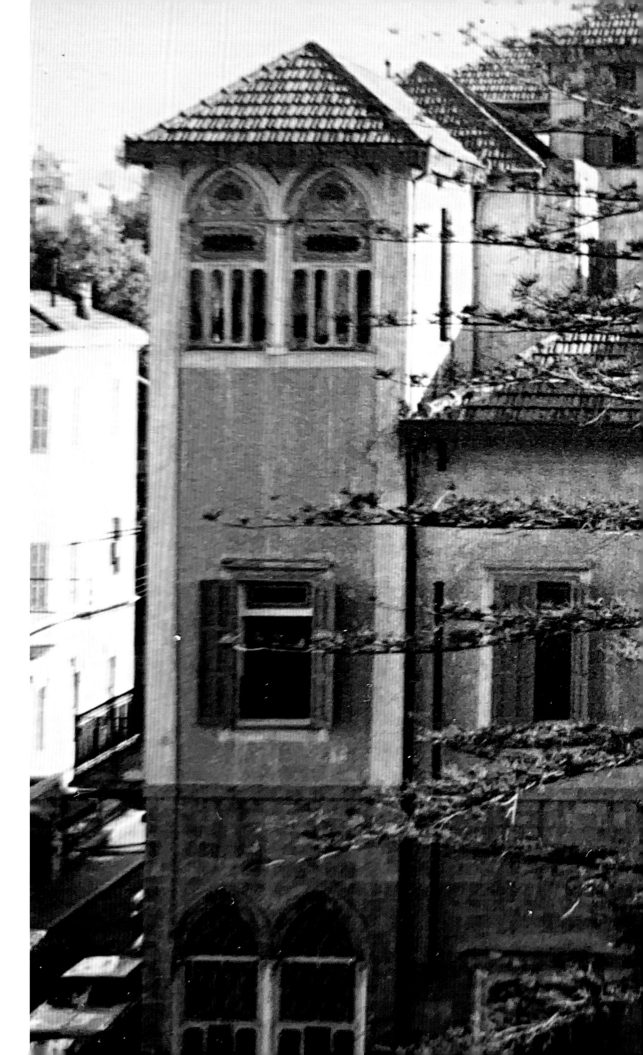

26

Front of the mansion

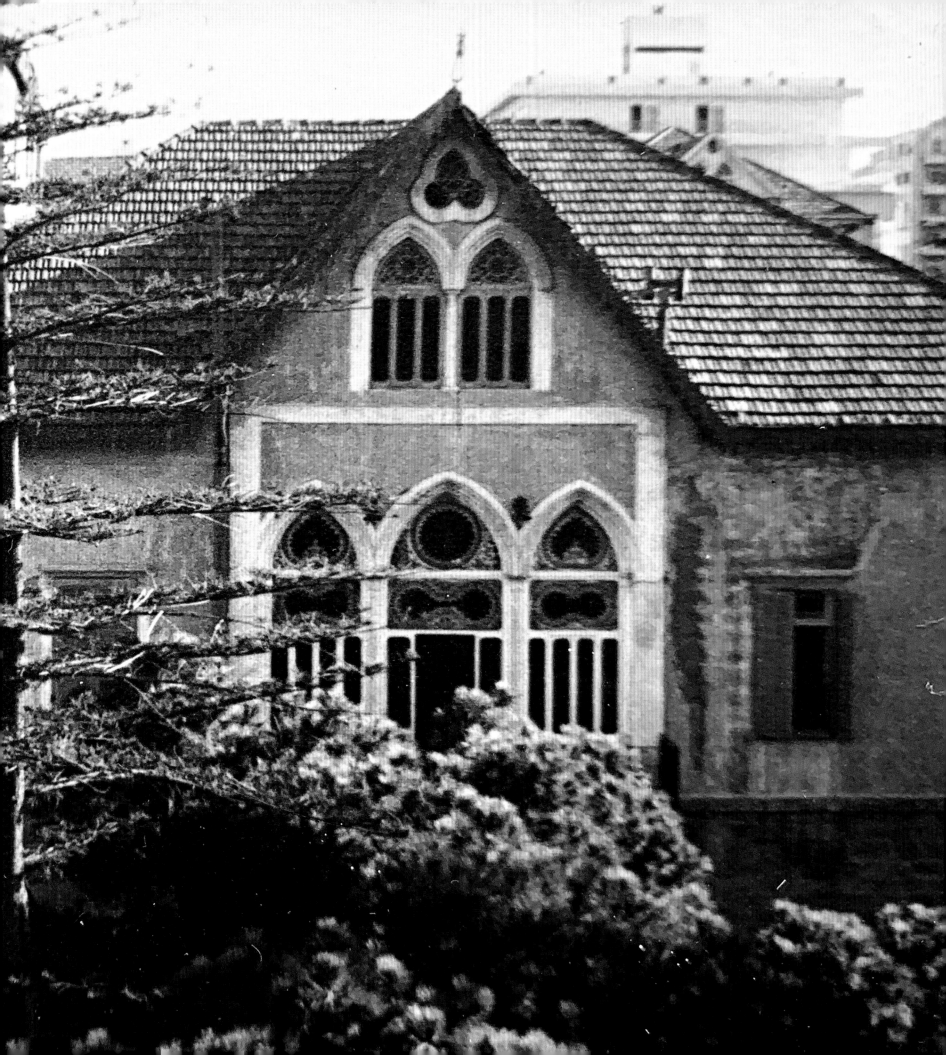

The early official records for the mansion were destroyed in a fire at the municipality building in Beirut during the Civil War of 1975–90. According to the Naamani family's oral history, preserved by weaving remembered experiences and details into stories handed down to subsequent generations, Hassan Naamani had the house built between 1870 and 1890. It is typical of the style of traditional Lebanese houses built around that era, when the city was still part of the declining Ottoman Empire.

The house is located in the Kantari neighbourhood of Beirut, designated as a historical area, rich in similar old buildings. It sits between Spears Street and Michel Chiha Street, while a side entrance is on May Ziadeh Street. The house is surrounded by a large garden, which included a tennis court and a marble-clad ornamental pool with a fountain.

It is arranged over two main floors, with an annexe of three floors forming part of the building. The property includes a small two-storey building, which is rented out as a shop. The total space of the property, including the garden, is 3,400 square metres.

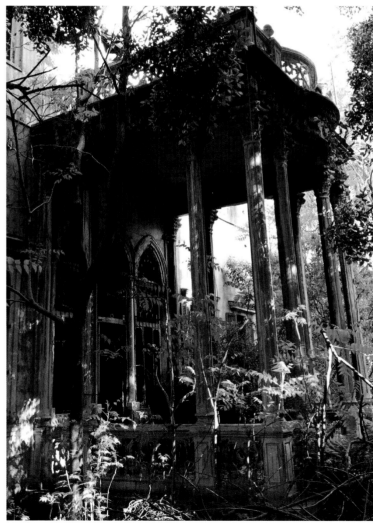

The mansion, views from different angles

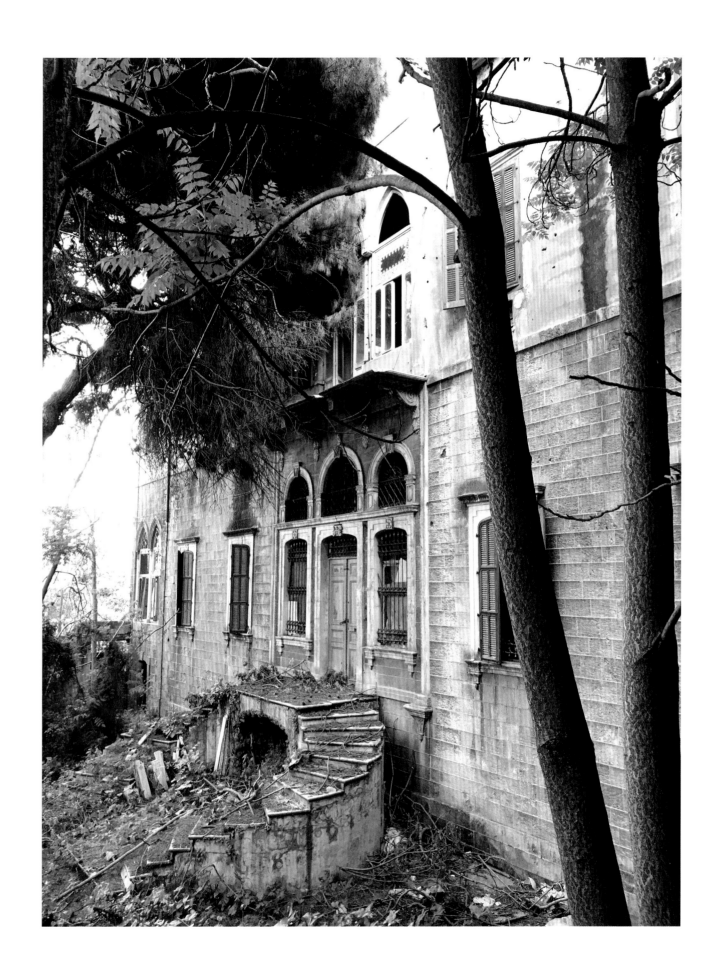

Architecture

The mansion comprises two main sections: the main house, consisting of two grand floors, each six metres in height, and a service area on two half-levels, each two to three metres tall. The main house is built of locally quarried sandstone, while the service part seems to have been built in at least two stages: a first stage, when the main house was built, is made of the same sandstone; the second part, extending beyond the area of the house to the south, seems to be more recent and is built of concrete. This final addition has an independent service staircase connecting all four of its half-levels.

The ground floor of the main house sits on an elevated and compacted earth fill, compressed within an enclosure of sandstone retaining walls two metres high. It is accessed to the north from Michel Chiha Street, through an iron gate, across the front garden and finally through a double helix-like set of external steps encased by wrought iron railings (fer forgé). The entrance door is flush with the external wall and leads to an entry lobby framed by a typical triple arcade (with pointed arches) leading into the central hall. This hall can also be accessed indirectly, from the side, by May Ziadeh Street to the east, through an enclosed U-shaped staircase which also acts as the main vertical circulation connecting all the main and half-levels of the house, as well as the serviced and service spaces. The large lobby connecting the stairs to the central hall used to have a generous marble basin.

Plan

The contents of plot 1787 are as follows: a plot of land with different trees, a pool of water and two buildings over 3400 square meters.

The main building is arranged over two main floors (Western apartments in terms of orientation), with an annex of three floors attached (Eastern apartments).

Each of the two main floors has a central hall which runs the length of the building, leading to several rooms. Each floor is an apartment with an entrance, rooms, hallways, kitchen, bathrooms and utilities.

The floors can be accessed through an enclosed U-shaped staircase, which also acts as the main vertical circulation connecting all the main and half-levels of the house.

The annex consists of several self-contained apartments over three floors, also accessed through another staircase.

The small building consists of a ground floor that contains a shop and a first floor containing two rooms that ascend to them from inside the shop.

Floorplans: Lama Siblini

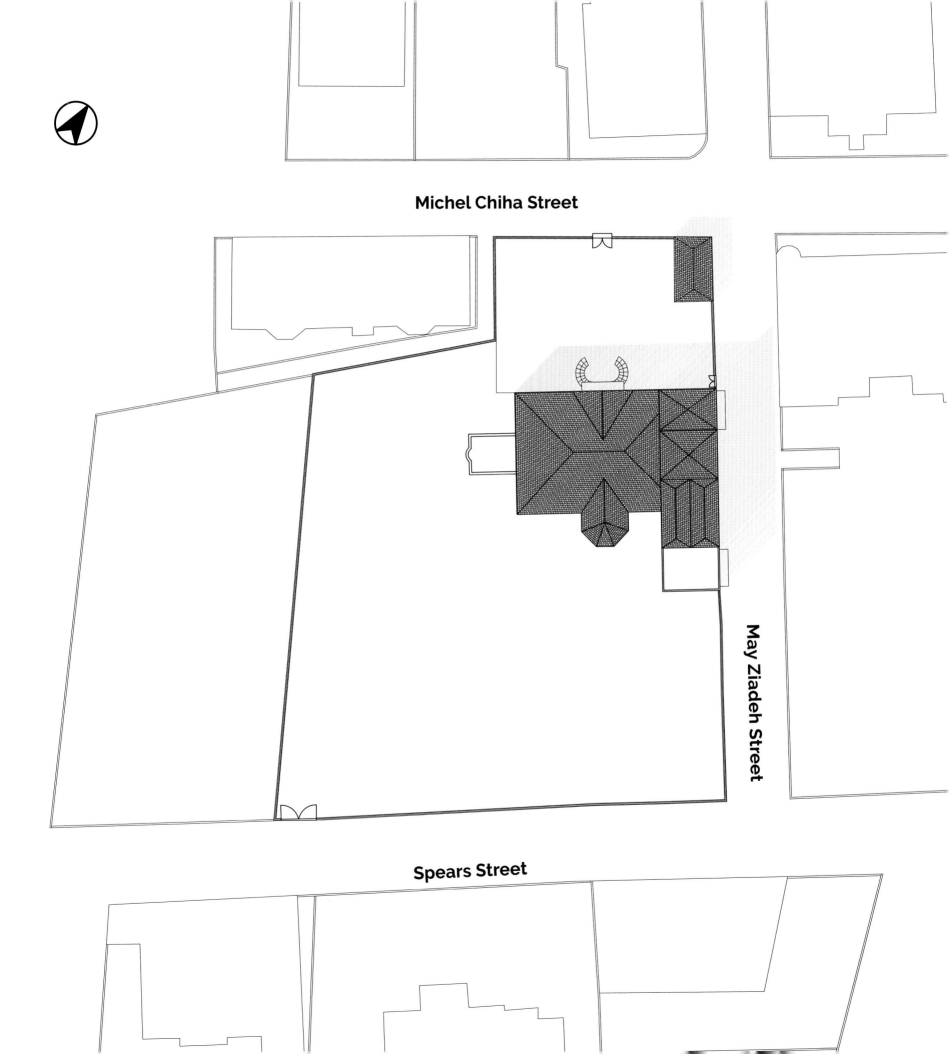

Michel Chiha Street

May Ziadeh Street

Spears Street

The house is perfectly symmetrical along the north-south axis of the central hall, which is framed by a second triple arcade to the south. However, the hall extends beyond the arcade into a truncated hexagonal room with large windows on each wall. The orientation of the central hall allows the south-west/north-east prevailing winds to ventilate the house naturally in the summer, inviting the cool summer breeze from the sea to cross the house from end to end.

Facing the side entrance door of the central hall, another door leads to a more intimate large space that opens on to a loggia framed by Corinthian-style columns and covered by the upper floor terrace. The loggia acts as an outdoor covered balcony with an open view to the private garden.

On the two sides to the east and west, the central hall opens on to more private rooms.

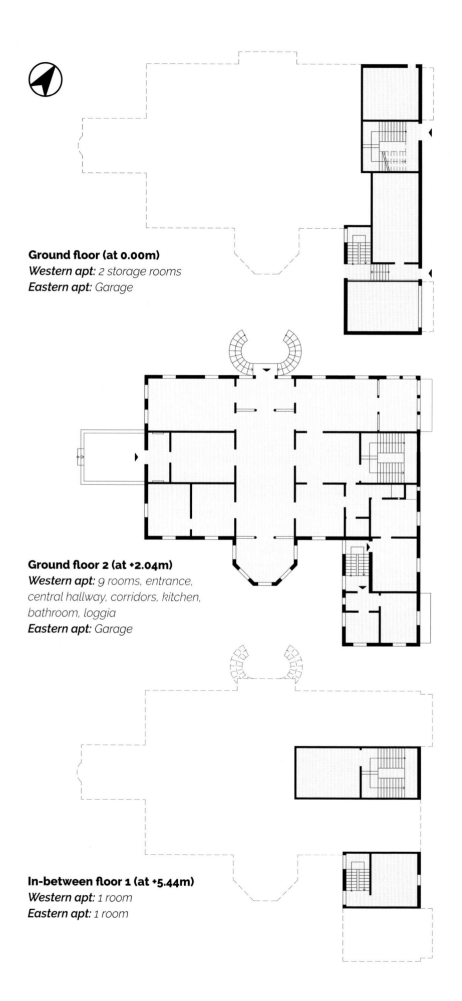

Ground floor (at 0.00m)
Western apt: 2 storage rooms
Eastern apt: Garage

Ground floor 2 (at +2.04m)
Western apt: 9 rooms, entrance, central hallway, corridors, kitchen, bathroom, loggia
Eastern apt: Garage

In-between floor 1 (at +5.44m)
Western apt: 1 room
Eastern apt: 1 room

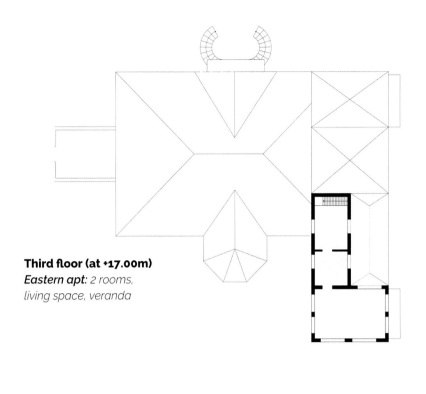

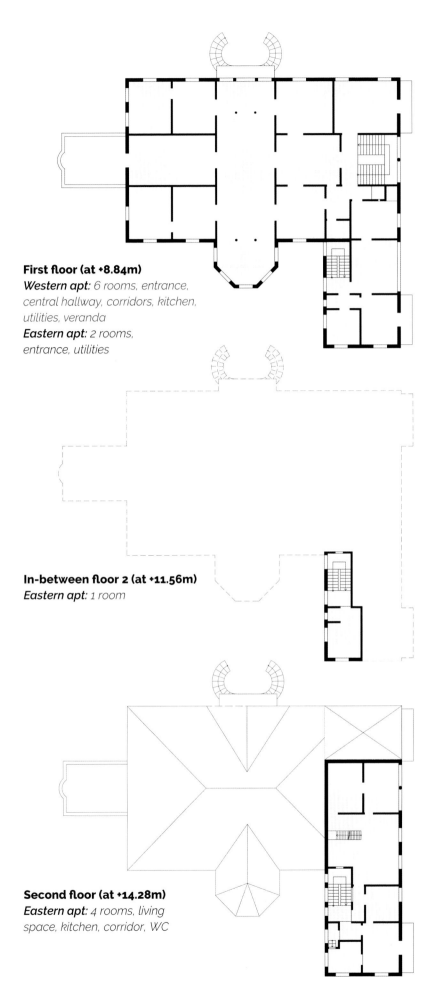

First floor (at +8.84m)
Western apt: 6 rooms, entrance,
central hallway, corridors, kitchen,
utilities, veranda
Eastern apt: 2 rooms,
entrance, utilities

Third floor (at +17.00m)
Eastern apt: 2 rooms,
living space, veranda

33

In-between floor 2 (at +11.56m)
Eastern apt: 1 room

Second floor (at +14.28m)
Eastern apt: 4 rooms, living
space, kitchen, corridor, WC

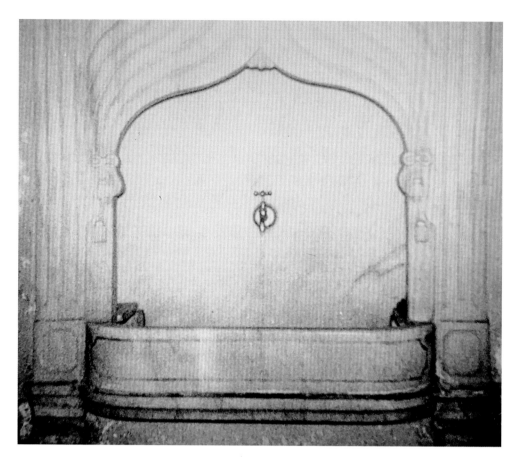

The central hall floor was covered with marble tiles, while the side rooms were covered with coloured cement (terrazzo) tiles. The back of the tiles is moulded with a mirror image embossment saying 'Khoury & Ghammache, Beyrouth' in both French and Arabic. This shows that when the house was built, a factory had started producing these tiles locally. In turn this also implies that the demand was substantial enough to justify the viability of such a factory.

The roof tiles, however, were imported and some were made in Marseille St-André by Guichard Carvin & Co., with the typical abeille (bee) logo, while others have an Italian company name: Laterizi, U.C.I.T. La Farfalla, Firenze (Florence).

The upper floor is similar in plan to the ground floor.

The house is covered with a red tile roof with many orientations following the main spaces of the house. The structure of the roof is of wooden beams and the ceilings on the upper floors use the typical baghdady wood and lath construction.

Old photos of the house show that the sandstone on the façades was left exposed on the ground-floor level, but plastered and painted on the upper level. The northern façade has an additional set of twin pointed-arched windows giving light to an accessible attic space within the red tile roof.

Typical of its time, all the regular windows are vertical or rectangular with louvred wooden shutters.

34

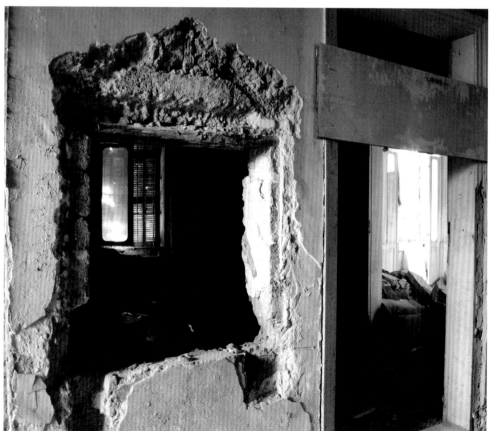

Top left: *Hand wash marble basin*

Bottom left: *Hole left by the removal of the basin*

Top right and centre: *Coloured cement tiles embossed with 'Khoury & Ghammache, Beyrouth'*

Bottom right: *Roof tile made in Marseille St-André by Guichard Carvin & Co., with the abeille logo*

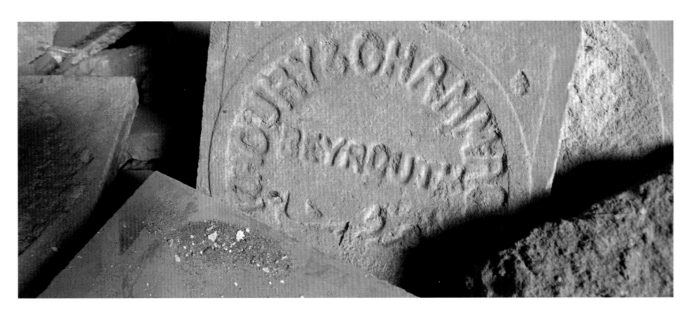

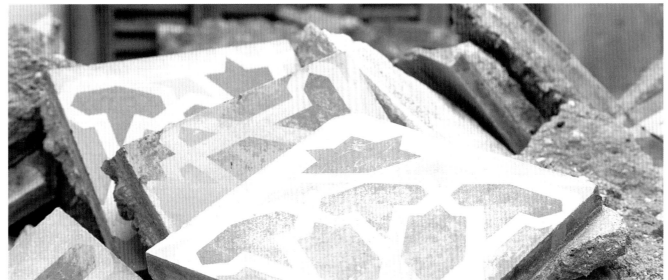

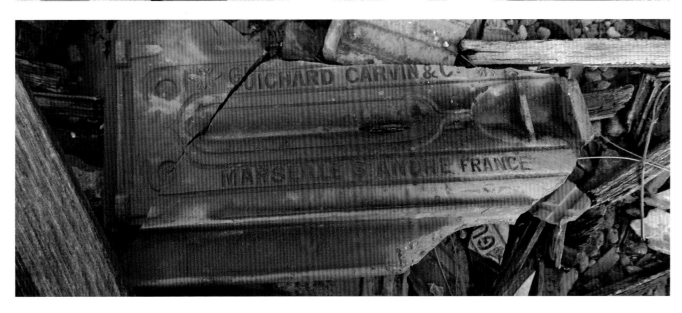

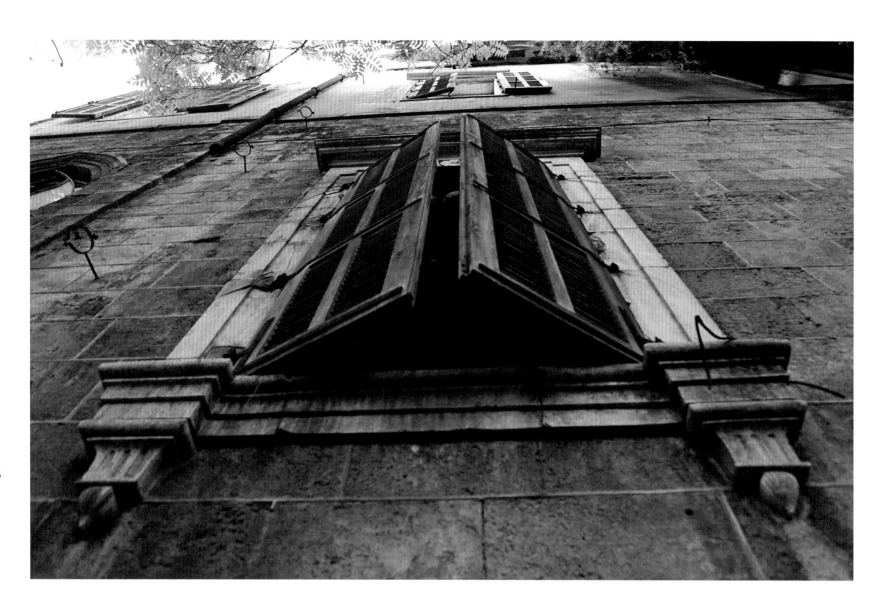

Above: *Window and shutters*

Right: *Fountain in the garden*

Urban landscape and other notable buildings in the area

The four properties below, built around the same time as the mansion, offer contrasting examples of buildings in the area with different functions that they may have served in their heyday. They have all had different journeys to the present condition in which they find themselves. Families cross paths inside and outside these houses, intertwined in political, business, social and various other spheres, a familiar theme within this book.

Zokak el-Blat is a stone's throw away, once a bourgeois garden district outside the old city walls of Beirut and home to one of the most fascinating houses, the Heneine Palace, now listed with the World Monument Fund. According to its website, the house was built in the mid-nineteenth century for a Russian aristocrat by the name of Tordoski, who decorated it in orientalist style, rather than the Neoclassical or Neo-Baroque styles popular at the time.

Left: *The Kantari neigh-bourhood is designated as a historic district, having a 'traditional character'*

Top right: *A panoramic view with the mansion and the garden at the centre*

Bottom right: *The mansion's damaged roof peaking out from the front garden trees*

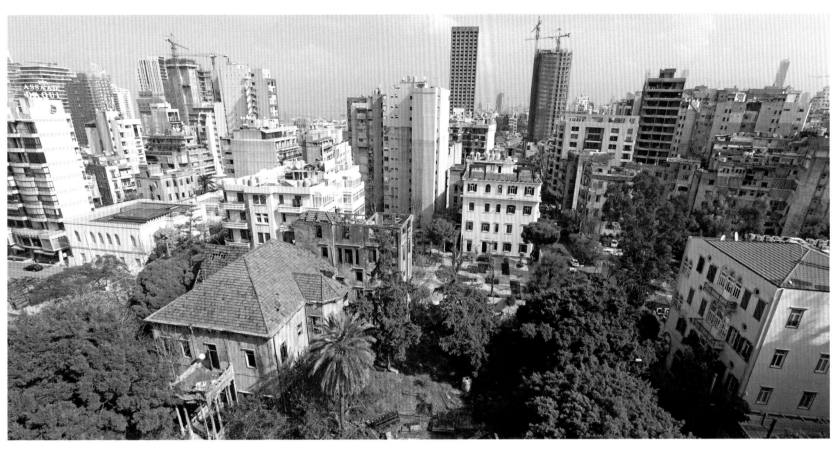

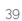

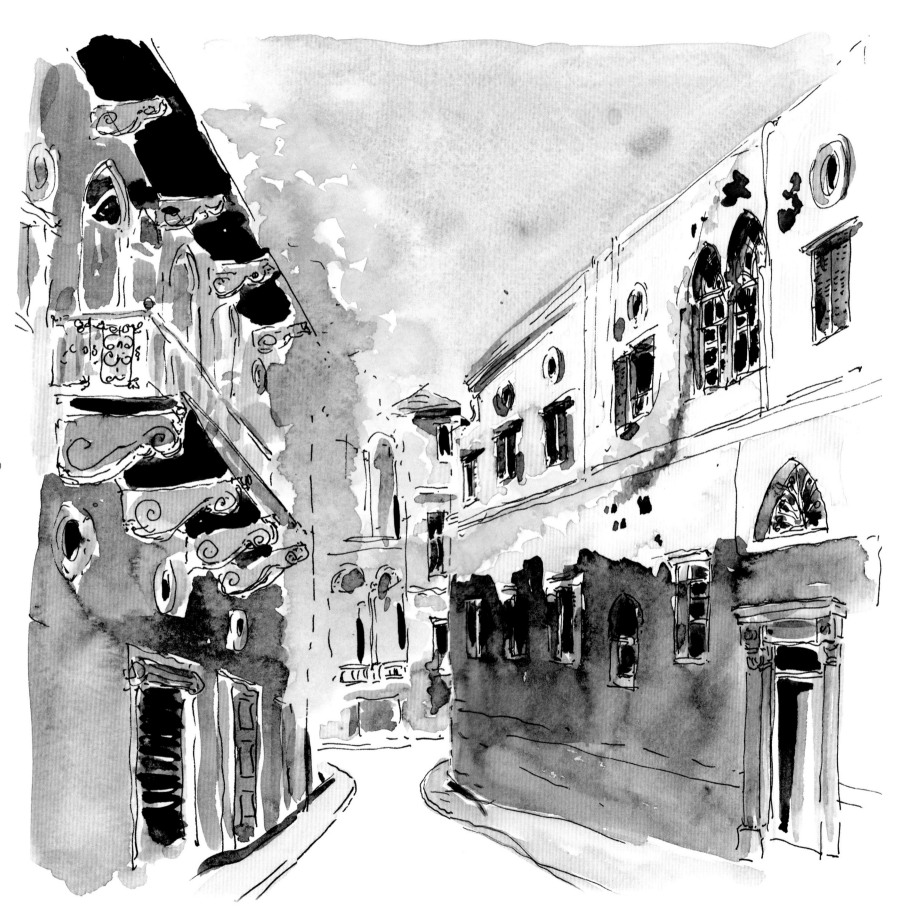

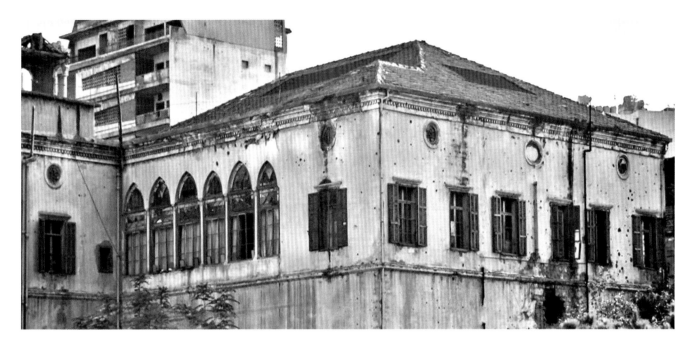

"The plain exterior of the building concealed an unusual Moorish-inspired interior, with fountains, plaster decoration in geometric motifs, and arcades of crenellated arches separating the different spaces. A long list of illustrious occupants has graced these sitting rooms: from the Russian nobleman for whom the palace was built, to the Mezher family of local landowners, who rented it to one of the founders of Beirut's French School of Medicine. Between 1914 and 1936, the building housed the United States Consulate-General, and it also served as a consulate of the Netherlands. Starting in the 1940s, the upper floor was rented to the writer, philosopher, and art collector Dr Dahesh, whose collection of European academic art later formed the basis of New York's Dahesh Museum of Art.

With the death of the last owner in 1970, the Heneine Palace was abandoned. After the outbreak of civil war in 1975 the ground floor became home to displaced families, who used makeshift walls to subdivide the large spaces. By 1990 these last occupants had been evicted and the palace now lies empty and decaying. The building has multiple owners, without clear agreement about its future, at the same time as the pace of real estate development in Zokak el-Blat has been intensifying."
World Monuments Fund

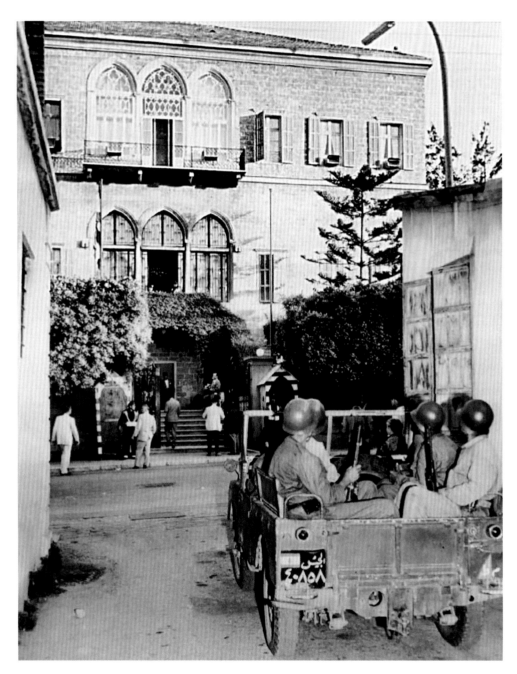

Closer to the house, to the east, the Bechara el Khoury house, also known as the Presidential Palace in its time, was built by Hanna Heneine in 1870. Heneine opened up the street (Michel Chiha Street), leading to Hamra, on his own land, the same street on to which the Takieddine el-Solh mansion's main entrance opens. Heneine's eldest daughter, Victoria, married Darwish Haddad. Victoria and Darwish's daughter, Renée, married Fouad el Khoury, the brother of the President, Bechara el Khoury. When Hanna Heneine lost all his fortune in the Depression of 1929 (while Darwish Haddad made his, selling cement and steel for construction), Haddad bought the house from Heneine but graciously allowed him to remain in it until his death, after which the el Khourys moved in. Darwish Haddad built a house facing it, in 1930, the first house to have central heating and a concrete structure.

The el Khoury house was the seat of the Presidency for the first fifteen years of the Lebanese Republic. Mohammad al Abboud was gunned down on its steps in 1953, just after a meeting with his political rival, Suleiman Al Ali, and President Camille Chamoun (more about this on pages 89-93).

During the Lebanese Civil War years, the house became run-down and eventually abandoned as the remaining el Khoury residents left the country. Today the house is owned by the Hariri family, who have restored it.

Below left and right:
el Khoury House

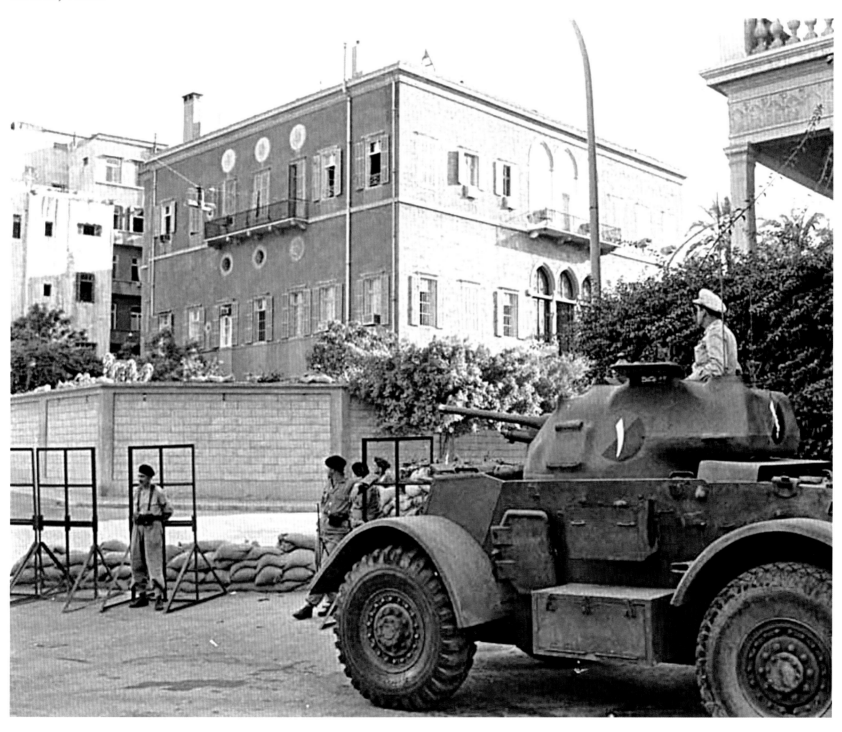

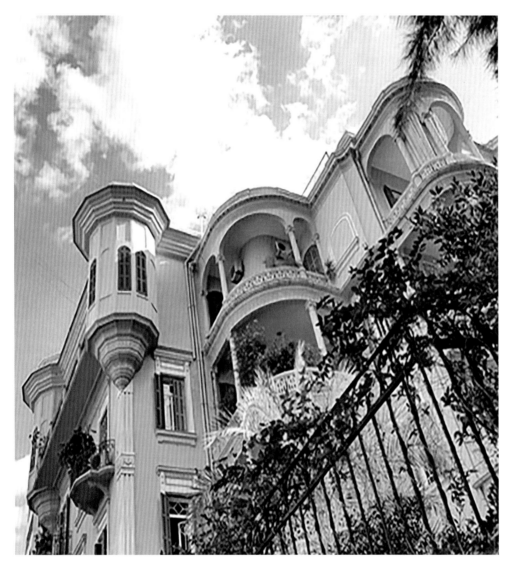
© Nayla Razzouk

Two blocks away from the mansion going north on May Ziadeh Street, in the Clemenceau area, the well-preserved yellow Kettaneh building (originally the Levy building) stands as a beautiful piece of architecture of the 1920s.

Prior to the Civil War, the Clemenceau and the greater Wadi al-Jamil neighbourhoods housed much of Beirut's Jewish community. Mr Levy, the proprietor of the building, also owned a rug store nearby. He sold the building in 1958, during the civil unrest of that year, and is said to have relocated to Israel. The Kettaneh brothers then bought the property. The Kettanehs established a transport and trade venture in 1922, working between Beirut, Damascus, Baghdad and Tehran. Following World War II, the Kettaneh company became the sole distributors of a number of American cars in the region. The car dealership still exists today. The descendants who remained in Beirut inherited the building, which is occupied by tenants as well as its landlord. Impressive preservation and recent renovations have rendered the building a protected heritage site.

Left and right:
Kettaneh building

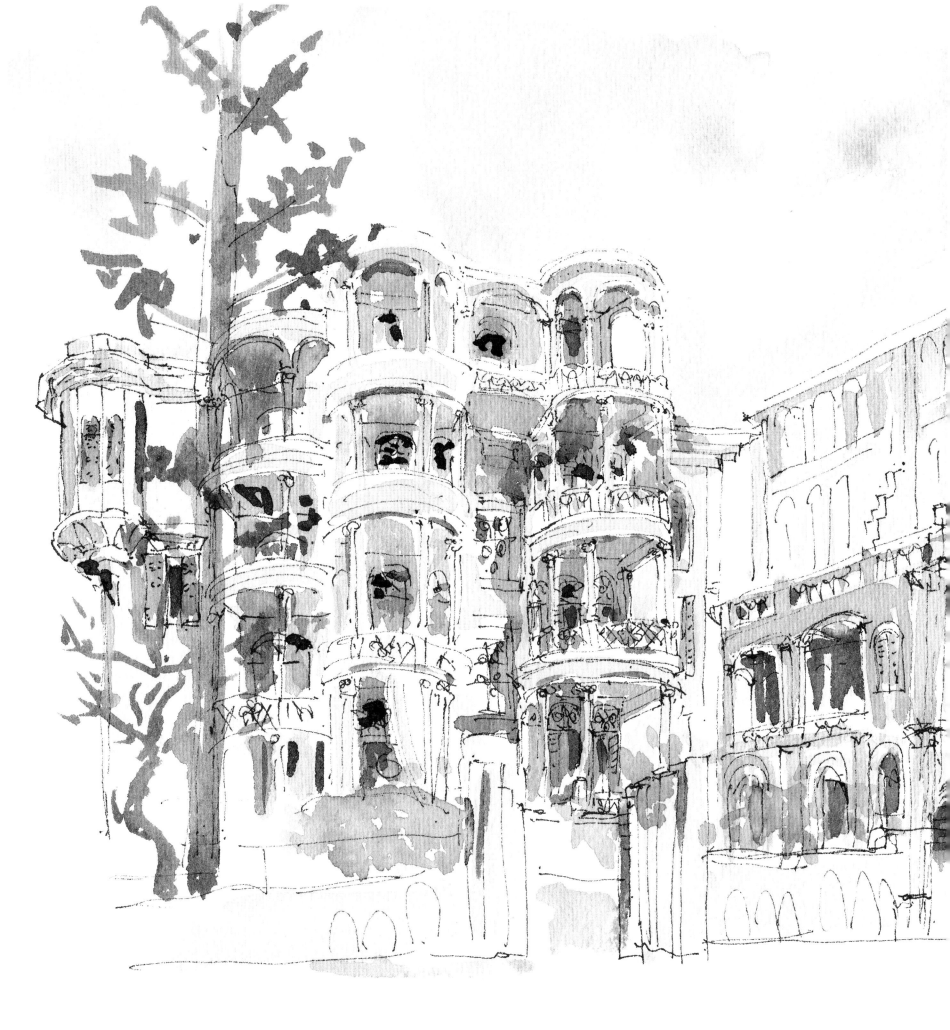

Finally, to the south, on Spears Street, is the Zico House, owned by the Yamout family (previously Beit Abou Dahr). The family kept the home in good condition before converting it into an alternative art exhibition space. It was built in 1924; the original owner was thought to be crazy for moving so far from the city centre to live in the wild. He also had to construct the road leading to Sanayeh, the area just to the south, marked by the public garden.

The area housed many interesting buildings and influential families. These houses were built in an area which was considered to be outside the city centre walls, but, of course, the city expanded.

Beirut emerged as a great metropolis towards the middle of the nineteenth century, the reasons being threefold: a demographic explosion, coupled with rapid urban expansion, including a thriving port and road-building, namely the highway between Beirut and Damascus; and then the cultural element, with the establishment of universities, hospitals, newspapers and political parties, which collectively cemented Beirut's status. The Industrial Revolution and the rise of capitalism in Europe, with the opening up of Ottoman markets to European trade, all helped towards Beirut's development, occupying an important place in the Arab and Mediterranean worlds. The Arab Renaissance (an-nahda) influenced political and cultural reforms, which were Western-inspired and came from within, flourishing in Egypt, Lebanon and Syria during the second half of the nineteenth and the early twentieth century.

Beirut became a vital transit hub for the outflow of goods and materials produced in response to the rising demand from Europe, chiefly through its port,

one of the main commercial ports of the Levant. Beirut was a point of entry into the Islamic world, for manufacturing but also the ideas of Christian nations. The city's Mediterranean influence stretched to an international style of urban development, shaping the growth of cities on both sides of the sea. The majority of buildings completed or under construction in Beirut at the turn of the twentieth century displayed French and Italian influences for the most part, while conserving elements of a Levantine architectural syntax. Some of the European influences were transformed directly; others were taken over from Ottoman models or annexed from contemporary Egyptian sources.

Construction had increased outside the city walls, with hundreds of country houses and villas stretching towards the mountains and countryside, about half inhabited by American missionaries and European families, and the other half by the local population. They lived among the orchards, olive trees, mulberry trees, prickly pears, pine forests and gardens surrounding the city. No longer confined by its walls, Beirut was attracting inhabitants from the mountains, the Syrian interior and from other cities such as Sidon and Tripoli.

Foreign consulates installed their consulates on Kantari Hill in the neighbourhood of Zukak al-Blat. They were followed by wealthy citizens – notables and merchants, Muslim and Christian alike, looking to flee the cramped conditions of the old town, building homes outside the walls. The Naamanis, who had the mansion built, were one such family, prosperous, making their fortune primarily from textile businesses, trading with Europe and other Middle Eastern countries.

While I was writing this book and specifically this chapter, a cataclysmic event of unimaginable magnitude destroyed Beirut and shocked the world. The port was the epicentre of the explosions which ripped through the city. Pressure waves from the blast ripped the façades from every building in neighbouring districts. Many of the buildings in the Gemmayze and Mar Mikhael districts, and further towards Achrafieh, are historic in character, built around the end of the nineteenth and beginning of the twentieth centuries. About sixty historic buildings in Beirut are now at risk of collapse following the devastating explosions. At least 8,000 buildings, many concentrated in the historic quarters, were affected. There have been concerns for years in Lebanon about historic buildings being sold, then demolished and replaced by high-rises. There have been recent reports that middlemen have been contacting owners of the blast-damaged historic buildings and offering high prices to buy their property.

48

Preserving our cultural heritage is vital for historical research, education and in order to reinforce a sense of identity. The mansion and other buildings and symbols of culture are significant, for they speak of shared roots and a sense of belonging and pride in the achievements of our ancestors. This is perhaps even more significant while Arab societies are experiencing turbulent times.

This page and next:
Examples of buildings in the neighbourhood in various states of disrepair

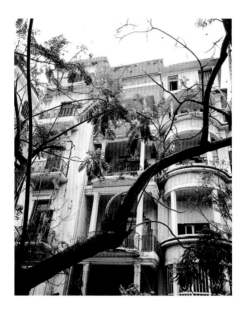

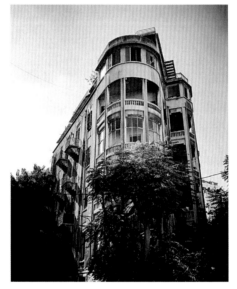

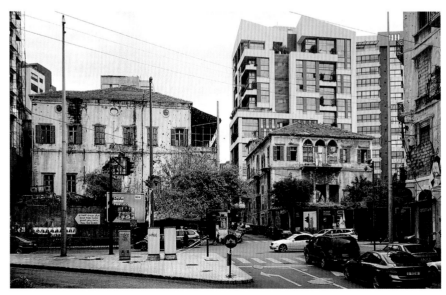

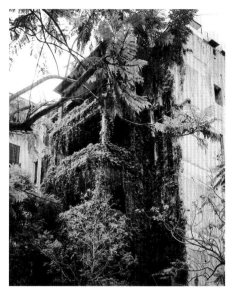

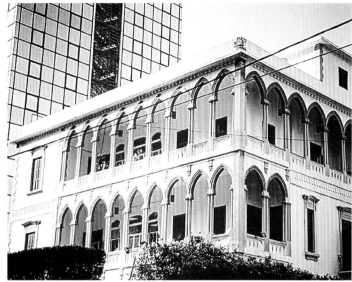

Above top: *Outside the immediate neighbourhood, Haigazian University.* Above: *Dar El-Nimer in 2016, an arts and cultural space*

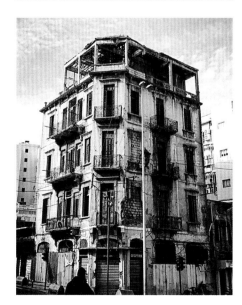

THE FALL OF THE OTTOMAN EMPIRE

The Naamani Family (1880-1930)

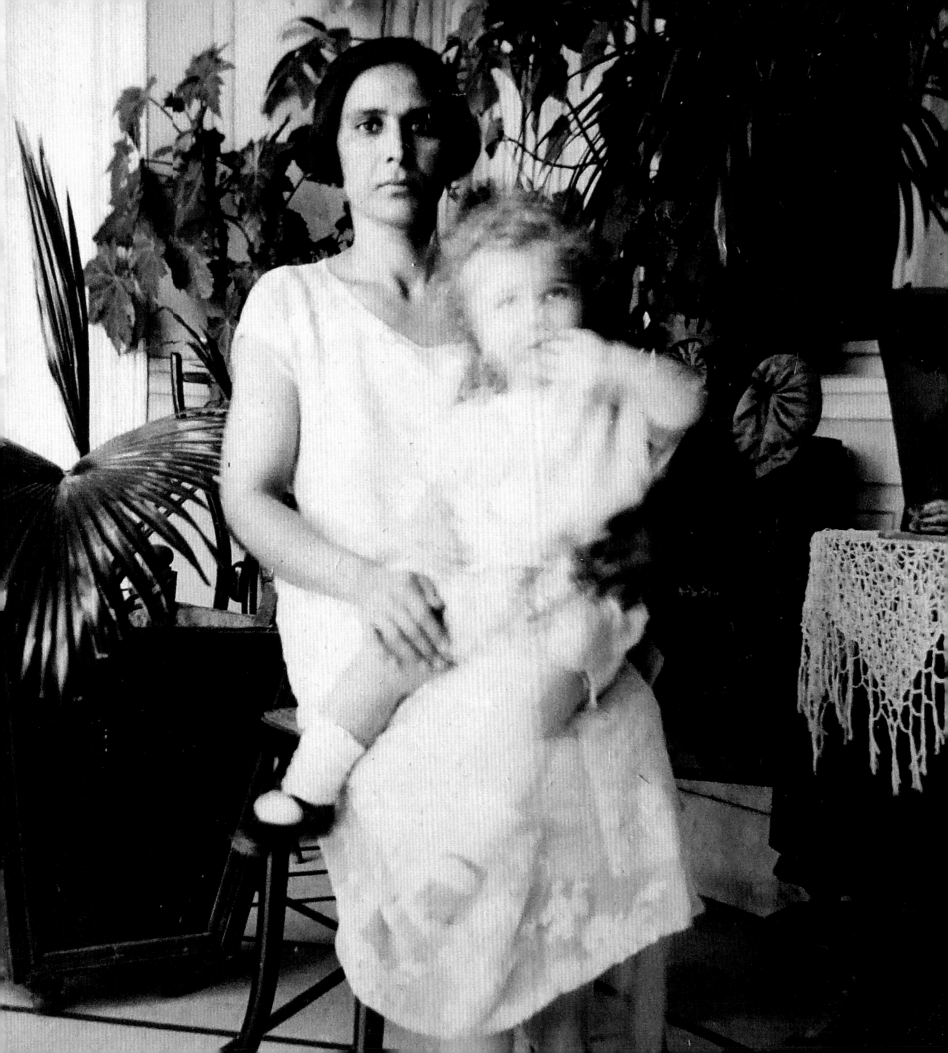

Previous page: *Bahia Naamani with Zafer in the mansion*

Left: *Hasan Naamani*

Right: *Hasan's daughter Hind marries her cousin Anis in 1931.* Front row from left: *Mounira wife of Nabih with her daughter on her lap, Hind, Anis, woman.* Back row: *man, Nabih, 2 men, Wajih, man*

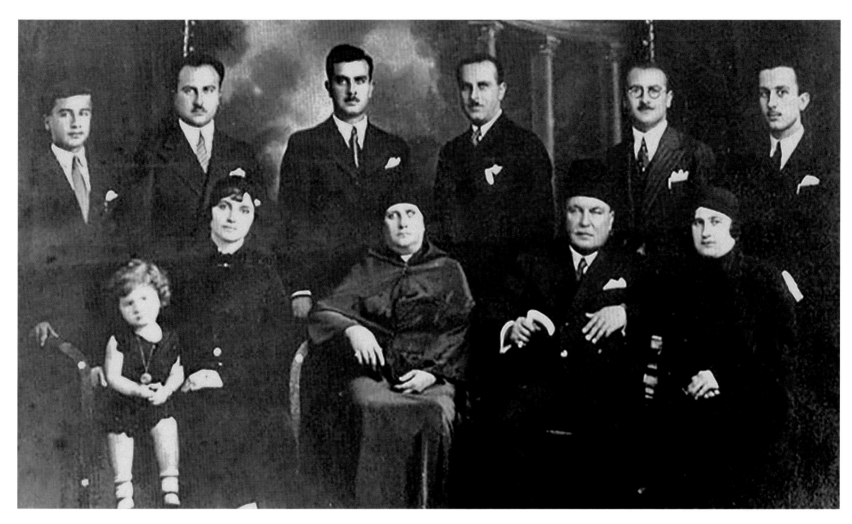

Hasan Naamani had the mansion built in Kantari where he lived with his extended family at the end of the nineteenth century during the Ottoman Empire, according to his grandson Hassan. Unfortunately all the records pertaining to this building were destroyed in a fire at the municipality building during the civil war of 1975-90. So it is the oral history and some remaining family records that will piece our timeline together on the early history of this building.

The Naamani family worked mainly in textiles, which they imported from Europe. The most prominent family member was Aref Naamani, Hasan's nephew, who was one of the wealthiest and most cultured French-educated notables among the Sunni Muslims. They also owned businesses abroad, from a hotel in Iraq called the Carlton, to shops in Beirut, and a business in Manchester among others. Aref owned a shop in Beirut, which was renowned for its expensive

materials from Italy and Europe, where all the affluent inhabitants bought the cloth to have their dresses and suits made.

Hasan's grandson remembers his father recounting to him how he rode his horse from the mansion and back daily to the shop in Souk al Tawileh, which he and his brother owned together with the Akoury family. The shop was called Naamani Brothers & Akoury. There were several souks in the centre of Beirut, which specialised in various goods. Before the Civil War Souk al-Tawileh and Souk al-Jamil were favourite shopping destinations, which housed fashionable boutiques and haute-couture houses, sold clothing, perfumes and other luxury articles, while Souk al-Franj functioned as Lebanon's biggest fruit, vegetable and flower market. Downtown was the city's bustling centre, typically chaotic and energetic, attracting Lebanese and foreigners alike from

all walks of life who intermingled, buying goods and services to suit every budget.

The family fortunes may have suffered for several reasons, one being Aref's support of Arab nationalism against the French colonisers, and therefore pressure was brought to bear on the entire family. The Great Depression affected economies and businesses across the world and lasted for about ten years (1929-39). There was also a rumour that a ship carrying a lot of their uninsured stock from Europe sank in the Mediterranean Sea, yet another factor forcing the family to close or sell off a lot of their businesses. The exact date that the house was sold is unknown, as well as the possibility that they rented part of their home to the Ammouns before selling to the next owners, the al Abboud/Abdel Razzak family.

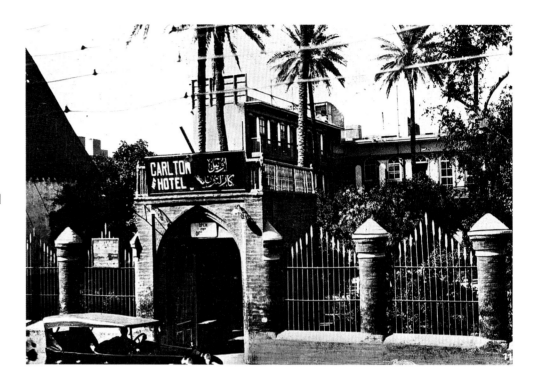

Above top: *Carlton Hotel, Baghdad, owned by Aref Naamani*

Below: *Train on the Iraqi railways, and ticket*

Wajih Anis Naamani

A fictional account of Wajih's journey from Iraq to Beirut, written by his daughter Bouchra, based on the writings in his diary and piecing historical events together.

" *June 1930: I am on a train going back home to Beirut via Palestine. Thank God my work in Baghdad is done for Uncle Aref. I sold Carlton Hotel to an Iraqi gentleman who will run it properly and as successfully as it was. Dr Sfeir who was planning an ideal project for the area left disappointed because the government did not approve it despite the previous agreement and the huge sum of money he invested in it (13 million English Pounds!). I still have the contract with me... what shall I do with it? Futile arguments he had with these people. Well now with the oil discovery in Iraq, in Mosul and Karkouk, business will flourish and maybe the future will be promising in this field and there will be job opportunities there.*

The sound of the train lulled me to sleep. I have long hours ahead of me. I might take a nap until Haifa or maybe after I take lunch. I moved to the restaurant wagon hoping to find some people I might know. The wagon was nicely furnished red, it was full and I did not recognise any of the faces. I had better go back to my seat.

I wonder where my father and mother are now, in Cairo or Alexandria with my younger siblings. Did father finish closing the shops and office in Cairo? Did my brother Nabih finish his task of closing the affairs of Uncle Aref in Milan? Anyway, we will soon meet in Beirut and discuss the latest affairs we did for dear Aref. This business of dealing with bankruptcy hit Aref suddenly... his offices in Manchester, Milan, Cairo, Alexandria and Iraq made him ask the help of all of us young men, my father his partner, my two elder brothers and myself.

Aref was involved with the Hashemist Faisal whose great interest in the Mosul field of oil was to build a pipeline to a Mediterranean port to help Iraq economically. He was caught between French ambitions, British ambiguity and American politics. Faisal, as described by Aref, his close friend, was a man of charm and intelligence. He had a vision for a modern and tolerant Iraq. Together they decided to ally themselves with the British, lured by the promise of Arab independence, which seemed like a mirage.

Earlier in 1920, Faisal was proclaimed king of Syria. The French were merely playing Faisal along. Once they crushed the Great Revolt of Syrian Druze, they lost interest in having a Hashemite rule Syria. In 1926, the French created the State of Greater Lebanon. Aref with the help of his closest friends Riad el-Solh and Amin Arslan (a patrician Druze Emir), all members of the General Syrian Congress, made secret contact with several members of the Administrative Council, without alerting pro-French die-hards like Daoud Ammoun, a Maronite who petitioned for an independent self-ruled Lebanon under French protection.

Aref was one of the wealthiest and most knowledgeable French-educated notables among the Sunni Muslims, along with Riad and Arslan; they were sophisticated and brilliant eloquent French and Arabic speakers. They were even prepared to take their case to the United States. Aref was ready to fund all

their travel expenses, known for his generosity and patriotism. French intelligence had carefully monitored Aref's moves. They considered him to be a dangerous agitator and a champion of Lebanese unity... most young men were enthusiastic, to name a few (Ahmad Bayhom, Salim Ali Salam, Ayoub Thabet, and Afif el-Solh, Najib Boustani, George Haddah...).

Their fight was to find a consensus on what makes them a nation, not to fly different banners, to be completely independent and plan for a better future and agree on a common vision.

Beirut... Beirut... I miss my beautiful city, I am looking forward to seeing all the family. Well, now I come to realise I have no place to stay, where would I go? Oh, I will go straight to my grandfather Hasan. He will find me a place in his beautiful large mansion even if it is crowded with all my uncles and aunts and young ones. And let's see who would be there beside the grandparents ... Uncle Jamil, Chafic, Hachem and Aunts Khadija and Bahia. Maybe mum Hind is there?! She might be visiting her family if she misses them, I will find her reading a book of Arsen Lupin or one of Al Helal's collection of books ... anyway with all this crowded home will I find a place to stay ... thank God I have my lovely wardrobe with the green glass and my boxes of books ... nobody would mind the books as they are all book lovers so I just need a bed and somewhere for my Oud. I will play it in the garden in the front, no, hmmm ... in the back, better, it is huge and you can get lost in it, plus grandfather Hasan likes peace and quiet. He is always serious and pensive, busy all the time, well of course anxious for news coming in especially when you are waiting for ships carrying your goods from abroad and now things are not looking good and you have all the reasons to worry.

Maybe Uncle Chafic and Hachem would be in Damascus doing their trade. Jamil is maybe married or abroad, so the aunts will be happy to see me and cook delicious food for me.

I arrived late at night to find the big black iron gate closed, the front door is also closed. I had better use the side entrance, I would probably disturb the neighbours on the ground floor, they are the Ammoun family. I could see a dim light coming from the door. Probably Mrs Victorine, Daoud's widow, stirring, tending to her two children Blanche and Charles. The carriage that brought me made some noises while bringing my things and that's why I heard someone coming down to meet me holding a lantern to see who is coming ... it was dear Aunt Bahia, always so helpful and cheerful ... whispering her welcome and her questions. She guided me up the stairs for two floors and then more stairs, another corridor, a few steps and there I was in a small room with a window looking on to the side entrance where I came from.

I am so tired from the long trip, I will sleep and rest and tomorrow will inquire about the rest of the household. Unpacking I heard Aunt Bahia telling me that Jamil and his family have settled in Saida in the south, Khadijeh is married and away for a week, Hachem and Chafic are in Damascus for their trade, but young Zafer and Nasser are here and she is taking care of them. Wasila and husband are good and so is Najla and her husband ... your mother Hind is in Cairo with your father. I could not hear the rest because I was already asleep... "

Wajih Naamani first left
next to Bechara Wakim and
other guests at the Carlton
hotel in Iraq

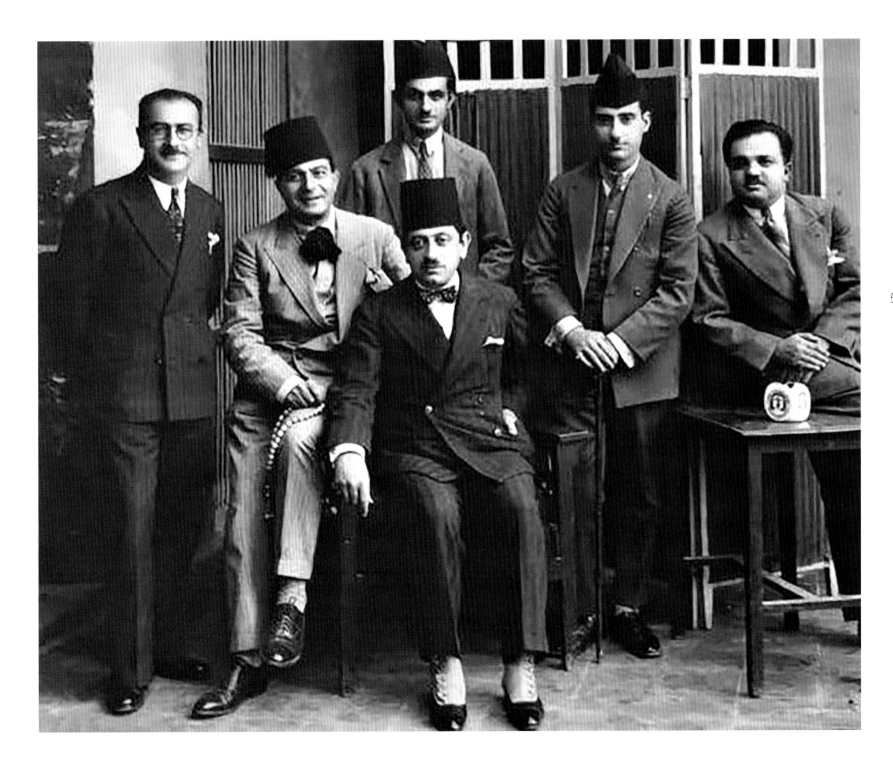

57

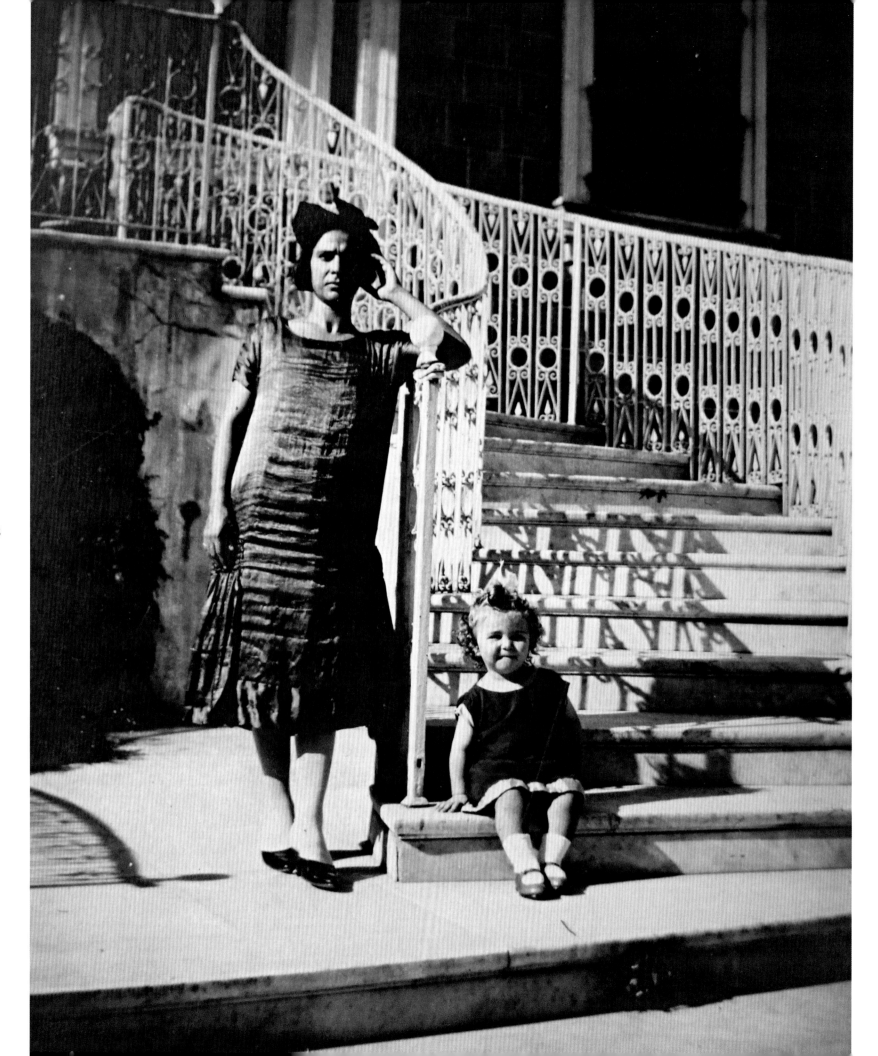

58

Left: *Bahia Naamani and Zafer at the base of the circular front entrance steps of the mansion*

Below: *Chafic, Hasan Naamani's son, in the mansion garden*

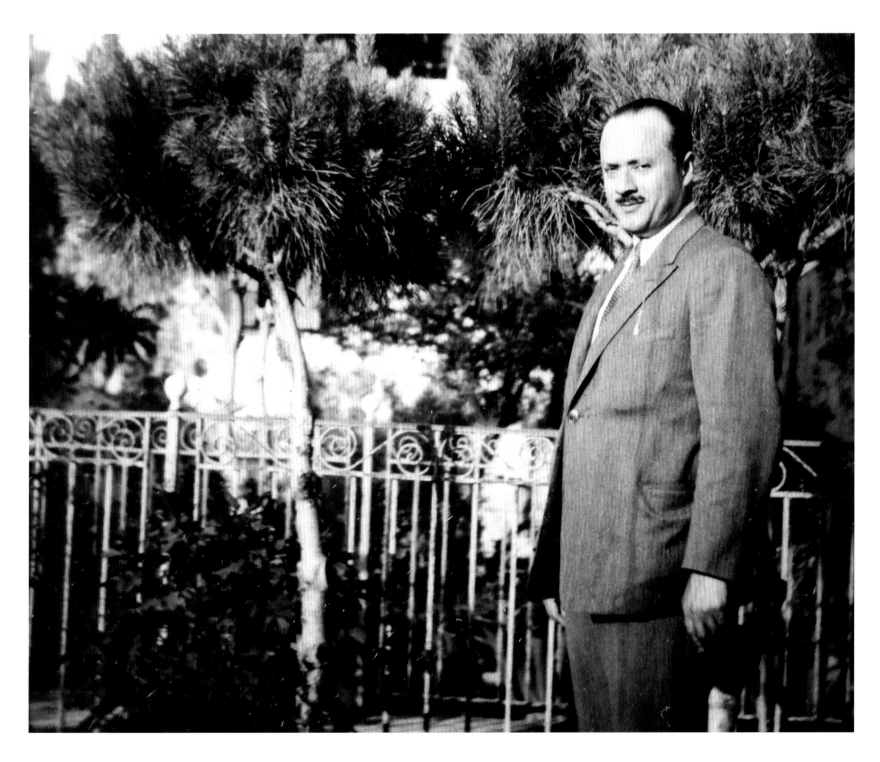

THE GROWTH OF THE CITY
Daoud and Victorine Ammoun (1918-73)

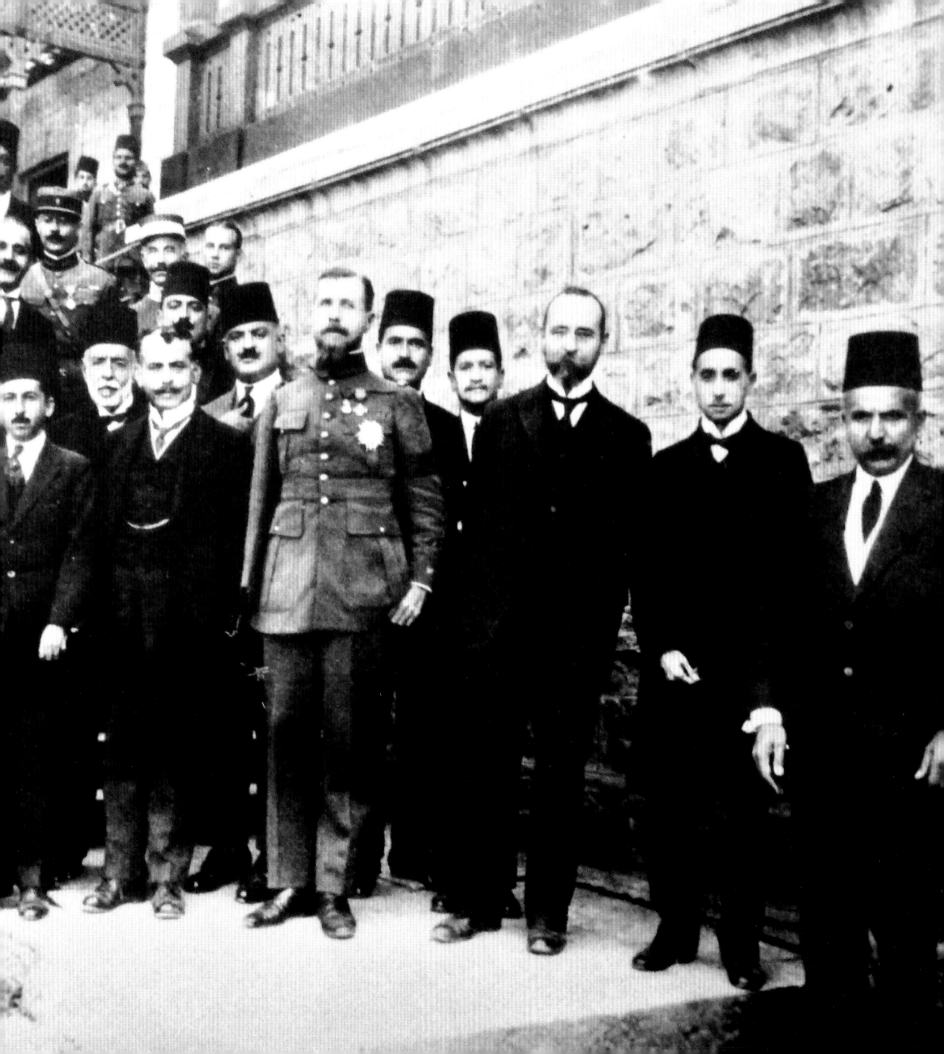

Daoud Ammoun and his family moved into the ground floor of the mansion after the Paris Peace Conference around 1919, according to his grand-daughter. They lived there together until he died in November 1922, leaving behind his widow Victorine (Chiha) and their two children.

Daoud Ammoun, who hailed from a family of notables dating back to the eighteenth century, was born in Deir el Qamar. He earned a law degree and became a member of the Lebanese Parliament. Deir el Qamar is a picturesque village characterised by stone houses with red-tiled roofs, south-east of Beirut. It is a predominantly Christian town peppered with churches.

62

Previous page: *Daoud Ammoun, with the watch chain hanging from his waistcoat, next to General Gouraud*

Right: *Painting of Ammoun Bey Ammoun*

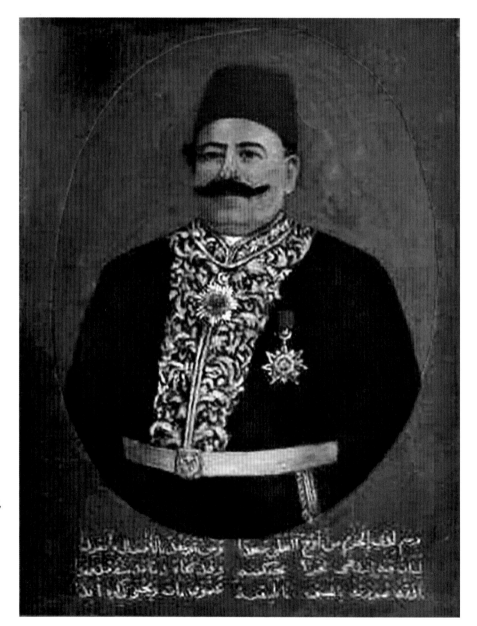

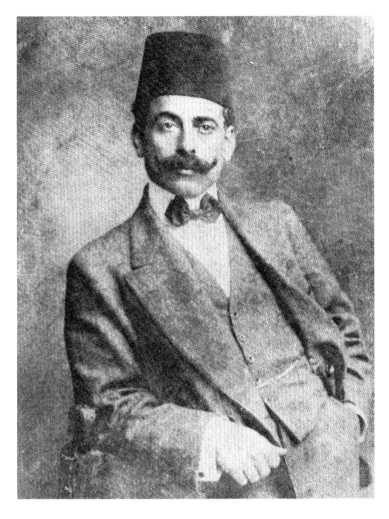

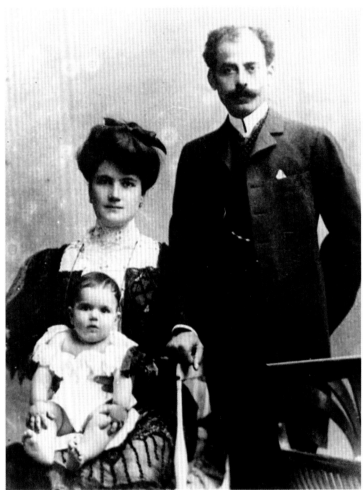

Above left: *Portrait of a
young Daoud Ammoun*

Above right: *Daoud, his wife
Victorine and their son
Charles*

Right: *Painting of Daoud Ammoun*

Opposite: *Victorine (Chiha) Ammoun, Daoud's wife, painted by her daughter Blanche*

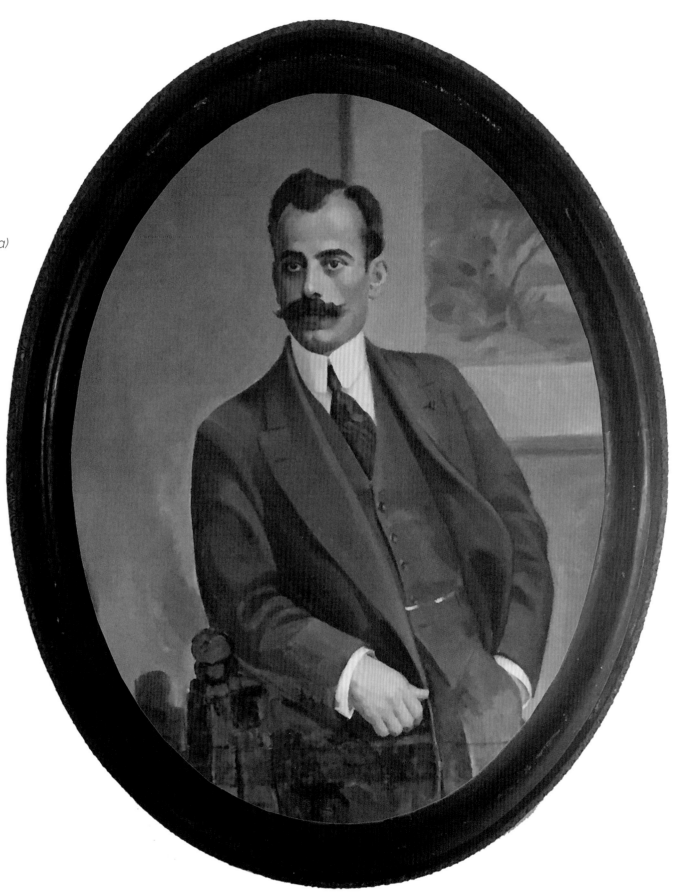

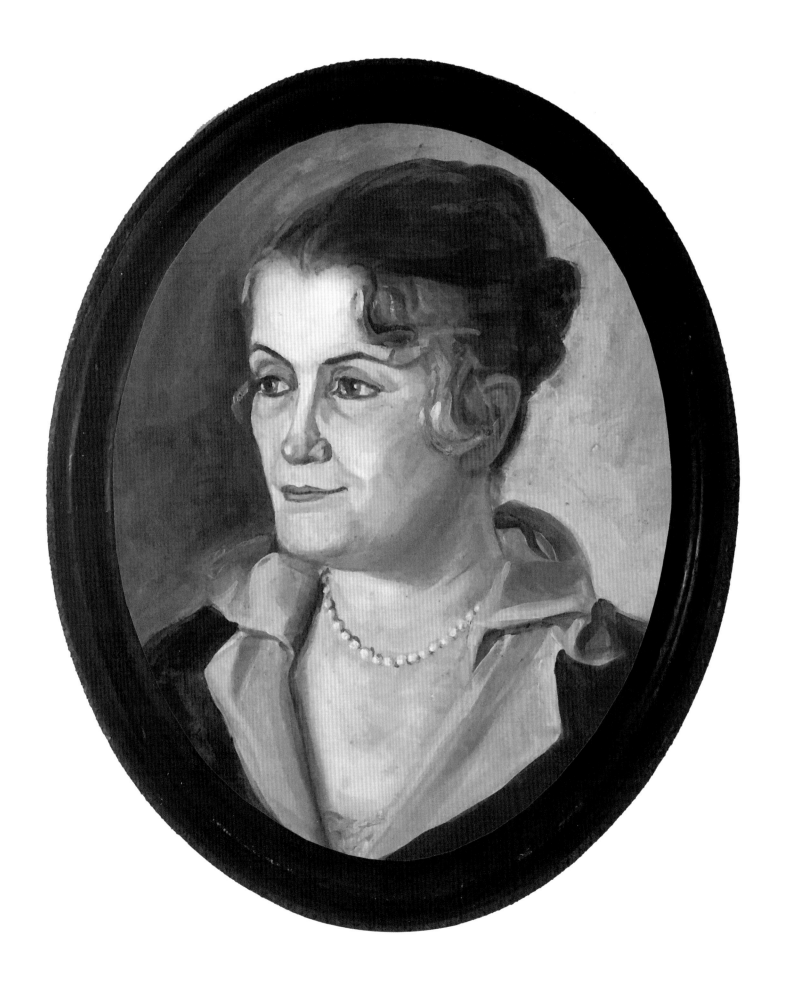

65

THE PARIS PEACE CONFERENCE

The Paris Peace Conference was the meeting of the Allied victors following the end of World War I to set the peace terms for the defeated Central Powers. The Ottoman Empire was split up in 1920 and its overseas territories were awarded by the newly formed League of Nations (which later became the United Nations) as 'mandates' to the United Kingdom and France. Lebanon and Syria were thus handed over to France, and Palestine and Iraq to the UK.

Daoud Ammoun, a member of Mount Lebanon's Administrative Council, headed the first of three successive Lebanese delegations to the Paris Peace Conference. It took the Lebanese two more delegations – one headed by the powerful Christian Maronite Patriarch Elias Hayek – and months of negotiations, including some street protests, to achieve some of what they were asking for. In February 1919, Ammoun petitioned the Paris Peace Conference for an independent, self-ruled Lebanon, under French protection. The Lebanon for which he pleaded was not just the traditional Mount Lebanon district, but a country enlarged 'within its historical and geographical boundaries' to include Beirut as its capital, Tripoli and the north, Sidon and the south, and the Beqaa valley in the east. Mount Lebanon had been an autonomous territory within the Ottoman Empire.

Although Christians, Muslims, Jews and other religions had lived relatively peacefully together under Ottoman rule for over 400 years, as the Empire crumbled, the Ottomans became increasingly acrimonious and desperate to crush uprisings and dissension. There were several incidents of Christian minorities being massacred, and many Muslims were also killed or jailed by the Ottomans. The rise of Arab nationalism, partly fuelled by the Western powers to defeat the Ottomans and their allies, as well as local aspirations for self-rule, swept across the region. The premise of Arab nationalism was to establish political, religious and historical unity among the peoples of the Arab nations and to gain independence from colonial powers.

While living in the Kantari mansion, Daoud Ammoun was elected president of the first Lebanese 'Administrative Commission' under the French mandate, the day after the creation of Greater Lebanon. He presided over it from October 1920 to the date of its dissolution in March 1922.

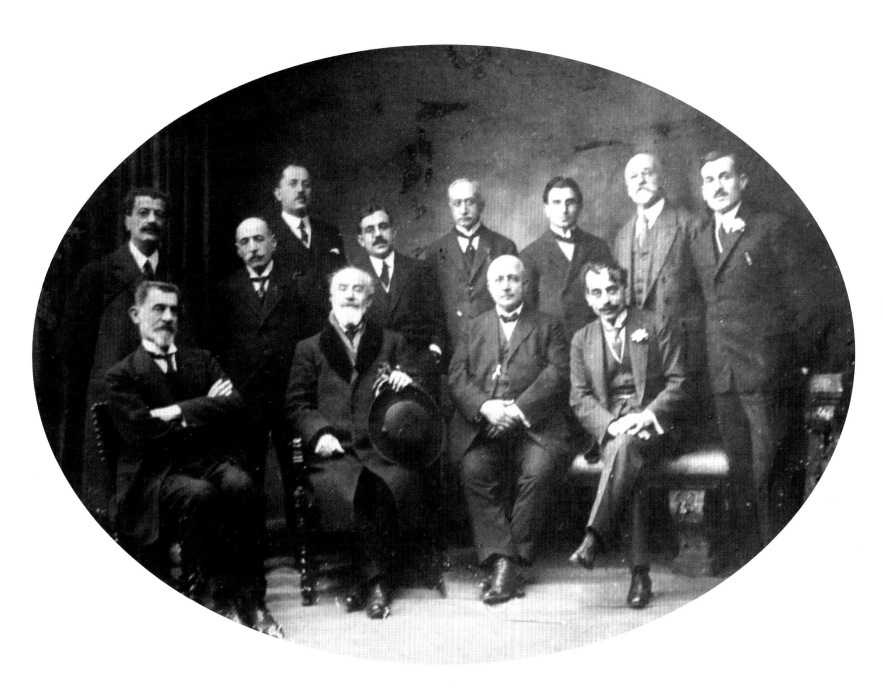

Daoud Ammoun, head of the first Lebanese delegation to the Peace Conference in Paris, is seated first on the right

67

Daoud Ammoun's two children were Charles (1905-63) and Blanche (1912-2011). Charles studied law at St Joseph University in Beirut and was also a journalist. He founded the French-language *Le Jour* newspaper with Mohammad al Abboud in 1934. It is believed that the Ammouns were sitting tenants when the property was sold. As his neighbour and landlord, perhaps with capital and a similar political outlook, Mohammad helped Charles start the newspaper. They sold it to Michel Chiha in 1937, though Charles continued to write for the newspaper until 1938.

Charles was often seen playing tennis in the grounds of the mansion. He was a member of Parliament, representing the Mount Lebanon district in 1937. He was also appointed a minister plenipotentiary, and permanent representative of Lebanon to UNESCO from 1949 until 1963. He wrote books on subjects including discrimination in education.

Blanche studied law, archaeological history and art, which was the passion she pursued. She was also a socialite, often hosting parties at the mansion. She married a French colonel who was based in Lebanon. They moved to Paris, where they had three children and where Blanche continued to produce art and write books.

Blanche and her family visited her mother Victorine at the mansion regularly, usually spending the entire summer holidays in Beirut. The grandchildren have fond memories of spending these holidays with their grandmother. She passed away in 1964, though the family continued to spend summers there. The Ammouns were asked to vacate the apartment in 1973, possibly because Takieddine el-Solh, who lived on the first floor with his wife Fadwa, was Prime Minister of Lebanon at the time and needed more space to accommodate the numerous visitors and staff.

Charles Ammoun painted by his sister Blanche

Below: *A self-portrait of Blanche*

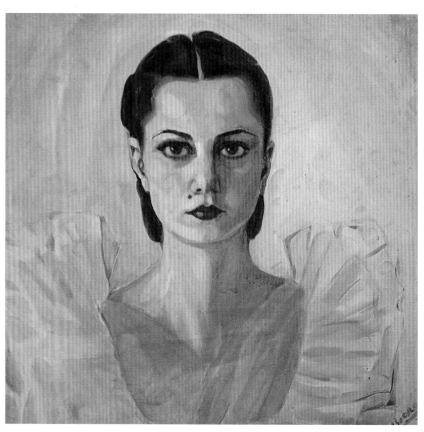

The book for which Blanche is best known for, which she also illustrated

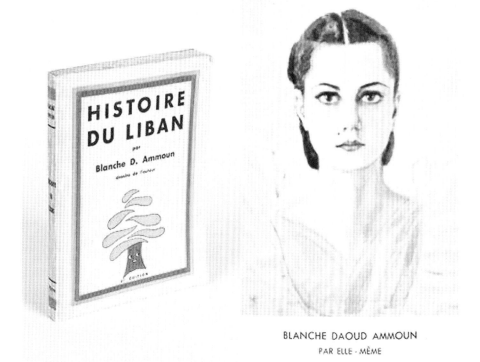

BLANCHE DAOUD AMMOUN
PAR ELLE - MÊME

Reception at the Kantari home for the launch of one of Blanche's other books, Queen Zénobie, *in 1962. Present are the minister Henry Pharaon, the Ambassador J. Harfouche, and in the centre, Blanche and her husband André*

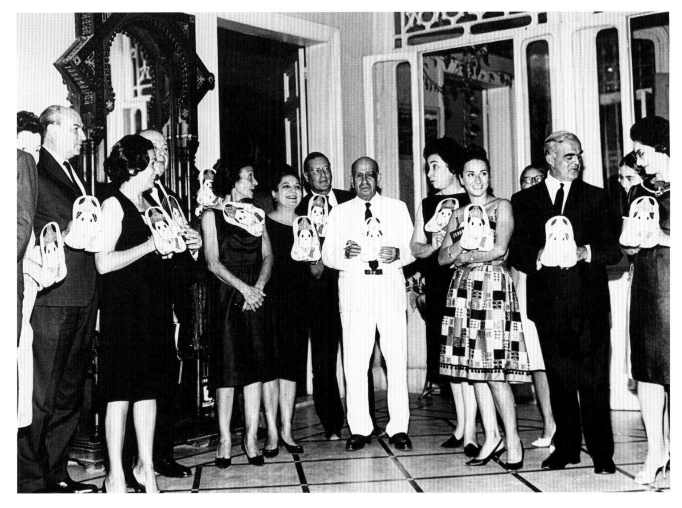

Left: *Blanche with her husband Colonel André Lohéac and Aimee Coury*

Above: *Blanche in the garden with her three children, Frank, Lyne and Gwen*

Right: *Blanche with her son Frank*

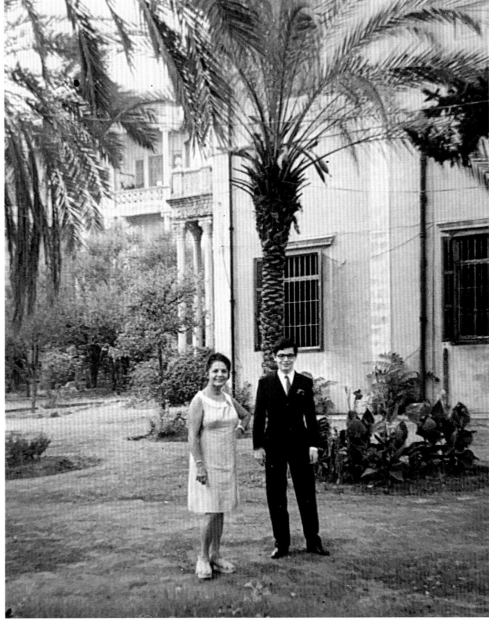

Right: *Reception at their home to launch her brother Charles' last publication* Cèdre Mon Héritage *in 1968, Blanche with Hind Boustani and Alfred Naccache*

Below: *Sami el-Solh with his daughter May Yassine and Blanche (1968)*

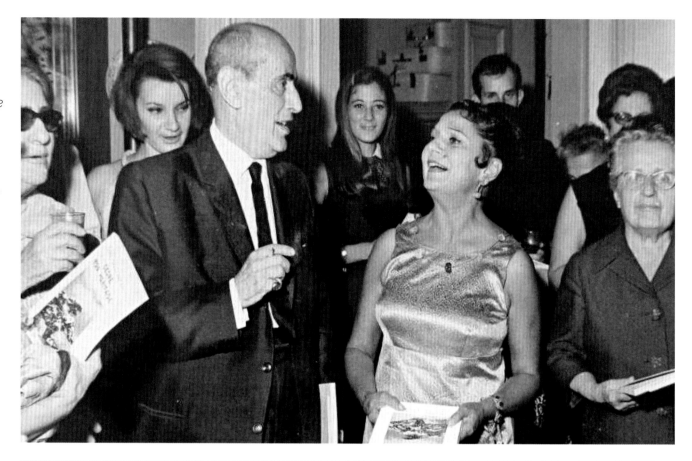

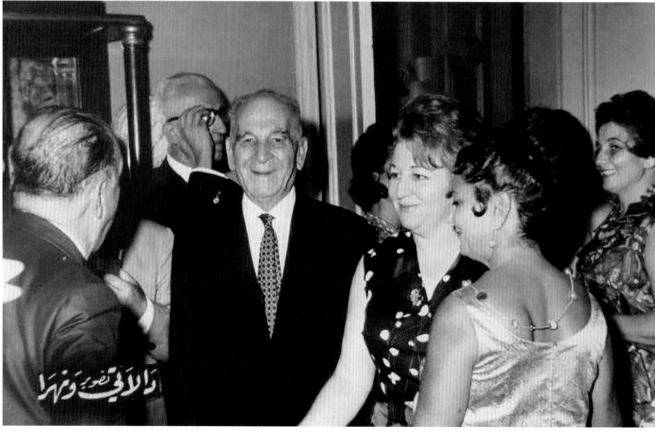

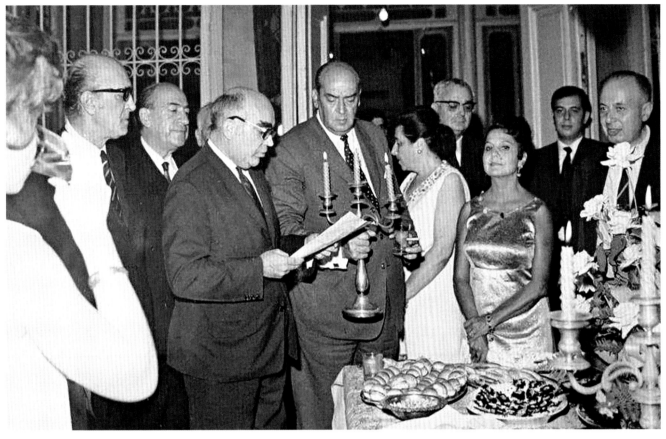

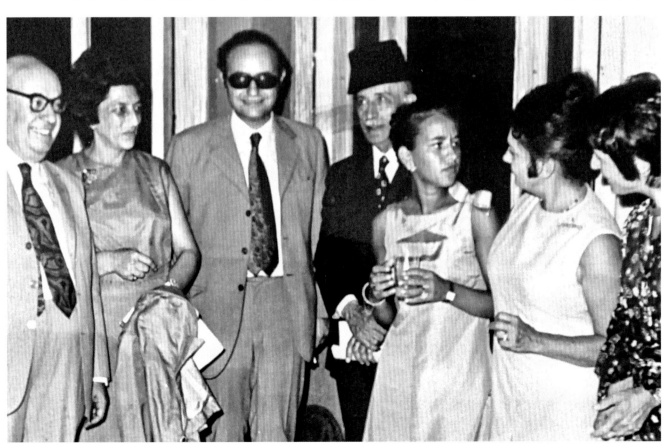

Left: *Camille Aboussouan,
reading aided by Naufal
and Blanche (1968)*

Below: *F.E. Boustany,
L. Dayan, H. Boustany,
Takieddine el-Solh, Lyne
Lohéac, Blanche and
Balkis Yassine, gathered
for the 50th anniversary
of Daoud Ammoun's
passing (1972)*

73

Lyne Lohéac-Ammoun
Paris, 23 March, 2019

The following is a contribution by Blanche's daughter Lyne.

"*My grandfather, Daoud Bey Ammoun, and his wife Victorine, née Chiha, rented Villa Kantari for more than half a century, from 1919 to 1973. They had two children. While trying to reconstruct with Nayla el-Solh the life that my grandparents and their children lived in this villa, I could appreciate how they had experienced historical moments, but also great social events.*

The family first settled in Egypt where Daoud Ammoun practised law. In 1913, they moved to Beirut when he was elected deputy of Deir el-Kamar to the Administrative Council of Mount Lebanon.

He sent his family back to Egypt in the summer of 1914, after the outbreak of the Great War, foreseeing the imminent entry of Turkey into this conflict. He was later told to take the last boat leaving for Alexandria, his house already surrounded by Ottoman soldiers. Luckily their friends were able to rescue some furniture and family pictures. Among the portraits preserved was that of Ammoun Bey Ammoun, who was made president of the Administrative Council of Mount Lebanon on two occasions – under Daoud Pasha and Rustem Pasha. In October 1918, after a four-year stay in Alexandria and even before the armistice of Moudros was signed between the Allies and the Ottoman Empire, Daoud Ammoun returned to Beirut. He then elaborated a project on the next political system in Lebanon. At the beginning of December, after a lot of hard work, he proposed his programme in his capacity as deputy of Deir el-Kamar, which adopted it unanimously.

Daoud Ammoun left Beirut at the end of December 1918 to travel to Paris as President of the Mount Lebanon Delegation to the Peace Conference. He remained there for two months, from January to March 1919, and pleaded for the creation of an 'independent Great-Lebanon, separated from Syria, with the temporary help of France'. Victorine, who was still living in Alexandria, wanted to return to Beirut, but Daoud, busy politically, could not find any suitable houses to rent. He finally found a house in April 1919, not without difficulty, because most of the suitable homes were requisitioned by the French and English armies, including their previous home. The house, whose entrance was on Kantari Street (renamed Michel Chiha around 1960), was at the corner of May Ziadeh Street. Kantari Street is an important axis, leading from the city centre to Hamra, the commercial street nicknamed 'the Champs Élysées of Beirut' because of its many shops, restaurants, cinemas and banks.

The entrance to the villa was through a majestic green wrought-iron door. A central alley, lined with a garden on the left and right, led to a double-flight staircase under which stood a grotto embellished with a fountain. As in most traditional Lebanese houses, one entered a vestibule with triple arcades, then a large hall around which the different rooms were ranged.

The hall opened to the left on to the dining room, and to the right on to a Western-style living room. There was a Moorish-style living room at the bottom, decorated with Arabic furniture, oriental

mosaics and a collection of old weapons. Daoud Ammoun used the grand salon to entertain his friends and discuss political issues as well as the various regional tensions of the moment. The house was a place of comings and goings, where the men of the French mandate crossed paths with established Lebanese politicians.

Among the dignitaries received was François Georges-Picot, renowned, notably, as co-signatory of the famous secret agreements of May 1916, the 'Sykes-Picot Accords'. Appointed High Commissioner of Syria in 1918 by Clemenceau, he was replaced in this post by General Gouraud in November 1919. A friendship had been established between François Georges-Picot and Daoud Ammoun since their meeting in 1915 in Egypt. Daoud Ammoun wanted to pay him a last tribute before his departure to France. He gave a grand reception, inviting all the politicians of Beirut.

After the proclamation of Greater Lebanon on 1 September 1920, General Gouraud announced the creation of an assembly, the Administrative Commission. Daoud Ammoun presided over this first assembly from 6 October 1920 to 8 March 1922, the date of its dissolution.

There were official but also personal visits when Daoud Ammoun fell ill during the summer of 1922, and for people to give their condolences when he died in November 1922. The atmosphere of the house at the time evoked the dying Ottoman Empire and the nascent French mandate. Later, the mood changed. The mansion hosted many children's parties, which Blanche evoked in one of her illustrated books, Lebanon of Yesteryear and Yesterday. *She recalled the fanfares, the disguises, and later, the party surprises in tuxedo and evening dress.*

Blanche, a painter, had an area that served as a studio. It allowed her to make large canvases painted in oil. Her 1937 book Histoire du Liban, *which she illustrated with seventy cartoons, also gave her a certain notoriety. Charles, a lawyer, received his clients at home.*

Victorine, for her part, entertained her guests at home, as was the custom at the time. I always remember her leaning against the double staircase rail awaiting their arrival. From there she gazed at the garden on either side of the alley, and the crenellated wall that marked the boundary of the property, where purple and carmine bougainvillea gave a splash of colour. The property included a small grocery store, named Balaa after its owner, which was useful because there were no shops in the neighbourhood. The store served as a reference for taxis, and the bus stop on the street was called Balaa.

During World War II, Blanche mixed with French officers and in 1944 met General André Lohéac, whom she married in Beirut a few weeks later. They moved to Paris in 1946. Charles had left the family home by that time and was already established in Paris. He was also the Permanent Delegate to the International Atomic Energy Agency in Vienna and a member of the Lebanese delegation to the UN, during several sessions. However, he never missed an opportunity to visit his mother when she travelled to Vienna or New York. He also wrote to her to make up for his absence. He mentioned, for example, the dinner given in his honour by the Lebanese expats of New York. He indicated in his

letter that the memory of Daoud Ammoun was still alive. In another, Charles referred to a meeting with the Egyptian delegate of the UN, who asked him if the D in his name was Daoud. When this was confirmed he spoke to him about Daoud's poems.

For her part, Blanche returned to Beirut every summer with her family. Friendships passed from one generation to another; the older ones who visited my mother came with their young children. We played in the big hall, but our grandmother was worried about us running around the Venetian chest, on which sat a beautiful, precious white and blue Chinese porcelain vase.

Subsequently, as young girls, my sister and I went out almost every night. Our grandmother, not always very reassured, granted us the 'midnight curfew' but this restriction was not always respected. She slept badly while we were out and her heart beat faster after midnight. When we got back, she would get out of bed and make us understand that our lateness caused her palpitations.

Victorine read and took her nap on the porch. She enjoyed a relaxing view on to the flowery lawn and the ornate pool surrounded by palm trees. Although she had no children or grandchildren at home for the rest of the year, she remained surrounded by people. The full-length portrait of Daoud Ammoun hung in the centre of the living room, and the family continued to keep in touch with her. After her death in 1964, the house remained closed for part of the year. But my mother Blanche and her three children returned to spend all summer there during the school holidays. Before our return to Paris, she would host a great reception to thank our friends for their many invitations.

Blanche managed to reunite all of Beirut society with her various receptions. Guests included prominent politicians, such as former Presidents Alfred Naccache and Camille Chamoun; Pierre Gemayel, 'Sheikh Pierre' (founder of the 'Kataeb' movement) and his wife Genevieve, whose two sons, Bashir and Amine, would become heads of state; and the MP and minister Raymond Eddé, the 'Amid', son of the President of the Republic, Emile Edde.

The receptions were always lively, as my mother invited her friends and their children. This was the case with the famous Prime Minister Sami el-Solh, who came with his daughter May Yassine and his grandchildren. Also present, with their children, were the ministers Joseph Naggear and Fouad Ammoun; the lawyer Michel Assaf; the magistrate Chucri Cardahi; the cardiologist Edouard Stephan; the family psychiatrist Robert Checri; the rector of the Lebanese University Fouad Ephrem Boustany; the journalist and historian Youssef I. Yazbec, and others. It was above all a family reunion.

Also among the guests were the ministers Dr Albert Moukhaïber, Edouard Noun, Khatchik Babikian, Takieddine el-Solh, Henri Pharaon; the ambassadors Camille Aboussouan and Joseph Harfouche; Assaad Khoury; the journalists Victor Hakim and Ghassan Tueni; and the famous pianist Henri Gorayeb. This list is not exhaustive, because it is limited to the different guests on our old photos, but it shows that arts and letters, diplomacy and politics rubbed shoulders easily.

I particularly remember three receptions that marked family events, and the many photos make them especially vivid. In 1965 an evening celebrated the publication of Blanche's second book, Zenobia, Queen of Palmyra, *which was later awarded a prize from the French Academy. To celebrate this success, my mother cut and painted several cardboard facemasks representing Zenobia, and had each guest pose with one. The second reception, in 1968, celebrated the publication of the book* Cedar my Heritage *by Charles Ammoun, who died in 1963. It was a tribute paid to him by UNESCO posthumously. Finally, in 1972, we commemorated the fiftieth anniversary of the death of Daoud Ammoun in Beirut, when the then President of the Republic Camille Chamoun discussed his political role, after which the journalist Youssef I. Yazbec testified to his admiration for the poems that Daoud Ammoun composed in Arabic, while he was a young lawyer in Egypt.*

A curious fact: each of these receptions honours, in turn, Blanche, Charles and Daoud, who all lived in this house. But these gatherings also honour Victorine, the pillar of the Kantari villa that she lived in from 1919 to 1964, followed by a short stay in Paris with her daughter Blanche. One summer we were surprised to learn that my grandmother did not own the house, which did not prevent us from feeling at home and enjoying being here, apart from the last two years before we left.

Takieddine el-Solh lived on the first floor of this house, but we did not cross paths because he came into his home through an entrance on May Ziadeh Street. He was a Member of Parliament, a minister, then appointed Prime Minister in 1973 by the President of the Republic Soleiman Frangié. A uniformed armed guard was posted in the garden to ensure the safety of the house. A third door, which gave access to the villa via Spears Street, was now used to admit cars, and the tennis court then served as a parking lot for Takieddine el-Solh's guests.

At the beginning of the summer of 1973, Mrs Takieddine el-Solh, who owned the villa, suggested to my mother that she give up the house, which she had continued to rent after the death of Victorine. Blanche, who returned to Lebanon regularly, then hastened to find an apartment. She wanted to stay in the Kantari neighbourhood, and found somewhere close to Clemenceau Street, overlooking the sea. She ensured that every child had a room, so that they could keep in touch with Lebanon and friends forever.

The villa is unfortunately in ruins now. I hope for a solution to safeguard our heritage. In the meantime, many friends have told me that as they walk past the house they feel emotional upon remembering my adorable grandmother Victorine, whom they knew as children. "

THE BELLE EPOQUE

The Abdel Razzak family
and Fadwa al Barazi
(1930-57)

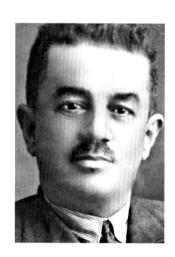

Abboud Abdel Razzak

Abboud Abdel Razzak el Merhabi was the charismatic modern founder of the family power. He converted the position inherited through the house of his grandfather Mohammad Pasha's Ottoman tax farming (iltizam – a taxation system carried out by farming of public revenue) into the status of a modern landowner and regional political leader. Abboud's father died when Abboud was a young child and his grandfather, a local leader, took on the responsibility of his grandson, sending him to Turkey to study law, when education was for the select few. Abboud was also enabled by the mandate to build up his estate on both sides of the Lebanese-Syrian border, where he could increase the breadth of his economic and political opportunities.

He had a reputation for ruthless and arbitrary rule, as well as being meticulous in his accounting of stocks. Nothing, therefore, could be siphoned off by the labourers or the aghas, an occurrence which tended to afflict other landowners. He had represented his region of North Lebanon five times as deputy, including the first Lebanese Parliament in 1927.

Mohammad al Abboud (it was customary for children to use their father's first name as their surname), the only child of one of the wealthiest men in Lebanon,

spent most of his time in Beirut, for he was very much a man of the city. Beirut was only two and a half hours south by car from Akkar, since the improvements in infrastructure had been made. Residing for the most part in the Lebanese capital, he had the tastes and way of life of any notable of the haute bourgeoisie. The luxury of his country mansion was part of the urban lifestyle of a well-known politician, businessman and large landlord whose centre of operations was Beirut.

His father had bought him the mansion from the Naamani family around 1931 to settle in with his new wife. Mohammad married a second time when his first wife could not bear him any children. He married Salma and about four years later Elham was born in the mansion around 1942/3. Upon hearing that Mohammad wanted to marry for a third time, presumably partly to father a son, Elham's mother Salma demanded a divorce and moved out of the mansion, taking her daughter with her. (Muslims are traditionally allowed to marry four wives at one time as long as they can all be supported equally. Salma could have stayed in another part of the house.)

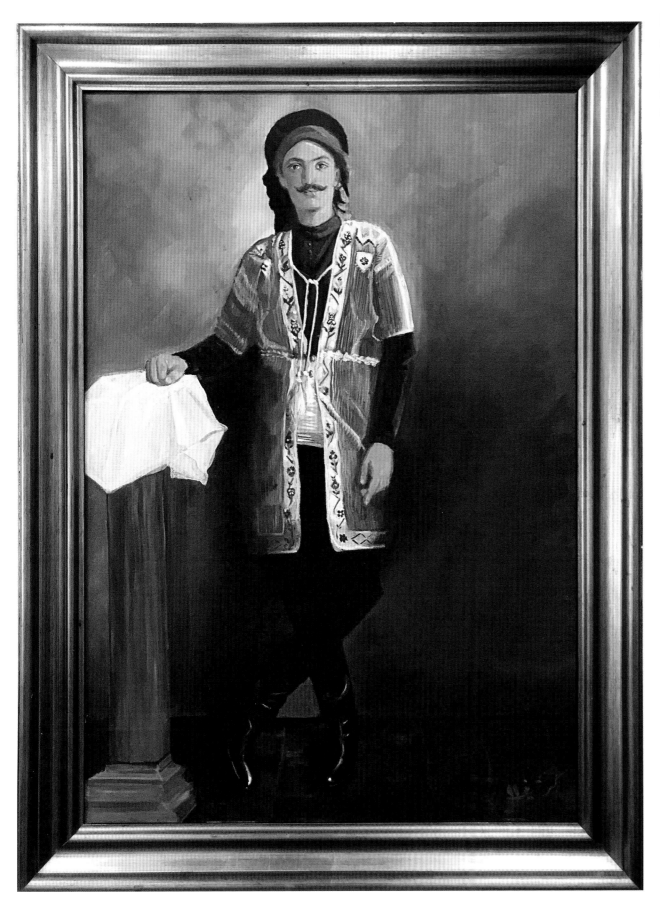

Previous page: *Fadwa as a young woman*

Left: *Painting of Abboud Abdel Razzak as a young man*

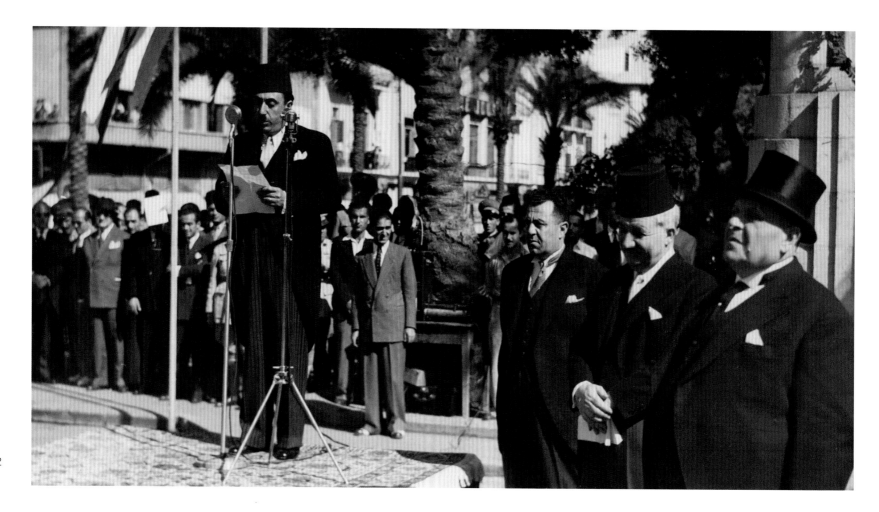

Mohammad married Fadwa al Barazi in 1947, his third wife. She was of a prominent political land-owning family from Hama in Syria, with Kurdish origins. Fadwa's cousin Husni al Barazi was Prime Minister in 1942 and another cousin, Muhsin al Barazi, served for a short time as Prime Minister in 1949, while Adib al Shishakli, a military leader and President of Syria 1953-54, was her maternal first cousin. Mohammad was looking for a new wife and heard about two beautiful young sisters in Hama. The marriage would also serve as a strategic alliance and strengthen his and his father's social standing and power. He visited their home and sat with the father and other male relatives. He was then led to a back room where he could take a peek at the unveiled sisters through shutters and make his choice. He chose the fairer-haired and blue-eyed Fadwa. When asked by her family if she would accept this proposition, she grabbed the opportunity with both hands to escape her stifling, traditional, patriarchal family. If she remained, her destiny would probably be to marry her cousin, with a very limited social life outside the family.

Fadwa had been scarred by an incident when she was seven years old, as she and her sister strutted to school, full of childish confidence, the apple of their parents' eyes, accompanied by the houseman. This innocence came crashing down when Fadwa felt a heavy blow on the back of her head and when she looked up, saw her uncle, a large, imposing and strapping figure of a man. He ordered the houseman to return the girls home and they were no longer allowed to attend school. From this moment onwards, Fadwa knew that she wanted to escape her family and this particular restrictive society, where it was not deemed proper for young girls to attend school and mix with the opposite sex. They received home tuition from then on, but Fadwa was not one to sit and concentrate with this style of teaching.

Left: *Annual Martyrs'
Day (1948) with Speaker
of the House Sabri
Hamade, Mohammad
al Abboud (minister of
finance) standing next to
the Prime Minister Riad
el-Solh and the President
Bechara el Khoury*

Right: *Fadwa and
Mohammad's wedding
(1947)*

83

Left: *Mohammad and Fadwa at a function with friends*

Right: *Mohammad and Fadwa occupy centre stage at the hippodrome in April 1948, at a race to raise funds for Palestine through the national lottery*

Mohammad was a bon viveur who enjoyed the finer things in life. They travelled the world, including London, Paris and Rome. Fadwa also accompanied her husband on official trips when he was a Member of Parliament, including a road trip from Beirut to Baghdad. They frequented the cinema at the Cinema Opera housed in the Art Deco building commissioned by his father and built in 1932, designed by the architect Bahjat Abdelnour. The basement also housed the Cinema Rio, another popular movie theatre. People would wait outside to catch a glimpse of the glitterati attending events, among them Fadwa, who was known for her beauty.

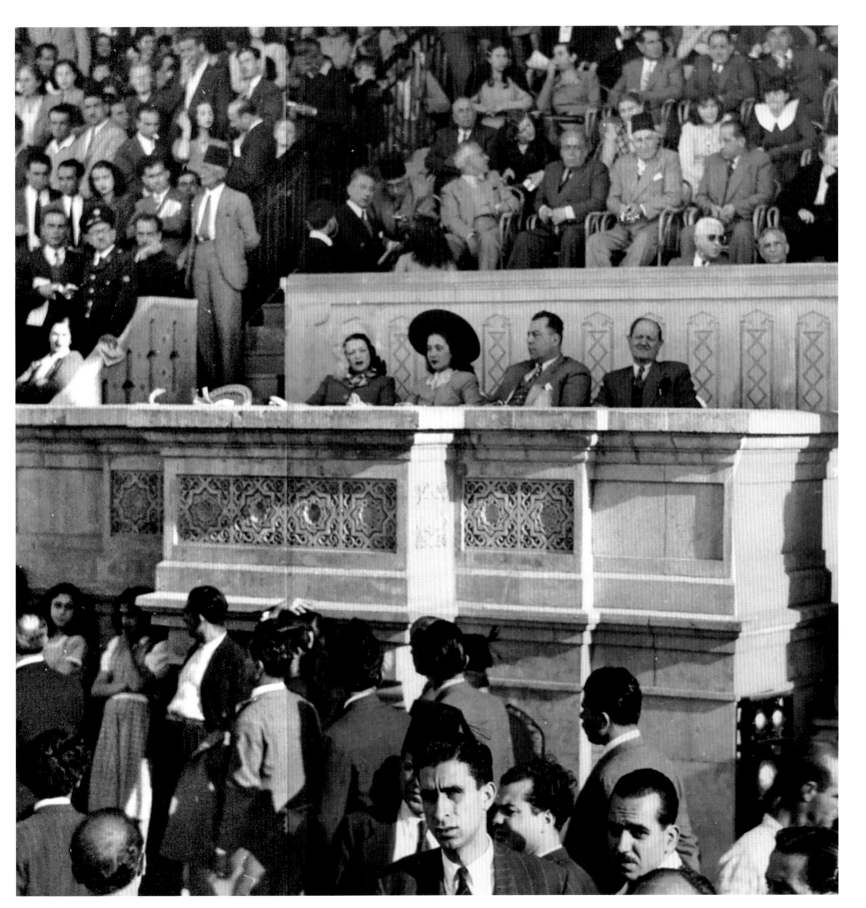
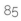

Right: *Count de Chayla, the French Ambassador, Charles Ammoun, the UN Ambassador and Mr Gabriel Murr (1951)*

Below: *Dinner in the presence of Mr Lowell Pinkerton, the US Ambassador, Count Chayla, the French Ambassador, Farhan Chbailat, the Jordanian Ambassador, and also the journalist, Mohammad al Samak*

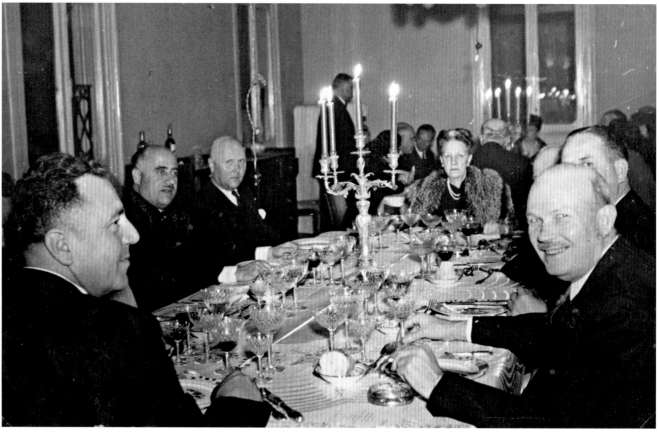

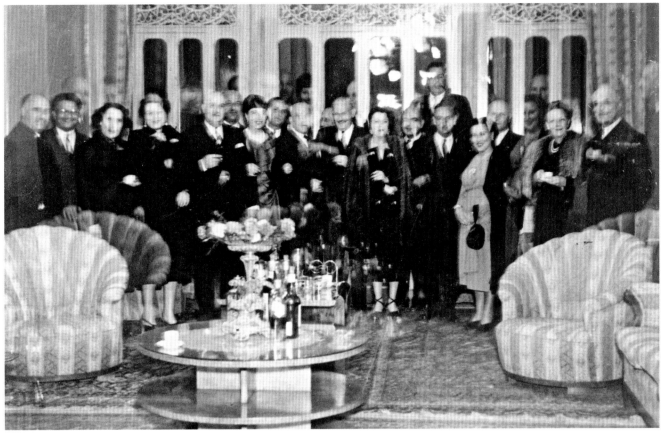

Left: *Mohammad and Fadwa entertaining guests at their home*

Below; *Dinner in the presence of Mr Lowell Pinkerton US Ambassador, Count Chayla the French Ambassador, Farhan Chbailat the Jordanian Ambassador, and slso the journalist. Mohammad al Samak,*

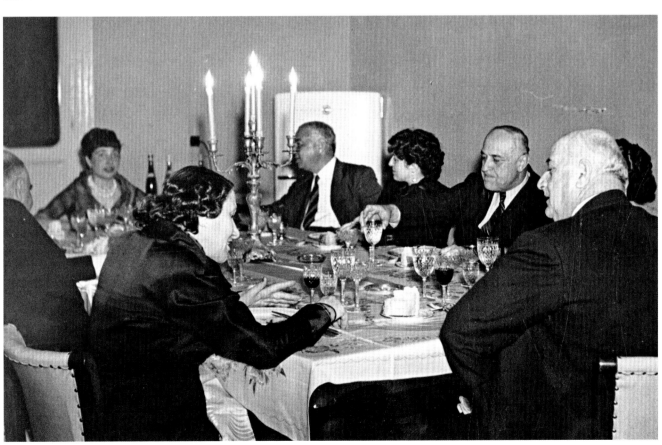

Above: *Mohammad
with President Bechara
el Khoury and Prime
Minister Riad el-Solh*

Right: *Mohammad with
Riad el-Solh*

Status and power had come to the minister thanks to the efforts of a shrewd father: aggressive in land procurement, consistent in alliance with the French during the League of Nations mandate period between the two world wars, and canny in urban investment, a father who made himself a key figure in northern Lebanese politics. Mohammad was groomed to succeed his father, not least by studying law in Paris, entering into politics and continuing his father's rigorous pro-French policy.

Mohammad and his father had contrasting styles of leadership and yet complemented and combined with one another to form one of the great stories of success in the accumulation of property and influence. The one problem was that Mohammad was an only son and also had no son. The future thus depended entirely on him. The patrilineal line of succession was threatened just when its influence was at its height. If anything were to happen to him, years of acquisition and alliance would be for nothing.

Mohammad al Abboud was expected to regain his parliamentary seat in the elections of 1953. His opponent, who had won the previous election, and the new President were against him, and became increasingly desperate when they saw defeat looming. They suggested a meeting to resolve the issue, and to try to persuade Mohammad to withdraw as a candidate. His enemies seem to have lured

him into a trap to eliminate him from the race, with fatal consequences. If he descended the steps of the Presidential Palace with the other candidate after the meeting, this would indicate that he had agreed to withdraw. If he refused to withdraw, he would have to come down by himself and the plan would kick in. A follower of his rival was lying in wait at the foot of the steps of the Presidential Palace, and as soon as the minister came down alone, this man took aim and shot him.

His wife Fadwa was preparing to make her way to Beirut from their home in Akkar, northern Lebanon, when she received a phone call from a close friend asking her to return as a matter of great urgency. It was only when she arrived back in the capital that she discovered what had happened when she heard the newspaper vendors shouting out the latest headlines: 'candidate shot near presidential palace'. She frantically rushed to the hospital where her husband had been taken.

Mohammad's daughter Elham from his second marriage, who was ten years old at the time, joined Fadwa and Mohammad's father, Abboud Abdel Razzak, with a variety of government officials, bodyguards, drivers, supporters and relatives, who crowded into the hospital, praying and planning the next move.

Mohammad succumbed to his wounds and died two days later.

The murdered man's father had decreed that his son was not to be buried until vengeance was taken. In cases of honour, blood revenge had to be shed before the body could be interred. The body of Mohammad was embalmed and put in a coffin, which was placed in a room in his mansion in Akkar (traditionally Muslims are buried within twenty-four hours of death). According to his new young bride Youmna, Abboud wept for his son every day and never failed to visit the casket left on display in his son's house, which was directly opposite his.

Abboud had put many of his assets in his only son's name and was intent on having more children in order to keep the bulk of his assets rather than sharing the inheritance with cousins and other family members. He also wanted to get Fadwa evicted from the house and back to her family in Hama. He had encouraged the marriage of his only son to a daughter of a leading Hama landowning family, the al Barazis, an indication of his social strategy. She had not borne him any children and now her husband was dead. Abboud, however, had not anticipated Fadwa's resistance and determination not to return to her family. She had become accustomed to a certain lifestyle and standard of living and had no intention of giving up this freedom. An acrimonious battle ensued, setting in motion several litigation suits, which remain unresolved today.

Abboud had married again, despite his advanced age, a teenage bride called Youmna from an agha's family that possessed land on the plain (agha was the middle social stratum at the feudal epoch, beys or landlords being the top and fellaheen being the lowest). She bore him a son named Mohammad after his murdered half-brother. As a youngster, for his safety he was sent abroad to Switzerland to be educated. He was in peril because sons grow up with the heavy duty of avenging fathers and he may have been in danger of being eliminated. Abboud also fathered two daughters, Arab and Zeina.

Five years after Mohammad al Abboud's murder, Abboud himself died from gunshot wounds received during the Civil War in 1958, attacked as his driver and bodyguard drove him through Beirut. People took advantage of the chaos perhaps to settle old scores. He was buried in his mansion facing his son's derelict mansion in the north.

Mohammad's widow, Fadwa, had remarried in 1957; therefore the only person who could make the decision to bury him was his daughter Elham. He remained in his casket in a dust-ridden room of his derelict mansion in Akkar, unavenged for twenty-five years, before his daughter finally gave permission for his burial, at the prompting of the village inhabitants who urged a solution to the pungent odour emanating from the house and permeating the village. His daughter did not attend the burial. It is extraordinary that he remained in this interlude between two worlds for so long.

Below: *Abboud Abdel
Razzak, seated, joined by
Henry Pharaon waiting at the
American University Hospital
for news of Mohammad as
doctors try in vain to save his
life (© Daily Star newspaper
(Friday 24 July 1953)*

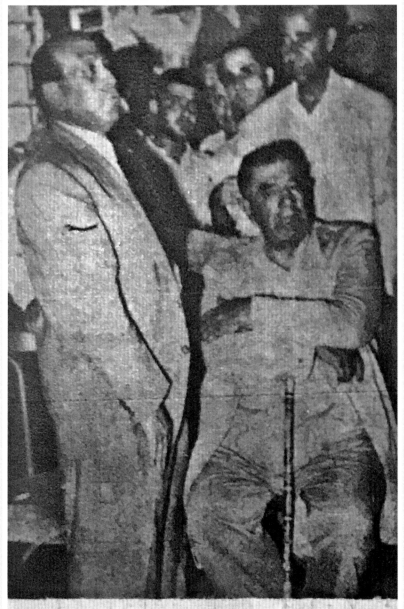

Mr. Abboud Abdul Razzak, father of Mohammed Abboud who di
yesterday morning, shot down by an assassin's bullets while he w
leaving the presidential palace Thursday morning. With the distract
father (seated) is Mr. Henry Phara on and other friends of the deceas
waiting at the American University hospital for news of the victim
doctors battled vainly to save him.

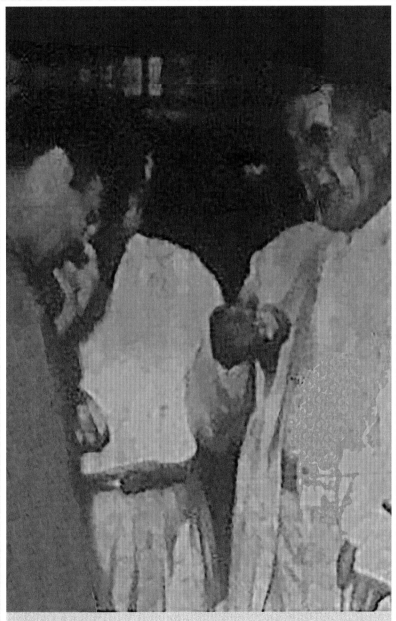

Abboud's Father Refuses Burial till Justice is Done

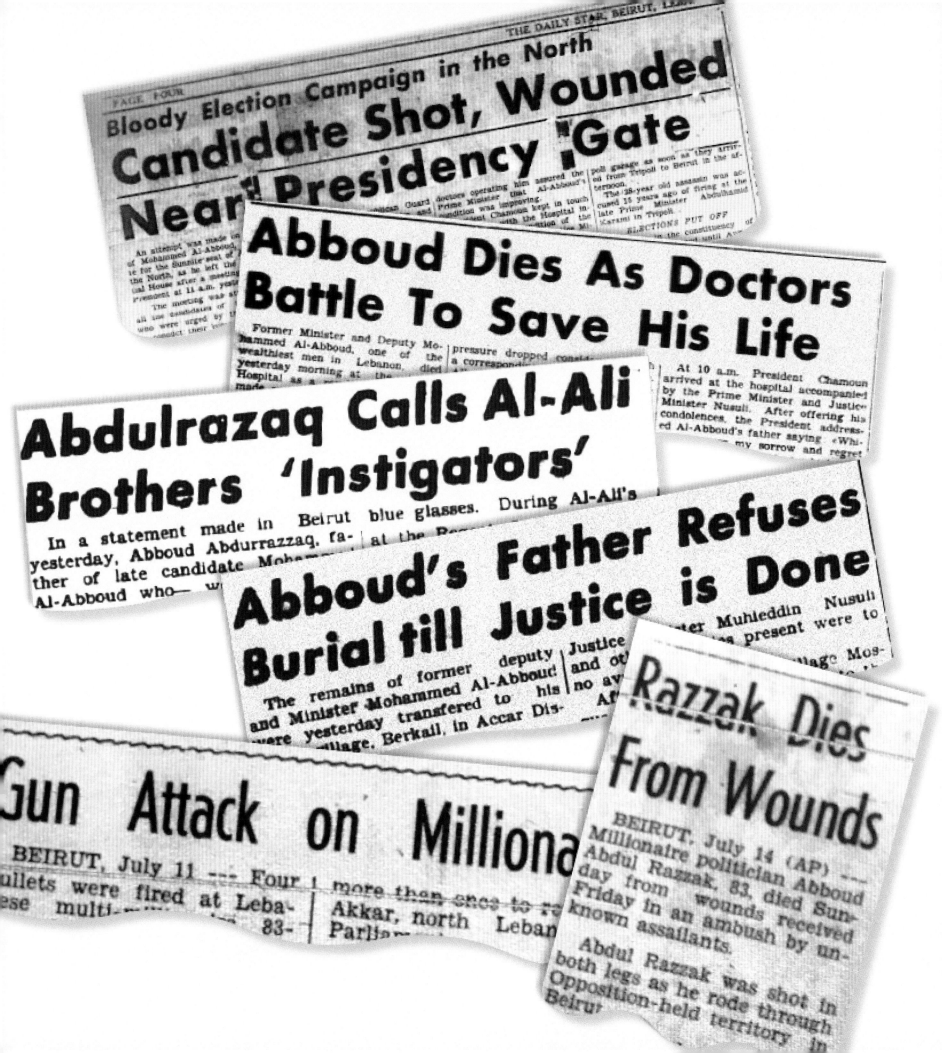

THE DAILY STAR, BEIRUT, LEBA...

Bloody Election Campaign in the North

Candidate Shot, Wounded Near Presidency Gate

An attempt was made on ... of Mohammed Al-Abboud, ... e for the Sunnite seat of ... the North, as he left the ... al House after a meeting ... resident at 11 a.m., yest...

The meeting was at... all the candidates of the... who were urged by the...

... doctors operating him assured the ... and Prime Minister that Al-Abboud's ... condition was improving. ... esident Chamoun kept in touch ... with the Hospital in... ... tion of the ... Mi...

poll garage as soon as they arriv... ed from Tripoli to Beirut in the af... ternoon.

The 28-year old assassin was ac... cused 15 years ago of firing at the ... late Prime Minister Abdulhamid ... Karami in Tripoli.

ELECTIONS PUT OFF

... the constituency of

Abboud Dies As Doctors Battle To Save His Life

Former Minister and Deputy Mo-hammed Al-Abboud, one of the wealthiest men in Lebanon, yesterday morning at the ... Hospital as a result ... made ...

pressure dropped const... a correspond...

At 10 a.m. President Chamoun arrived at the hospital accompanied by the Prime Minister and Justice Minister Nusuli. After offering his condolences, the President address-ed Al-Abboud's father saying «Whi... ... my sorrow and regret

Abdulrazaq Calls Al-Ali Brothers 'Instigators'

In a statement made in Beirut yesterday, Abboud Abdurrazzaq, fa-ther of late candidate Moh... Al-Abboud who— w...

blue glasses. During Al-Ali's at the Re...

Abboud's Father Refuses Burial till Justice is Done

The remains of former deputy and Minister Mohammed Al-Abboud were yesterday transfered to his ...illage, Berkail, in Accar Dis-

Justice ... and ot... no av... Af...

...ter Muhieddin Nusuli ...s present were to

...llage Mos-

Gun Attack on Milliona...

BEIRUT, July 11 --- Four ...ullets were fired at Leba-...ese multi-... 83-

more than once to re... Akkar, north Leban... Parli...

Razzak Dies From Wounds

BEIRUT, July 14 (AP) --- Millionaire politician Abboud Abdul Razzak, 83, died Sun-day from wounds received Friday in an ambush by un-known assailants.

Abdul Razzak was shot in both legs as he rode through Opposition-held territory in Beirut

Son, then father, are shot and die from injuries five years apart, to the month.

Mohammed al Abboud

An attempt was made on the life of Mohammad al Abboud, candidate for the Sunnite seat of Accar in the north, as he left the Presidential House after a meeting with the President at 11am yesterday.

Elections in the constituency of Accar were adjourned until 9 August. The Army will have direct control over the elections in the north, and the general Officer Commanding has been given wide powers for this purpose."

" In a statement made in Beirut yesterday, Abboud Abdel Razzak, father of late candidate Mohammed al Abboud who was assassinated on 23 July, accused Suleiman Al-Ali, Mohammed's competitor in the Accar constituency, and his brother Malek Al-Ali, of being the instigators behind the assassin."

Abboud Abdel Razzak

" Four bullets were fired at Lebanese multi-millionaire 83-year-old Abboud Abdel Razzak, while he was stepping into his car in front of his house in Hamra Street, Karakol Druze, today. One of the bullets hit him in both feet.

Abboud once played a very important role in Lebanese politics, and was elected more than once to represent Akkar, north Lebanon, in Parliament. He gave up running for elections in 1934 when his son Mohammad took his place.

It was reported that Abboud had received a letter from a friend three days ago advising him to leave Beirut because there was a plot to assassinate him. The reasons were not revealed."

" Millionaire politician Abboud Abdul Razzak, 83, died Sunday from wounds received Friday in an ambush by unknown assailants. "

POLITICIANS AND SOCIALITES

Takieddine and Fadwa el-Solh

(1957-88)

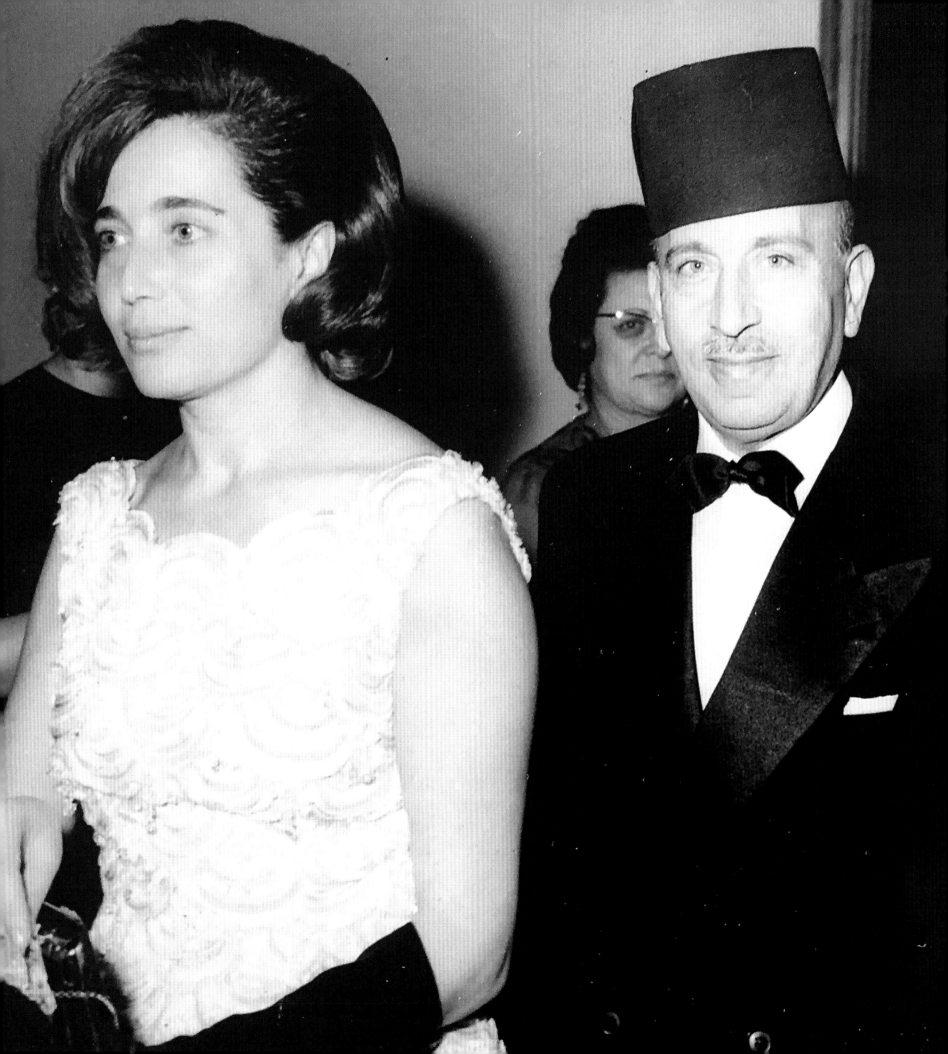

Takieddine el-Solh had joined the Lebanese Foreign Service in Egypt where he was serving as the Lebanese Embassy Councillor. Upon his return to Lebanon, he sought to enter politics, as many of his relatives had done before him.

He had noticed a very attractive woman on a couple of occasions in the mountain retreat of Alley, where they had a summer house. After conferring with his nephew Khaldoun, he decided to arrange an introduction to Fadwa al Barazi and thus a meeting was set up, unbeknown to her. This was to take place at the Riviera Hotel. She received a call from her lawyer one evening, asking her to meet him in the lounge of the hotel. She agreed, though she thought it an unusual request at such a late hour; nonetheless she got dressed and made her way there, in the car that the lawyer sent to collect her. There she was introduced to a distinguished gentleman wearing a fez, who, upon seeing her, found it impossible to take his eyes off her. This made her slightly uncomfortable – she interpreted his stares, at the outset anyway, as perhaps a hint at a wardrobe malfunction, but soon realised she had made a big impression on him and that this was all a contrived set-up. She was not keen on a fez-wearing man, which usually signified to her quite an old-fashioned outlook. In spite of this, she consented to be taken home by him with the driver, who took the scenic route in order to buy Takkiedine more time.

After four years as a widow, with numerous court cases pending, brought against her by her father-in law, Fadwa was under enormous pressure to leave the mansion and return to her family in Syria. All her assets or inheritance had also been frozen as part of the litigation. She found herself overrun with suitors, but was holding out for someone special, from an influential family, powerful enough to shield her from these problems. She was determined to hold on to her home despite all the difficulties. She had already pawned the diamond necklace gifted to her by her late husband as a wedding present, to cover her daily expenditures and living costs.

Takkiedine, having been working abroad, did not have his own home yet, and was temporarily staying at his sister and brother-in-law's home. When he and Fadwa decided to get married in 1957, he suggested they stay at his sister's, but Fadwa was not ready to give up her home. Takieddine was not comfortable with the idea of moving into another man's home, so Fadwa came up with a ploy. They would rent a house in the mountains for the spring and summer season, as was customary to escape the heat and humidity of Beirut. This would buy her around six months to use her considerable persuasive powers to entice him into relocating to the mansion for the other half of the year. Her ploy obviously worked.

He dropped her off at her front door and as she closed it behind her, she could feel his stare almost searing through the metal door.

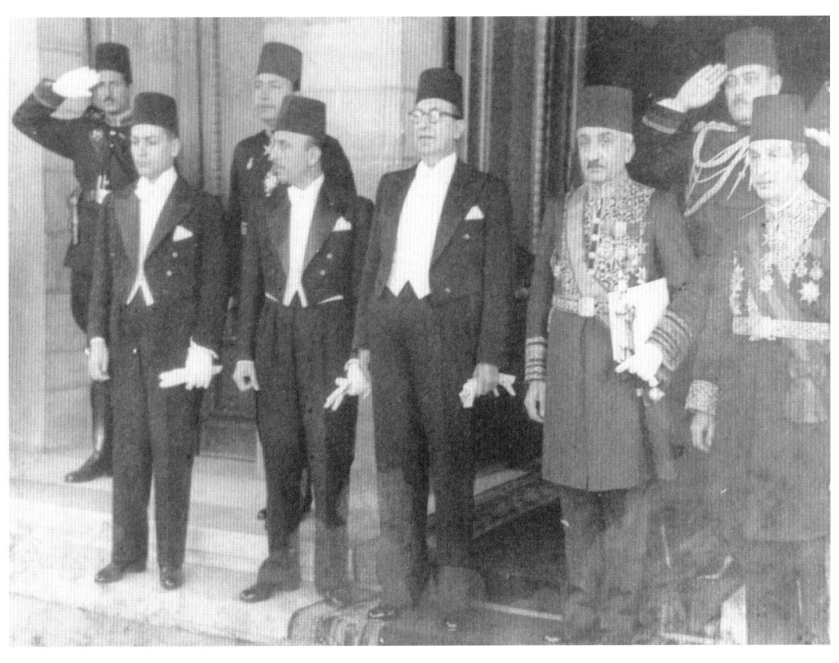

Takieddine, second from left,
as the Head Consulate at the
Lebanese Embassy in Egypt

The same year that they married, Takieddine was elected as a member of the Lebanese Parliament and thus their journey together began in life and politics.

Takieddine's family traced their origins to Arab tribes from Yemen, namely an influential tribe called el-Solh (al-Sulh, and various other spellings). The Arabs ruled a large swathe of the area, enabling some of the el-Solhs to travel around the region and much further, eventually settling in Andalusia, which was under Muslim rule. Here, all Arabs were eventually expelled at the end of the fifteenth century, following the reconquest of the Iberian Peninsula by the Catholic Monarchs, Isabella I of Castile and Ferdinand II of Aragon. Some of the el-Solhs settled in Lebanon, on a hill in Sidon overlooking the Mediterranean, instead of returning to Yemen. For generations after this, el-Solh houses were built and rebuilt on the same plot. A book dealing with the history of the 'land fortress' of Sidon mentioned that the el-Solhs had possessed the keys to the fortress since 1660, stating that a branch of the family was still living there from the eighteenth until the early twentieth century.

In Arabic 'solh' means peacemaking or reconciliation. It seems probable that the el-Solhs earned this name because of their role as peacemakers between conflicting parties in a society where law courts were often inadequate, and this role was highly valued.

Ahmad Pasha el-Solh, Takieddine's grandfather, laid the foundations for generations to follow, with his moral compass, integrity and honesty. During the nineteenth century he rose to the status of grandee (nobleman) of the Ottoman Empire, which ruled the region for over 400 years. He spearheaded the family's political fortunes: they were feudal, landowning, Arab nationalists, encompassing administrators, lawyers, judges and officers in the Ottoman Empire army. Ahmad Pasha shared intellectual ties and ideas about the early Arab movement with Prince Abdel Kader, who became an influential friend. As the Empire crumbled, the family supported King Faisal I in the push for independence from the European colonisers.

Takieddine el-Solh in his signature tarboush (fez) at an official parade

Ahmad Pasha el-Solh

Ahmad was born in 1810 in Sidon. His parents sent him to Istanbul as a young man, where he learned Turkish and, upon his return a few years later, was hired as a translator for the Ottoman army. Hence began his steady rise in the military and civilian bureaucracy of the Empire. As Ahmad's ambitions grew, he moved to Beirut with his younger brother, Abdel Rahim.

By the time Ahmad Pasha died in Beirut in 1902, he was a patriarch covered in honours, known and respected across the Middle East. He was both rich and influential, owning three villages in South Lebanon – Tul, Tamra and al-Sharqiyya. He had also acquired a stretch of the Beirut coastline, from the Mövenpick Hotel to the new lighthouse. Jutting out from the sea here are some distinctive rocks called Rawsheh, known at the time as Sakhrat al Pasha, the rock of the Pasha, i.e. Ahmad Pasha.

His sons, grandchildren and extended family forged a political dynasty and also played leading roles in their chosen fields such as law, diplomacy, academia and journalism. The young members of the family were clever, dynamic, politically astute and organisationally gifted. The family formed a close-knit 'private party' of advisers, unconditional in their loyalty, and included speechwriters with wide contacts.

The family's influence straddled the epoch of the Ottoman Empire and Arab independence, with the old guard, spearheaded by Ahmad Pasha and his brother Abdel Rahim, followed by Kamel, Monah and Rida during the transitional stage of European colonialism. Then the younger generation took up the mantle, including Sami, Afif, Riad, Kazem, Takieddine and Rachid, active during the turbulent years of transition of power and then independence. Riad's and Sami's roles are well documented. Adel, his son Monah, Abdel Rahman (Sami's son), Wahid (assassinated in 1958), to name but a few, all played vital roles in the family.

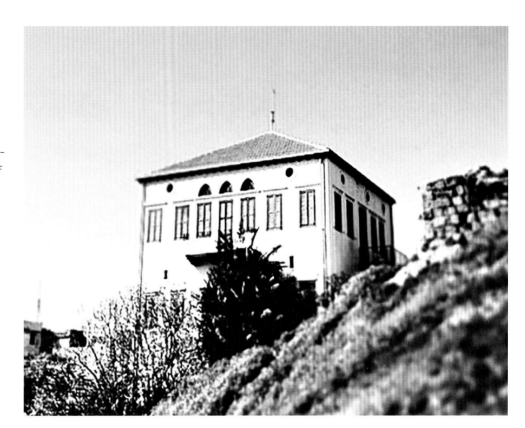

101

Above: *A group of leaders in traditional dress, who accompanied Prince Abdel Kader on his tour. In the centre is Monah el-Solh, standing on the right is Prince Saïd Arsslan*

Below: *Founding members of the Makassed Islamic Association in Sidon – a philanthropic association which includes running schools, hospitals, and scouts. In the centre is Monah (Ahmad's son), to his right Nassif Pasha al Assaad, standing in the centre is Rida el-Solh, on the extreme right is Munib el-Solh, and on the extreme left Hussein al Jawhari*

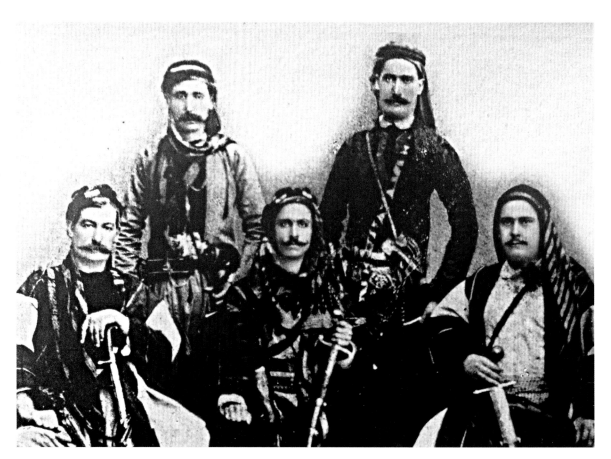

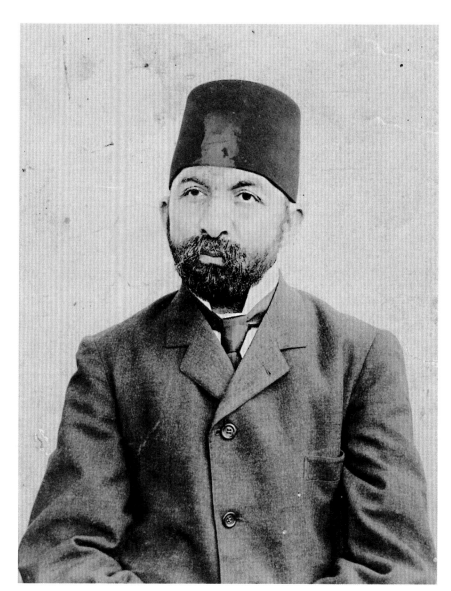

Above: *Rida el-Solh, one
of Ahmad Pasha's sons*

Left: *Monah el-Solh, another
of Ahmad Pasha's sons*

Right: *Kamel, Ahmad Pasha's eldest son, who was a judge in the Ottoman Empire, here with his son Afif and daughter Afifeh*

Opposite: *Monah's daughter Baseemeh, with Rida's daughters Balkis (later to marry Sami) and Alia*

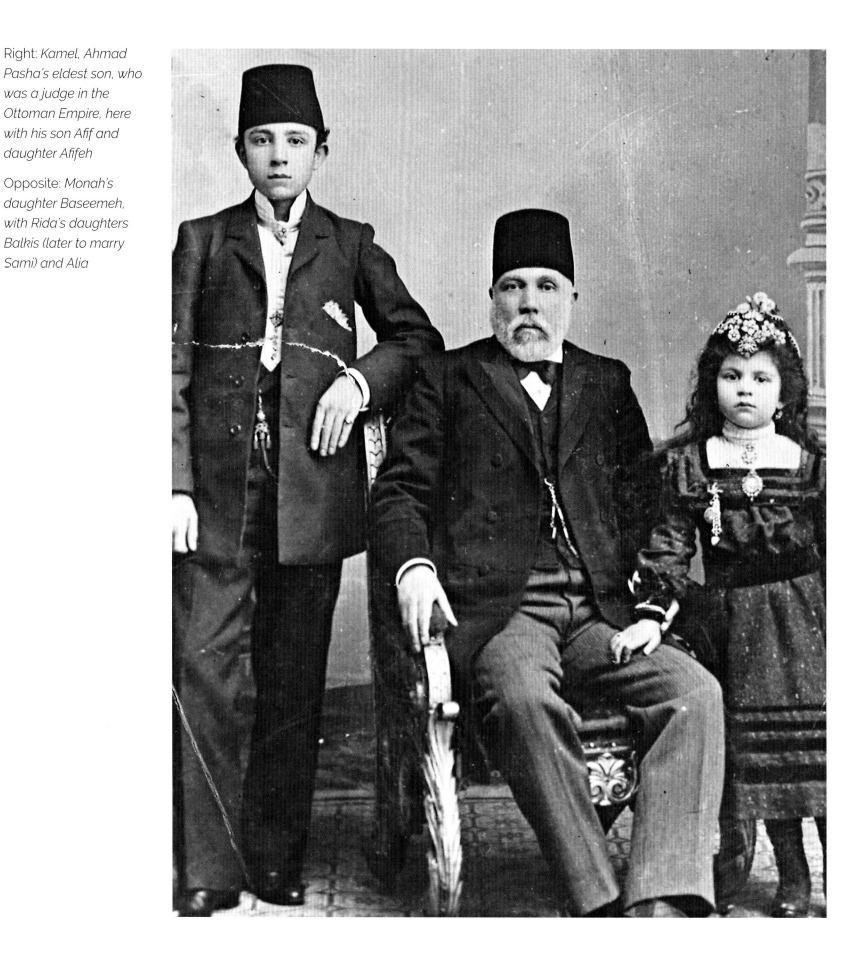

AHMAD PASHA EL-SOLH'S DESCENDANTS

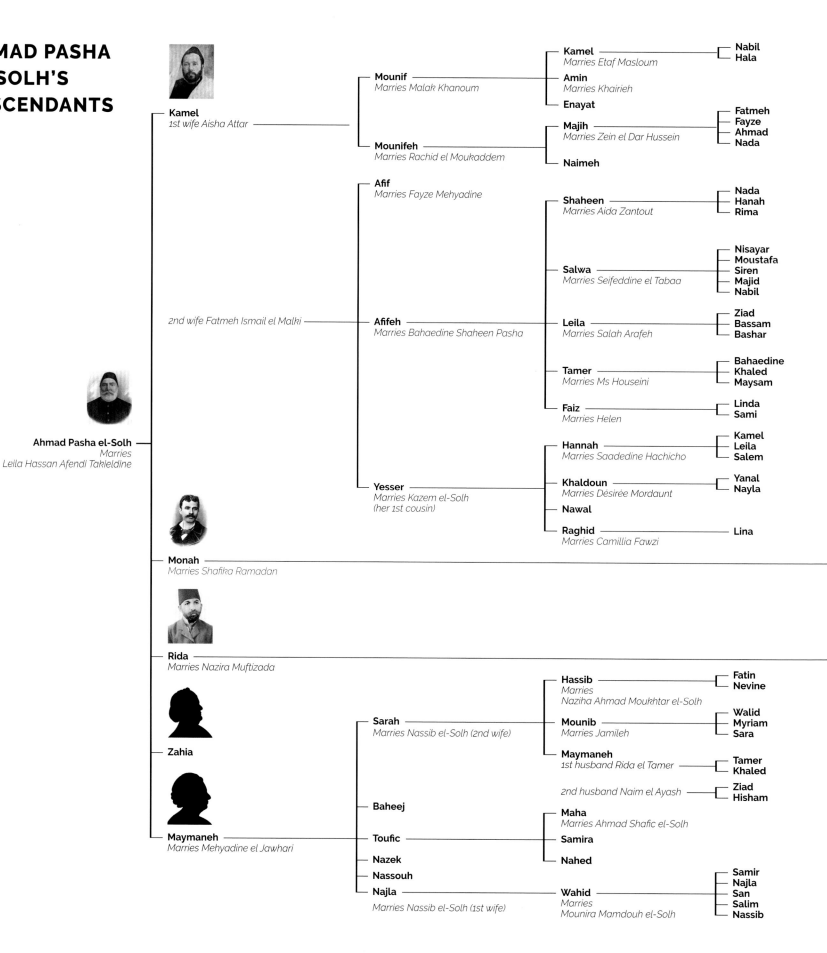

Ahmad Pasha el-Solh
Marries
Leila Hassan Afendi Takieldine

Kamel
1st wife Aisha Attar

Mounif
Marries Malak Khanoum

Kamel
Marries Etaf Masloum
— Nabil
— Hala

Amin
Marries Khairieh

Enayat

Mounifeh
Marries Rachid el Moukaddem

Majih
Marries Zein el Dar Hussein
— Fatmeh
— Fayze
— Ahmad
— Nada

Naimeh

2nd wife Fatmeh Ismail el Malki

Afif
Marries Fayze Mehyadine

Afifeh
Marries Bahaedine Shaheen Pasha

Shaheen
Marries Aida Zantout
— Nada
— Hanah
— Rima

Salwa
Marries Seifeddine el Tabaa
— Nisayar
— Moustafa
— Siren
— Majid
— Nabil

Leila
Marries Salah Arafeh
— Ziad
— Bassam
— Bashar

Tamer
Marries Ms Houseini
— Bahaedine
— Khaled
— Maysam

Faiz
Marries Helen
— Linda
— Sami

Yesser
Marries Kazem el-Solh
(her 1st cousin)

Hannah
Marries Saadedine Hachicho
— Kamel
— Leila
— Salem

Khaldoun
Marries Désirée Mordaunt
— Yanal
— Nayla

Nawal

Raghid
Marries Camillia Fawzi
— Lina

Monah
Marries Shafika Ramadan

Rida
Marries Nazira Muftizada

Zahia

Maymaneh
Marries Mehyadine el Jawhari

Sarah
Marries Nassib el-Solh (2nd wife)

Hassib
Marries
Naziha Ahmad Moukhtar el-Solh
— Fatin
— Nevine

Mounib
Marries Jamileh
— Walid
— Myriam
— Sara

Maymaneh
1st husband Rida el Tamer
— Tamer
— Khaled

2nd husband Naim el Ayash
— Ziad
— Hisham

Baheej

Toufic

Maha
Marries Ahmad Shafic el-Solh

Samira

Nahed

Nazek

Nassouh

Najla
Marries Nassib el-Solh (1st wife)

Wahid
Marries
Mounira Mamdouh el-Solh
— Samir
— Najla
— San
— Salim
— Nassib

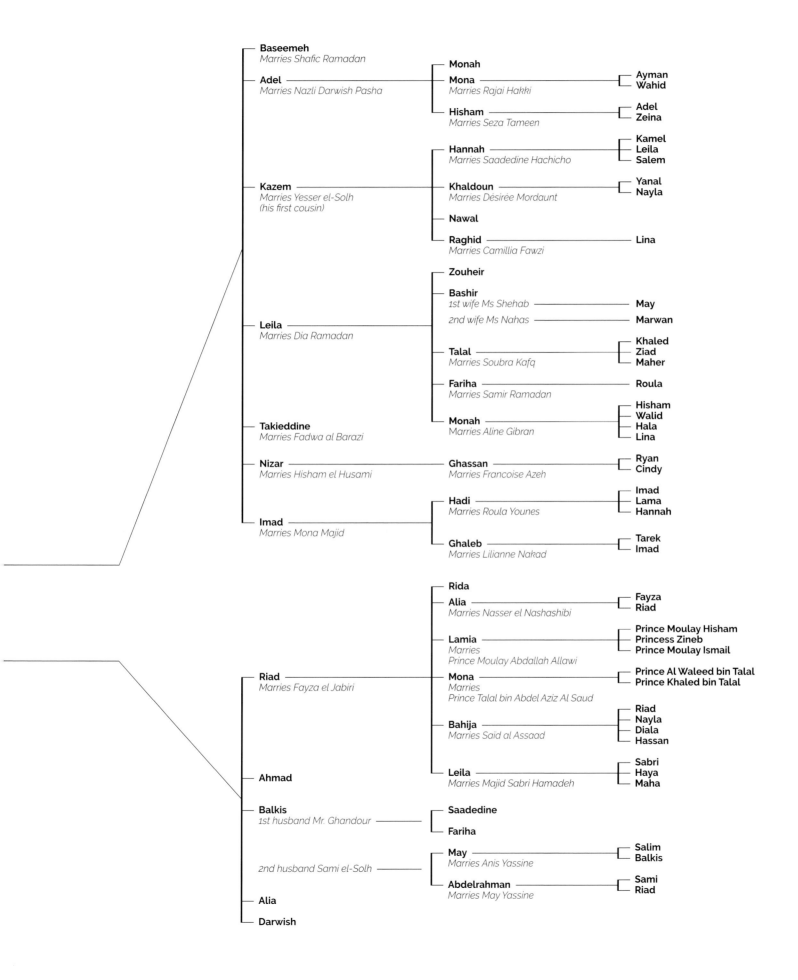

Baseemeh
Marries Shafic Ramadan

Adel
Marries Nazli Darwish Pasha

- **Monah**
- **Mona**
 Marries Rajai Hakki
 - Ayman
 - Wahid
- **Hisham**
 Marries Seza Tameen
 - Adel
 - Zeina

Kazem
Marries Yesser el-Solh
(his first cousin)

- **Hannah**
 Marries Saadedine Hachicho
 - Kamel
 - Leila
 - Salem
- **Khaldoun**
 Marries Désirée Mordaunt
 - Yanal
 - Nayla
- **Nawal**
- **Raghid**
 Marries Camillia Fawzi
 - Lina

Leila
Marries Dia Ramadan

- **Zouheir**
- **Bashir**
 1st wife Ms Shehab — May
 2nd wife Ms Nahas — Marwan
- **Talal**
 Marries Soubra Kafq
 - Khaled
 - Ziad
 - Maher
- **Fariha**
 Marries Samir Ramadan — Roula
- **Monah**
 Marries Aline Gibran
 - Hisham
 - Walid
 - Hala
 - Lina

Takieddine
Marries Fadwa al Barazi

Nizar
Marries Hisham el Husami

- **Ghassan**
 Marries Francoise Azeh
 - Ryan
 - Cindy

Imad
Marries Mona Majid

- **Hadi**
 Marries Roula Younes
 - Imad
 - Lama
 - Hannah
- **Ghaleb**
 Marries Lilianne Nakad
 - Tarek
 - Imad

107

Riad
Marries Fayza el Jabiri

- **Rida**
- **Alia**
 Marries Nasser el Nashashibi
 - Fayza
 - Riad
- **Lamia**
 Marries
 Prince Moulay Abdallah Allawi
 - Prince Moulay Hisham
 - Princess Zineb
 - Prince Moulay Ismail
- **Mona**
 Marries
 Prince Talal bin Abdel Aziz Al Saud
 - Prince Al Waleed bin Talal
 - Prince Khaled bin Talal
- **Bahija**
 Marries Said al Assaad
 - Riad
 - Nayla
 - Diala
 - Hassan
- **Leila**
 Marries Majid Sabri Hamadeh
 - Sabri
 - Haya
 - Maha

Ahmad

Balkis
1st husband Mr. Ghandour

- **Saadedine**
- **Fariha**

2nd husband Sami el-Solh

- **May**
 Marries Anis Yassine
 - Salim
 - Balkis
- **Abdelrahman**
 Marries May Yassine
 - Sami
 - Riad

Alia

Darwish

Between the collapse of the Ottoman Empire and the rise of European colonialism in the Middle East, the Arabs saw a real opportunity for independence. The Emir Faisal I emerged as one of the unifying Arab leaders. In 1919, Afif, Ahmad Pasha's grandson, son of his eldest son Kamel, moved to Damascus, joining King Faisal I of Greater Syria, and in 1920 was elected as a member of the Syrian Congress, representing Tyre in South Lebanon. The purpose of the Congress was to secure the independence and unity of the Arab world. His uncle Rida el-Solh (Riad's father) represented Beirut and was Home Secretary of the Congress, and his first cousin Riad represented Sidon.

The Sykes-Picot Agreement signed in 1916 was implemented a few years later to partition the crumbling Ottoman Empire in the Arab Orient and Anatolia between the British, French and Russians. Later, in 1920 the Congress was dissolved. Faisal, his ambitions and hopes dashed, withdrew to Iraq where he became king. Rida and Riad returned to Lebanon, leaving Afif in Syria to continue the fight for independence.

Aref Naamani, who also appears in the top photograph, was part of the Congress as well as being one of Riad's best friends. Part of his family first owned the mansion that Takieddine would later live in.

The Balfour Declaration of November 1917 changed the course of history, when British duplicity promised control over Palestine to both Arabs and Zionists; its effects are still felt today. The McMahon-Hussein Correspondence (1915) pledged to respect the recognition of the independence of Arab countries in exchange for Arab support against the Ottoman Turks. There were also other agreements and treaties signed which stood in stark opposition to the Balfour Declaration. These include the Anglo-French Declaration (1918) and the King-Crane Commission (1919).

Political activists set up a number of underground groups in the 1920s and 1930s to fight for Arab independence from European powers. Kazem el-Solh, another of Ahmad Pasha's grandsons, son of Monah, was the proprietor of the *Al Nida* newspaper, first published in Lebanon in 1930. He was a founding member of the Red Book secret society in 1936 and established the Al Nida political party with his brother Takieddine in 1944. He was the author of a document called *El Sahil* (the coast), a forerunner of the Lebanese constitution. He was Lebanese Ambassador to Iraq from 1947 to 1960. Upon his return to Lebanon in 1960, he was elected as a Member of Parliament representing Zahle. He was nominated for the position of PM but did not have full support, as he was not an ardent Nasserist.

Members of Faisal's Arab Congress (1920) including Rida el-Solh, Afif el-Solh, Riad el-Solh and Aref Naamani

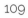

Members of the National Bloc (1932)
Front row (left to right): *Shukri al-Quwatli, Mazhar Pasha Raslan, Ibrahim Hananu, Hashem al-Atasi, Fares al-Khoury, Najib al-Barazi, Mohammad al-Nahhas*
Back row: *Ihsan al-Sharif, Tawfiq al-Shishakli, Fayez al-Khoury, Saadallah al-Jabiri, Said al-Ghazzi, Afif el-Solh*

The family has produced four Prime Ministers from the 1940s to the 1990s: Riad, 1943-45, 1946-51, assassinated in 1951; Sami, 1942-43, 1945-46, 1952, 1954-55, 1956-58; Takieddine, 1973-74 and again in 1980 but unable to form a cabinet; and Rachid, 1974-75. The leaders were often charismatic and idealistic, non-sectarian, practising an open-house style of politics.

through writing and journalism. Leila, Riad's youngest daughter, served as the Minister for Industry from 2004 to 2005, making her one of the first women ministers in Lebanon. She has been the vice-president of Al Waleed bin Talal Humanitarian Foundation in Lebanon since its establishment in August 2003 (Prince Al Waleed bin Talal is Leila's

The el-Solh family has always believed in coexistence between its mosaic of religious factions.

Above: *Riad el-Solh*

The country has the most religiously diverse society of all states in the Middle East. Perhaps that is yet another reason why they were respected by all sides.

The family has also produced some very strong women, who were involved in politics; among them was Mounira Solh, who stood for election in 1960, 1964 and 1968 and established the Al Amal institute for the disabled, the first of its kind in the Middle East. Alia, Riad's eldest child, was also very politically active, later picking up the pen to express her views

nephew, the son of her sister Mona). Under her management, the foundation has backed many projects in support of education, health and social organisations throughout the country.

Opposite below:
Fadwa (first from left) and Takieddine (fourth) with four of Riad el-Solh's daughters – Lamia (widow of late Prince Moulay Abdallah of Morocco), Leila, Alia, and Mona (mother of Saudi Prince Al Waleed bin Talal)

Top right: *Sami el-Solh with President Bechara el Khoury campaigning in the South*

Below: *Takieddine and Rachid el-Solh (who also served as PM 1974-75 and again in 1992), with President Suleiman Frangieh*

Right: *The el-Solh family and Saadedine Ghandour. Back row, left to right: name unknown, Moutstafa, Kazem, Adel, Takieddine, Mounib, and Imad. Centre row: Moumtaz, Sami, Moukhtar, Wahid, and Riad. Front row: Nassib, Abdelrahman, May, Monah, and Saadedine Ghandour*

Below: *Brothers Takieddine, Kazem, Adel and Imad with King Mohammad VI of Morocco*

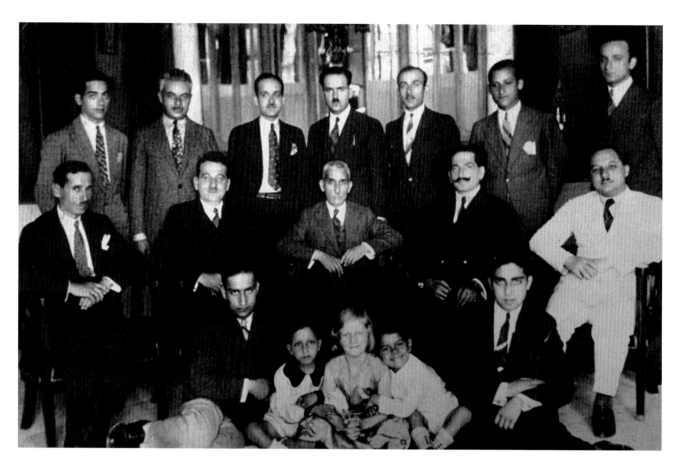

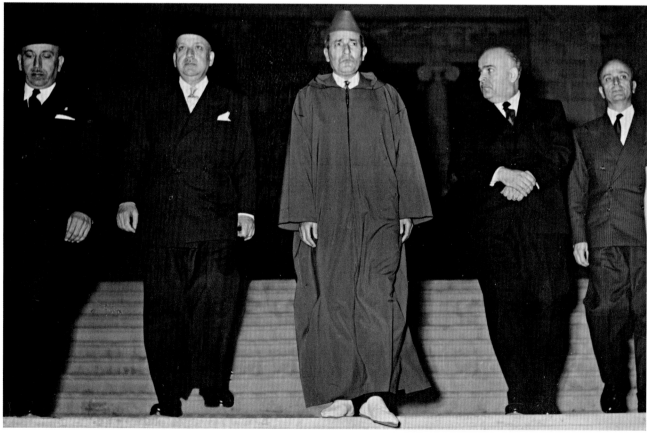

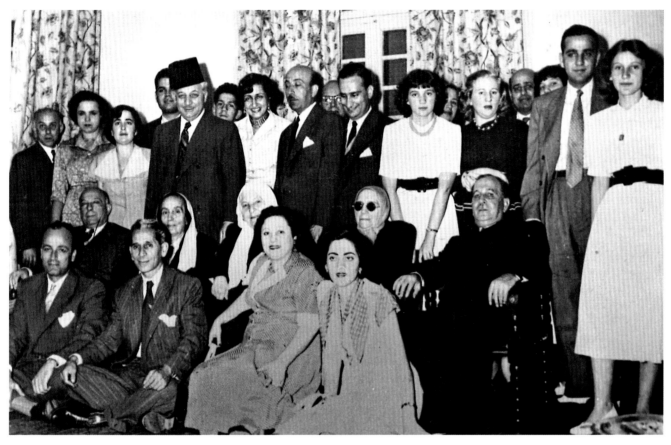

Left, front row, left to right: *Imad, Waheed, Mounira, and Salma*; 2nd row: *Afif, Shafica Ramadan (Kazem's mother), Nazira (Riad's mother), Fatmeh (Afif's mother) and Sami*; 3rd row: *Husami, Nizar, Souad, Riad, Naziha, Takieddine, Hasib, Mona, May, Abdel Rahman, and Lamia*; 4th row: *Monah, Khaldoun, Anis, and Alia*

Below: *Kazem el-Solh inspecting the troops as Lebanese Ambassador in Iraq (1947-60)*

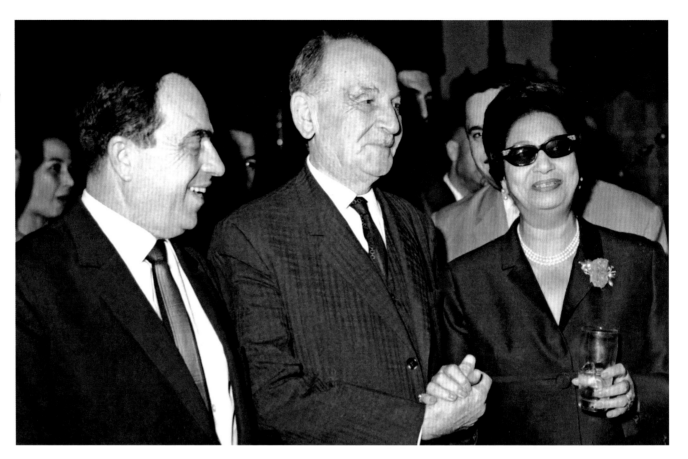

114

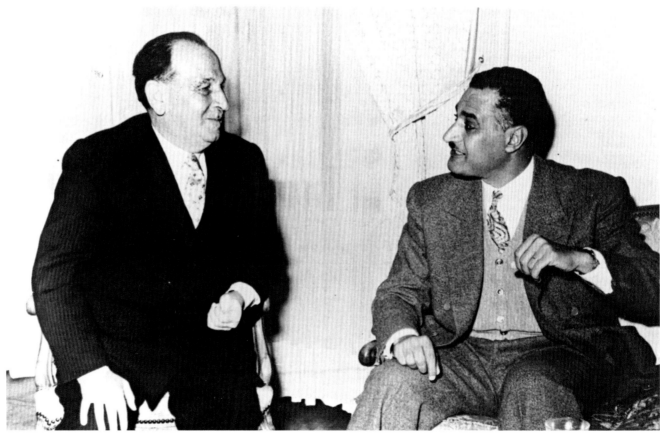

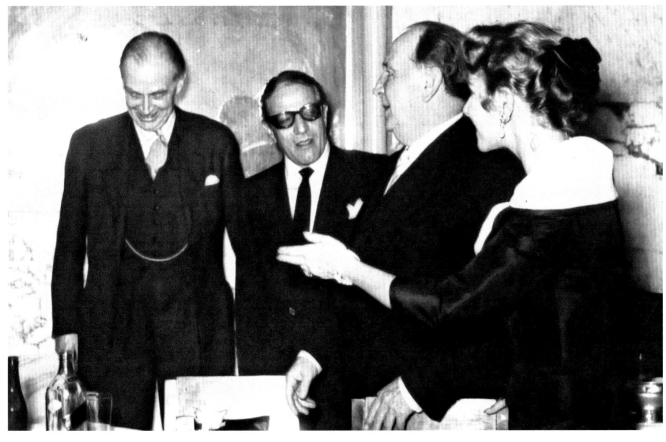

Left: *Sami el-Solh with Aristotle Onassis, the shipping tycoon and Maria Callas, the opera singer and Kurt Waldheim*

Below: *Sami greeting the Shah of Iran and his wife Soraya, with Lebanese President Camille Chamoun and his wife Zelpha*

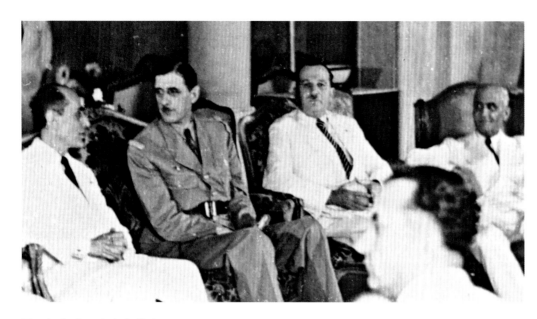

Top left: *Sami el-Solh to the right of Charles de Gaulle during his visit to Lebanon*

Top right: *The Mufti of Jerusalem greeting Kazem el-Solh*

Bottom left: *Adel el-Solh, the mayor of Beirut on board an American Ship in Beirut*

Bottom right: *Sami el-Solh with Pope Paul XXIII*

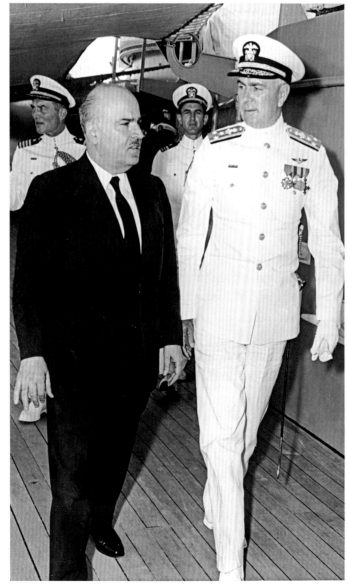

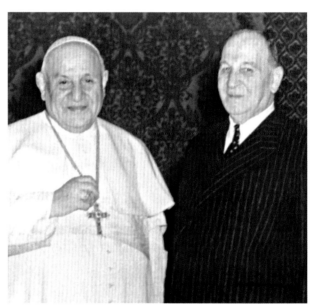

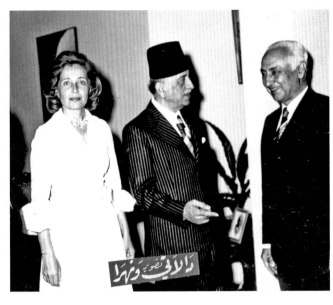

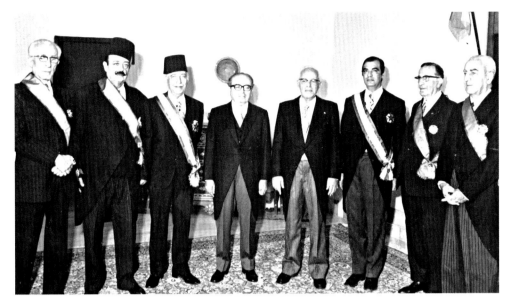

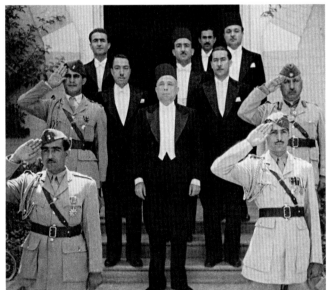

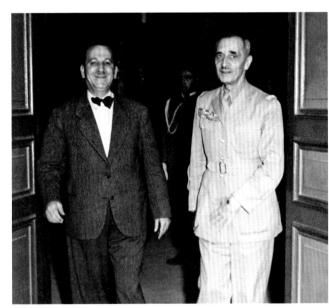

Top left: *Fadwa and Takieddine el-Solh*

Top right: *Takieddine and Rachid el-Solh, with President Suleiman Frangieh and other MPs*

Bottom left: *Afif el-Solh as Syrian Ambassador to Iraq (1947-51)*

Bottom right: *Sami el-Solh with French General Georges Catroux, a delegate general under de Gaulle who proclaimed the Lebanese independence on 26 November 1941*

117

FADWA AND TAKIEDDINE'S LIFE TOGETHER

Takieddine's political career continued to thrive, as he was re-elected from 1964 to 1968 (Baalbek), representing the Bekaa region in eastern Lebanon, and appointed Interior Minister 1964 to 1965. He served as Prime Minister and Minister of Finance from 1973 to 1974, during which time he was very active, meeting world leaders and attending conferences, participating in cultural events, often accompanied by Fadwa. He was a man of great intellect and charisma.

For her part, Fadwa was quite involved in cultivating the land that she inherited from her first husband. Her family owned extensive land in Syria, so this was already in her blood, as she had been surrounded by it while growing up. She employed a reliable manager to oversee the land and crops. She bought more land in the south and managed to channel water to it to irrigate it and make it profitable. She would often oversee her projects personally and would spend the entire day on the land, frequently returning home sunburnt, which was somewhat incompatible with the wearing of a cocktail dress during the receptions she often attended as the PM's wife.

The extensive garden became the hub for socio-political and cultural gatherings, as well as playing a pivotal role in the 'open house' style of politics practised by Takieddine.

Citizens came to the mansion to discuss matters of concern and ask for solutions to their problems.

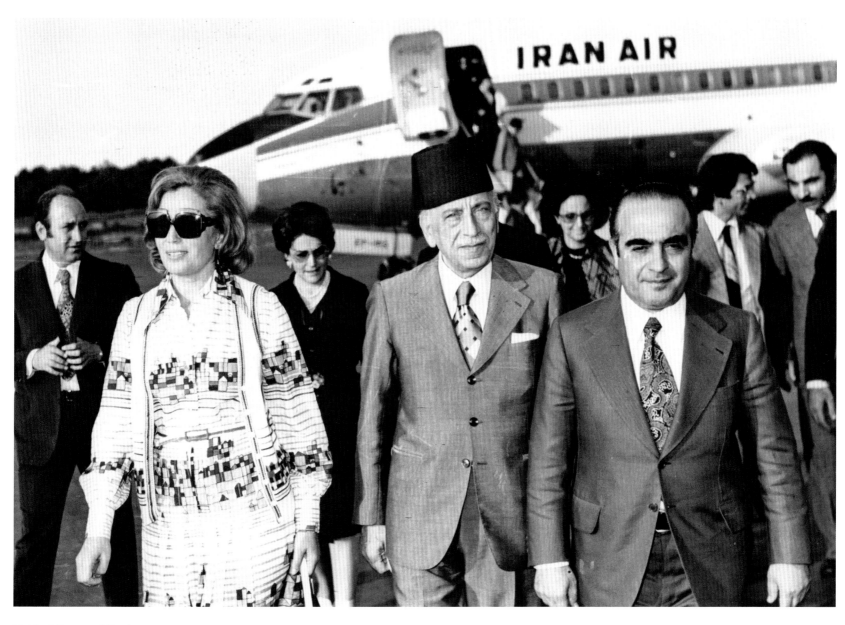

*Takieddine and Fadwa
arriving in Iran for an
official visit, accompanied
by Fouad Naffaa, the
Lebanese Foreign Minister*

Right: *Fadwa and Takieddine in Paris*

Below: *Takieddine and Fadwa attending the Baalbek International Festival in 1974, with May Arida, president of the festival, Lina (Fadwa's niece) and Leila el- Solh*

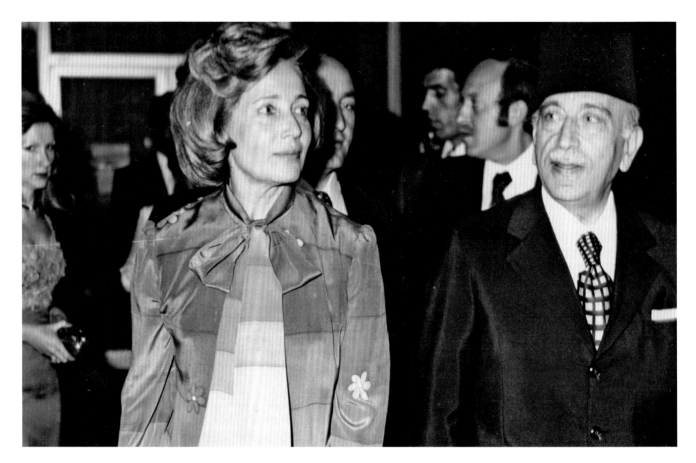

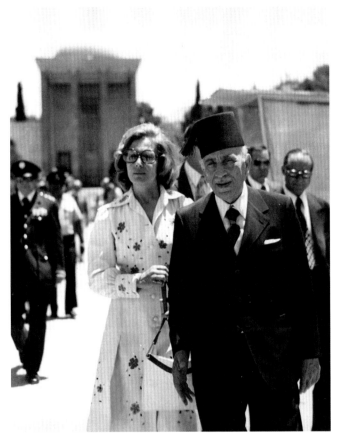

Left and below:
*Takieddine and Fadwa
on an official trip to Iran*

Right: *Takieddine being held aloft after winning an election*

Below: *Takieddine in the cockpit of a plane exchanging pleasantries with the crew*

Opposite: *Takieddine heading a parliamentary session as Prime Minister*

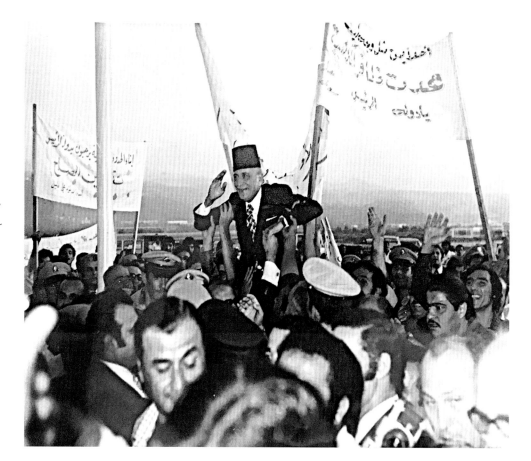

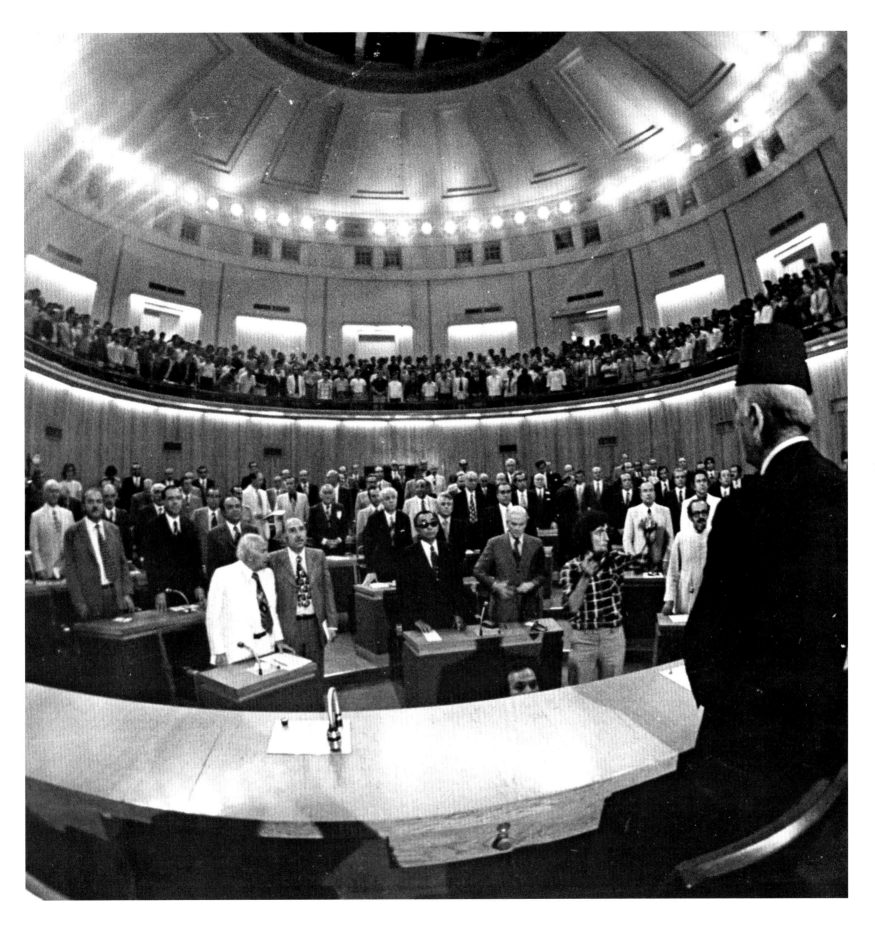

Right: *Takieddine greets King Faisal of Saudi Arabia*

Below: *Takieddinne meets with Indira Gandhi, Prime Minister of India at the 4th Non-Aligned Summit Conference in Algeria (1973)*

Left: *Fidel Castro of Cuba next to Takieddine at the Algerian Conference*

Below: *Takieddine with Yasser Arafat, the leader of the PLO (Palestinian Liberation Organisation)*

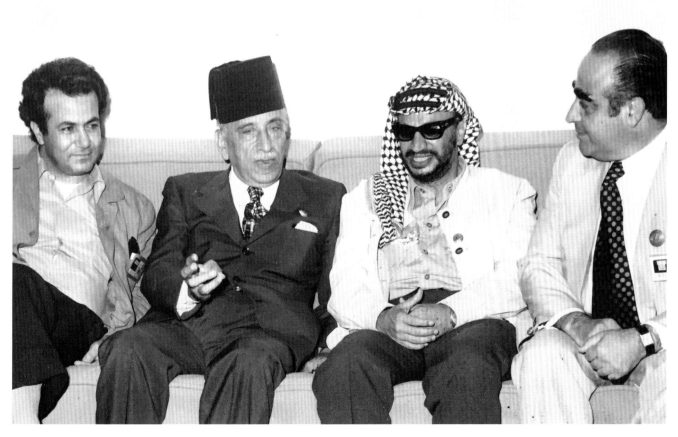

Rising tensions between the different factions in Lebanon finally spilt over on Sunday 13 April 1975 when a bus full of Palestinians was attacked in Beirut, marking the beginning of the Civil War. It lasted for fifteen years, initially pitting Maronite-oriented right-wing militias against leftist,Muslim-oriented militias supported by the PLO. During the course of the fighting, however, alliances shifted rapidly and unpredictably. Furthermore, powers such as Israel and Syria became involved in the war and fought alongside different factions. Peacekeeping forces were also stationed in Lebanon. The war ended in October 1990, claiming the lives of some 200,000 people, and left Lebanon in ruins.

Israel invaded Lebanon again in 1982 to expel the PLO (Palestinian Liberation Organisation), raining down death and destruction that resulted in thousands of casualties. Beirut was battered for seventy-five days, the operation finally ending in a grotesque massacre of women, children and the elderly at Sabra and Chatila refugee camp, enabled by the Israelis. (Lebanon has hosted Palestinian refugees since 1948, the year of the Nakba (Catastrophe), when hundreds of thousands of Palestinians fled or were forced out of their homes by Zionist militia as the state of Israel was created. Palestinian refugees are scattered among twelve camps and forty-two gatherings across the country, often described as urban ghettos.)

Takieddine was a great believer in his country and resisted any pressure to leave throughout his political career, even when bombs were falling on the house. It had a wooden roof covered in tiles, which was therefore quite dangerous during shelling. Takieddine, Fadwa and the staff had to flee to the kitchen for refuge, as it was the only room in the house with a concrete ceiling.

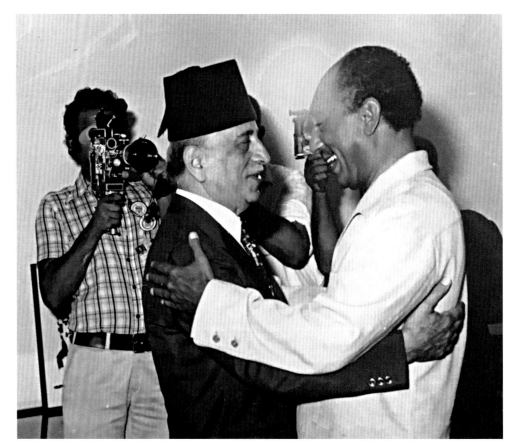

Above: Takieddine greets Anwar Sadat, the Egyptian President

Left: *Takieddine meets with Saeb Salam, the former PM, at the mansion*

Below: *Takieddine wiith Walid Jumblat, politician representing the Druze, at the mansion*

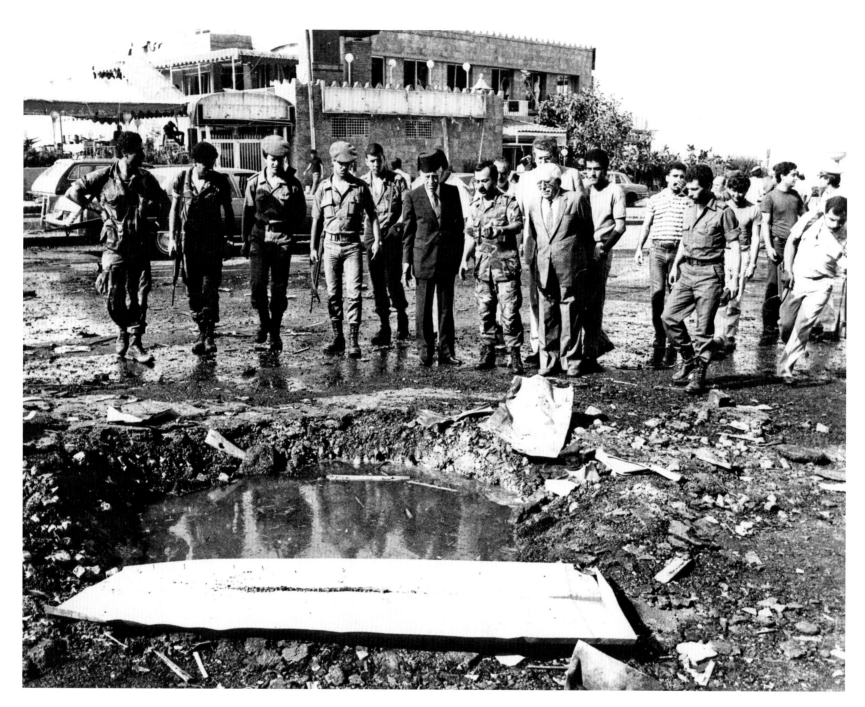

Takieddine inspecting an Israeli bomb crater in Beirut in 1982
© Assafir *newspaper*

Opposite: *Damage to the mansion's sitting room ceiling after it was hit by Israeli shelling in 1982 during their invasion of Lebanon*
© Assafir *newspaper*

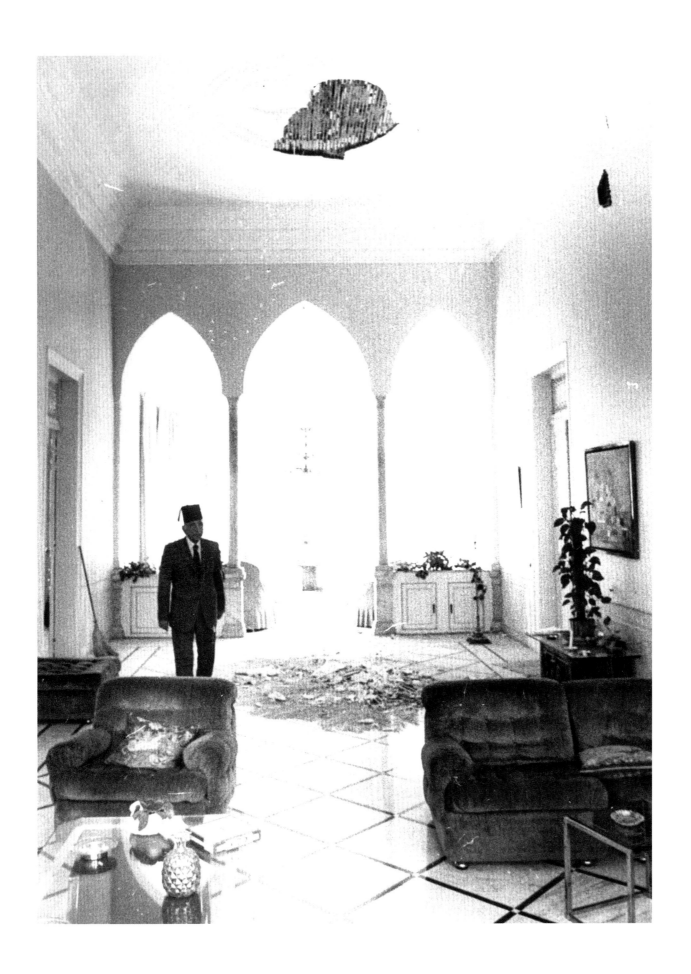

Takieddine was asked to form a government in 1980 at the height of the Civil War, but was unsuccessful because of political conflicts and pressure from the Syrian regime, which maintained a military presence in the country. On several occasions around this time there had been bullets fired at ceilings of the house, but recently Takieddine had found a bullet-hole in his pillow. He took this as a serious warning, coupled with the advice he had received from several well-connected politicians, including Nabih Berri (the speaker of Parliament), that his life was in danger.

He left his beloved country in November 1988 and travelled to Paris, where he and Fadwa had an apartment. He fell ill while there and was admitted to hospital. Fadwa was summoned from Beirut to be by his side. He passed away a few days later, on 27 November 1988. His body was flown back to Beirut where he received a state funeral attended by thousands of people. The funeral procession departed from the mansion and snaked its way to his final resting place.

Takieddine at home in conversation with Samih el-Solh, Director of the ministry of interior
© Fouad Elkoury (1984)

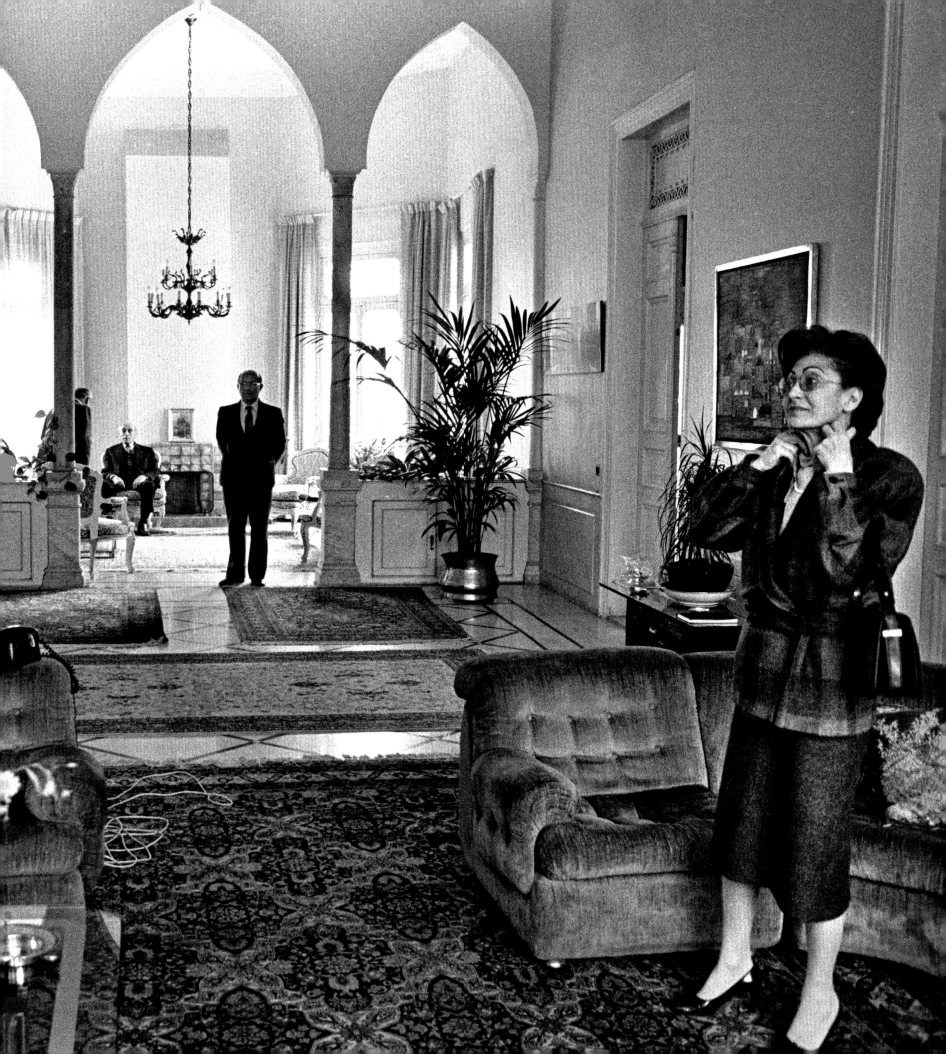

DEMISE

Takieddine's death and
abandonment of the mansion
(1988-2020)

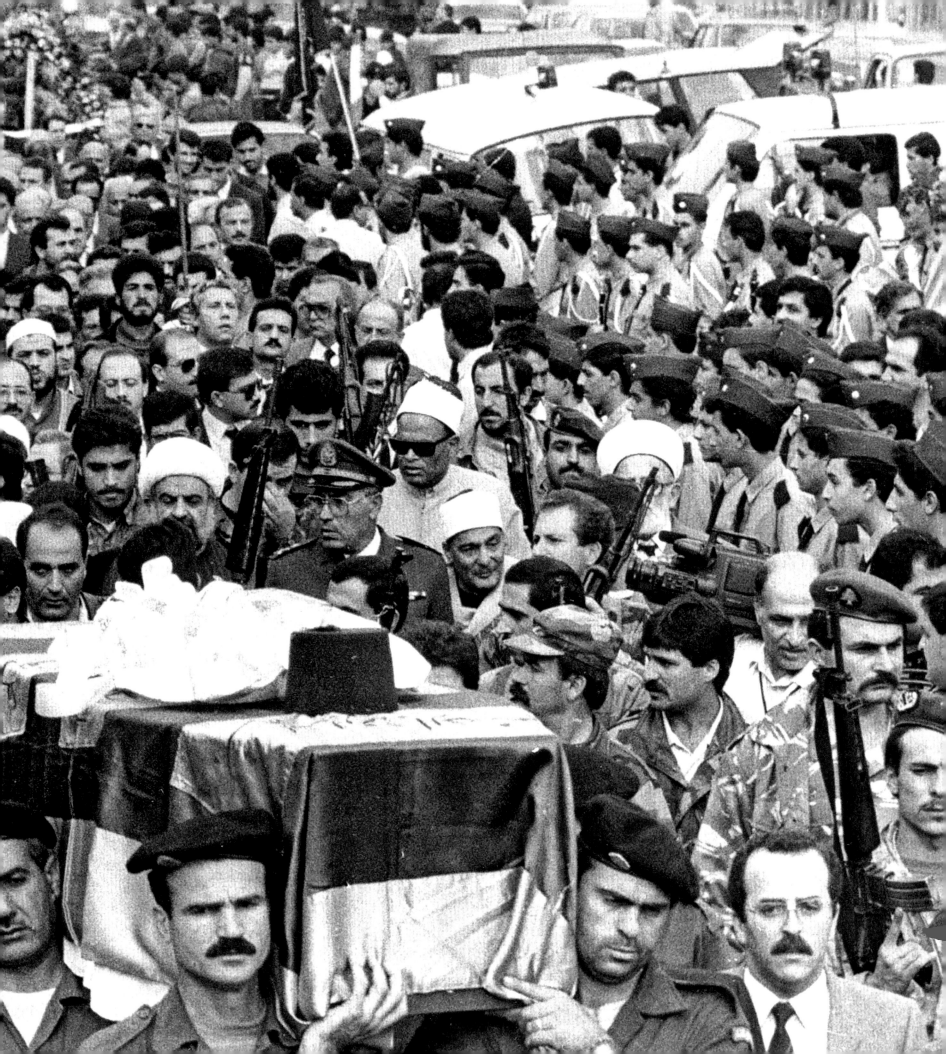

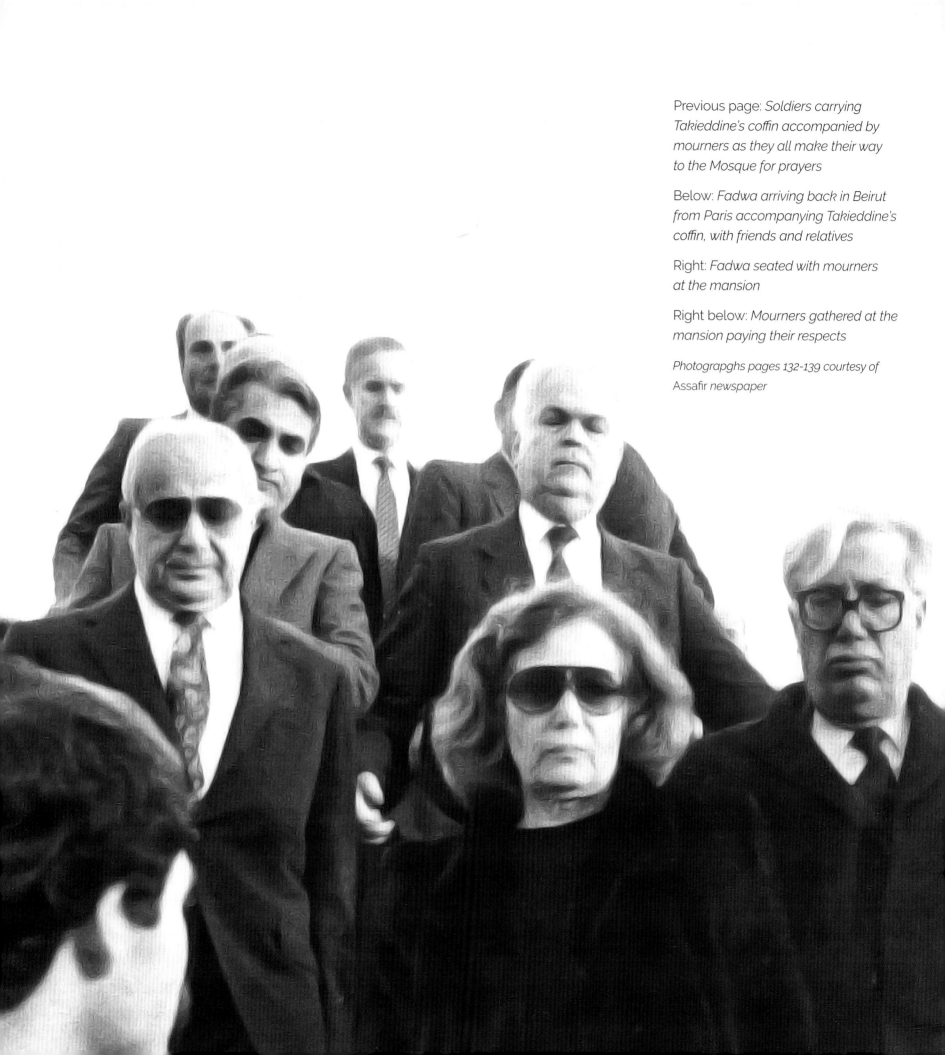

Previous page: *Soldiers carrying Takieddine's coffin accompanied by mourners as they all make their way to the Mosque for prayers*

Below: *Fadwa arriving back in Beirut from Paris accompanying Takieddine's coffin, with friends and relatives*

Right: *Fadwa seated with mourners at the mansion*

Right below: *Mourners gathered at the mansion paying their respects*

Photograpghs pages 132-139 courtesy of Assafir *newspaper*

135

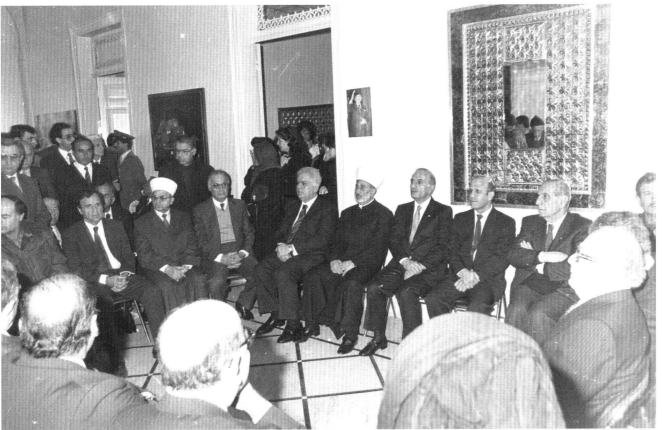

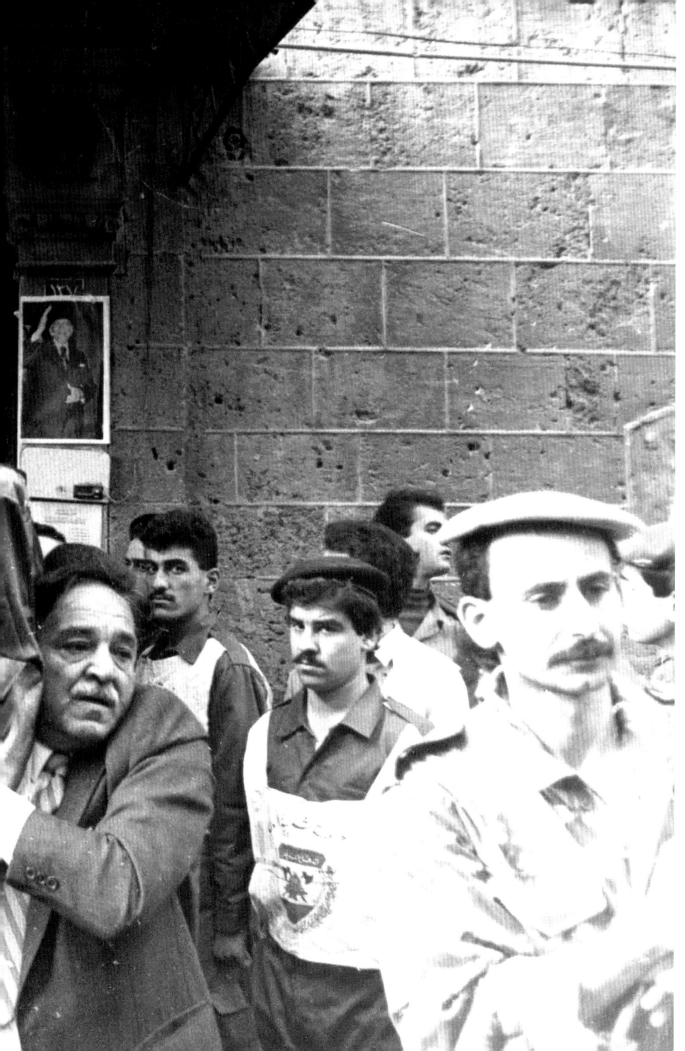

Takieddine's coffin being carried out of his home, making its way to the mosque

Right: *Takieddine's coffin surrounded by mourners at the mosque*

Opposite: *Takieddine's tarboush (fez) on top of his coffin*

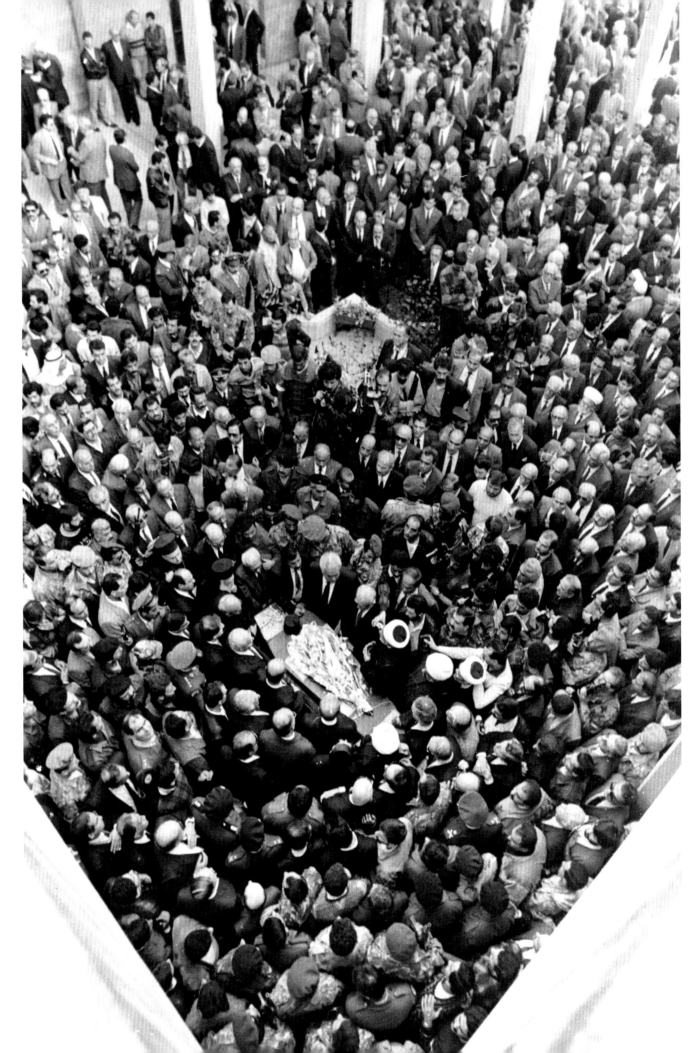

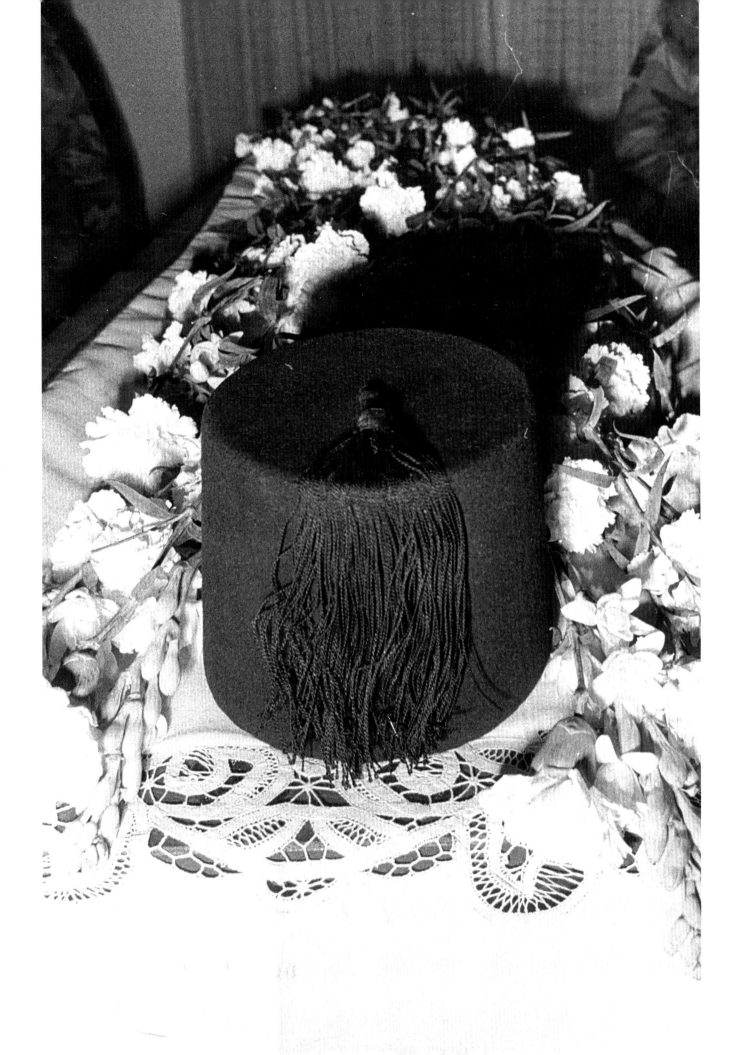

THE DEMISE OF THE MANSION

For most of its existence, the mansion had been legally occupied and well maintained. After Takkiedine's funeral in November 1988, Fadwa had little interest in rattling around the large house alone. She had already bought a more manageable flat in another part of Beirut, where she now spent most of her time. The battle for the sharing out of the inheritance picked up pace once again, between Fadwa, Mohammad al Abboud's daughter Elham, and Abboud Abdel Razzak's family. The mansion thus became uninhabited and vulnerable to disrepair and unwanted visitors.

In 2002, the *An-Nahar* journalist and heritage conservationist, May Abiakl, was alerted to demolition works taking place at the mansion and took immediate action to try to stop them, because the building was an important example of our architectural heritage and history. She wrote an article in her newspaper which gathered support. She successfully challenged the legality of the court judgement that gave permission to demolish the mansion, and thus earned it an invaluable reprieve. The contractor employed to demolish it had already removed most of the fixtures and fittings.

In around 2013-14, a group of squatters had been living there, mainly in a small self-contained apartment in the southern section. This had a functioning kitchen, a toilet and a large room, into which were fitted four beds and a couple of tables. These men found odd jobs, among them parking cars at the fast-food chain around the corner. This may explain the amount of rubbish and empty fast-food cartons strewn around the ground floor, which they seemed to have used as a rubbish tip. They used a lock and chain to secure the door to the small apartment, probably for fear of anybody else walking into the abandoned house as they had done.

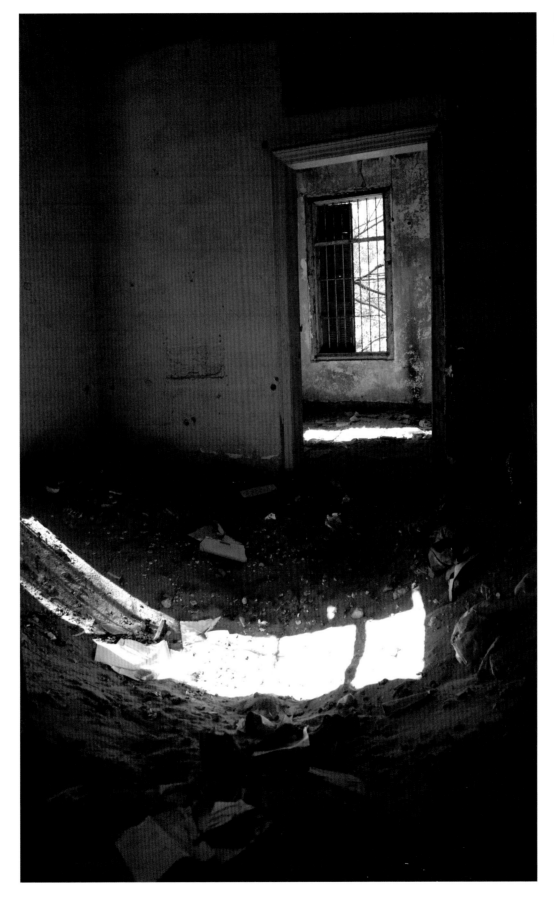

Ground floor room where
the body was buried

141

Right: *The mansion's second floor apartment in the annex used by the squatters*

These men were squatting in the mansion for several reasons. There have always been a great number of Syrian workers in Lebanon, from the mid-1960s onwards. The majority of these tended to be low-skilled male workers in construction, agriculture and cleaning services. Most of them live in precarious and squalid conditions, as their main aim is to send the money they make to their families back home. The flow of immigration was the result of several factors. The economic boom in Lebanon in the 1960s resulted in a massive recruitment of Syrian workers. During the Civil War, many Lebanese emigrated, with labour shortages as a result. During this time, the Syrian army was sent in as a peace-keeping force and controlled the Lebanese border, making it easier for Syrian workers to enter and leave the country. After the war the influx continued, since Lebanon needed an ample workforce for reconstruction. In 2005, following the assassination of the former Lebanese Prime Minister, mass protests and the withdrawal of Syrian army forces from Lebanon, there was greater insecurity for Syrian workers in the country. Since the start of the Syrian Civil War in 2011, there has been a massive influx of immigrants into Lebanon, from all walks of life, estimated at over a million refugees escaping the war.

In 2014, however, two of the squatters were convicted of murder, following an investigation by the police into a missing person. It transpired that the two suspects lured the victim to the house and then murdered him on the first floor, subsequently burying his body in a room on the ground floor.

An unknown person, who knew a couple of the men squatting at the mansion, asked to store some of his belongings temporarily in a ground-floor room, while his family moved into a smaller apartment. Following the arrests, the police secured the mansion and the man did not dare to re-enter the property to recover his belongings. It was obvious that someone had been rifling through the boxes, as pictures, books and papers were strewn across the room.

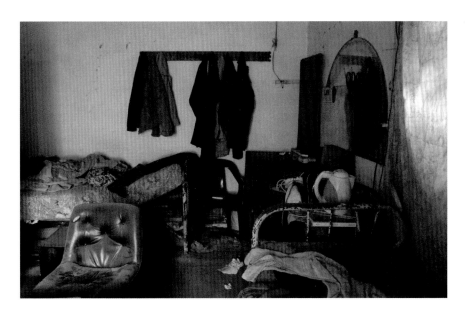

Top left and centre:
*The squatters' dwellings
with four beds*

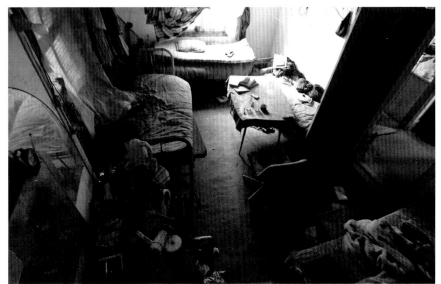

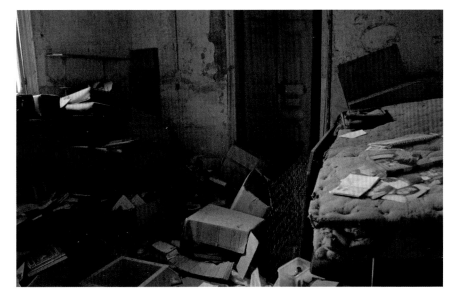

Left: *The storer's
belongings*

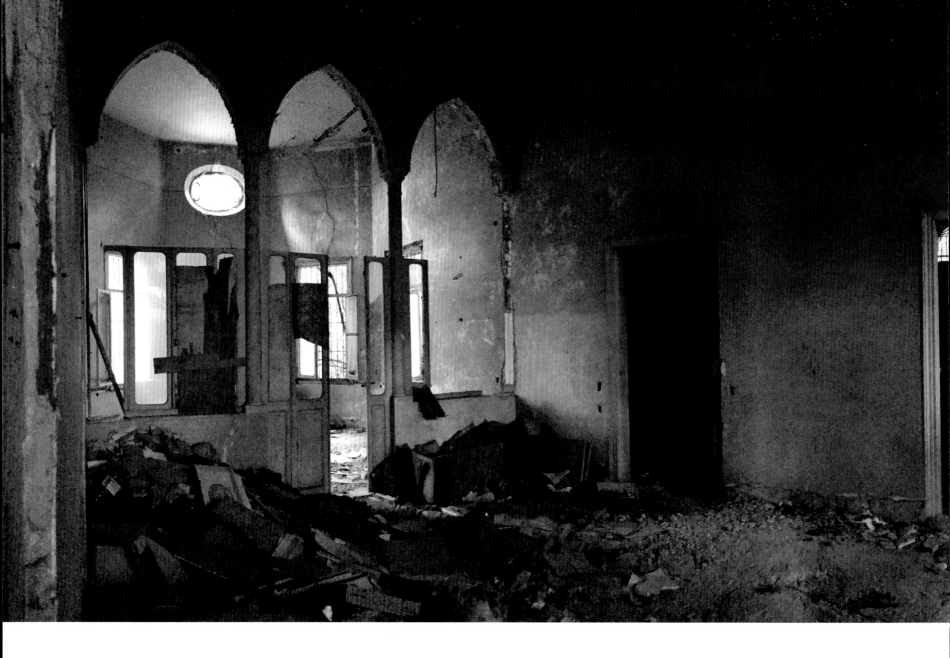

ABANDONMENT

Photographs (2016 - 2020)

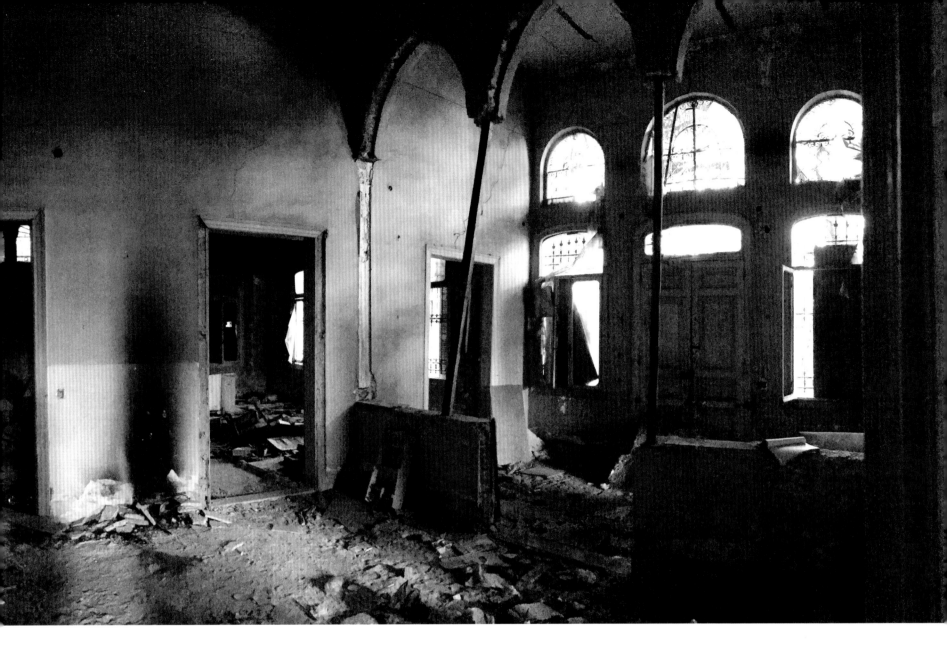

These photographs were taken over four years during my visits to Beirut and the mansion at different times of day. I would usually climb a wall into the garden and enter through a window, depending on how secured the property was. I was eventually able to borrow the side door key from the Abdel Razzak family. I tried to take photos from outside, from every building I could enter. They show the exterior of the building in its mainly roofless state.

At each new visit, I discovered a room that I had overlooked or passed by. Each time I was aware that things had moved, such as chairs and other objects. I was getting to know these walls and tried to listen to their stories, imagining the rooms full of people. I of course visited my uncle when I was young, so I do have memories of the interior. Sometimes I felt I was being watched, and once some stray cats and I frightened each other in a room where there had been a chain and lock on the door. A building was being constructed on the other side of the garden, so I assumed some of the workers used the property.

Here are some of my impressions during my journeys through this mystifying and enigmatic mansion.

As I enter from the side entrance on May Ziadeh Street, I climb the first flight of stairs. This was how Uncle Takieddine and Aunt Fadwa reached their first-floor abode. This is the door at which Takieddine dropped Fadwa off after their first meeting. I notice the peeling paint and plaster on the crumbling walls.

I enter through the gap left by the demolished doors to the Ammoun family's large ground-floor apartment. I am struck by its transformation into a graveyard of detritus, drowning in fast-food cartons and bags of rubbish. There are objects strewn around, such as a kettle, a desk that has seen better days, an armchair, a small television. The sumptuous marble floor has been ripped out, as have the tiles that gave colour to the rooms. Pools of natural light seep through the broken shutters, reflected on the walls, bringing out their deep colours. The library, the dining room, the bedrooms, the grand central room – life pulsated through them.

I climb up to the first floor which Uncle Takieddine and Aunt Fadwa occupied. This seems much lighter, partly because of the absence of sections of ceiling and roof. Nature has reclaimed some of these exposed rooms, with shrubs and trees

snaking through the bricks. Rather than marble, sand pervades underfoot, throwing you off-balance and into uncertainty. An old radio/record player is abandoned in the middle of the large central room. Flowery wallpaper adorns some rooms and a forgotten pink slipper awaits the return of its owner. A makeshift bed and a fan point to recent unwanted guests in a tiled white room.

I climb again through the annexe, which will undoubtedly uncover yet more sadness. I come across a mezzanine floor where a desk and a washing machine linger. I go on to the third floor – no sign of a roof, and the cracked walls are completely open to the elements. I wonder if it is safe to be here as I teeter on the edge of a gaping hole, once the ceiling of a room below.

I seek out familiar objects amidst the sea of rubbish, sand, debris, cracks and destruction. I take comfort in the thought of walking in the footsteps of those long gone.

She is still beguiling and mysterious, waiting for more of her secrets to be unlocked.

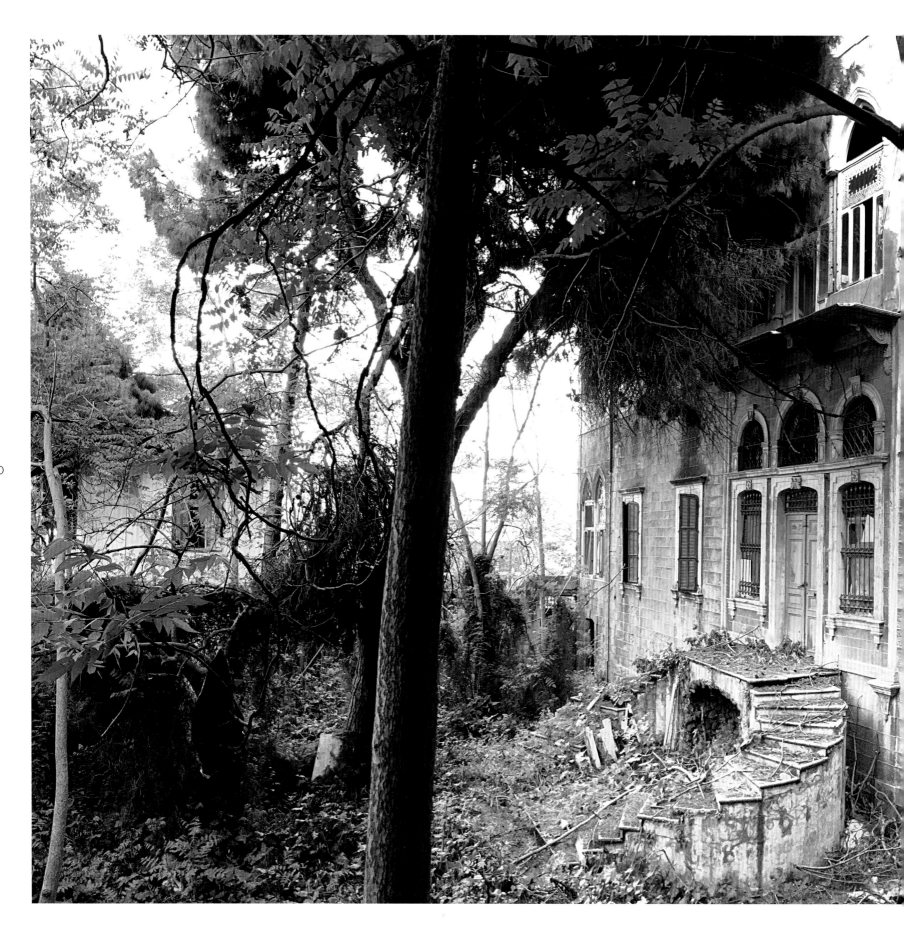

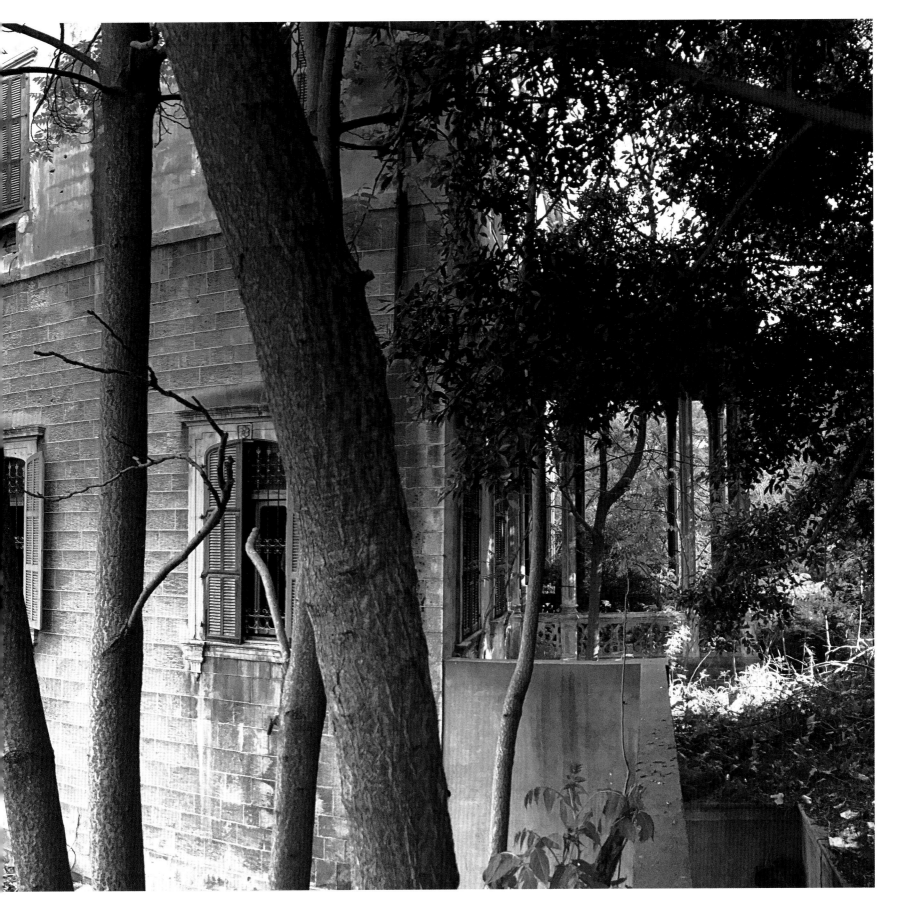

152

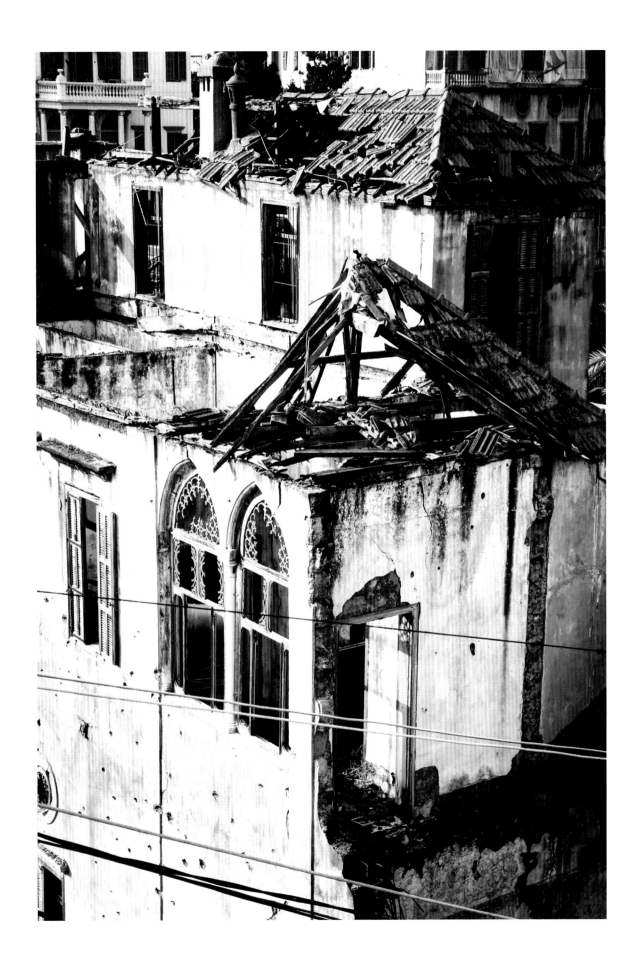

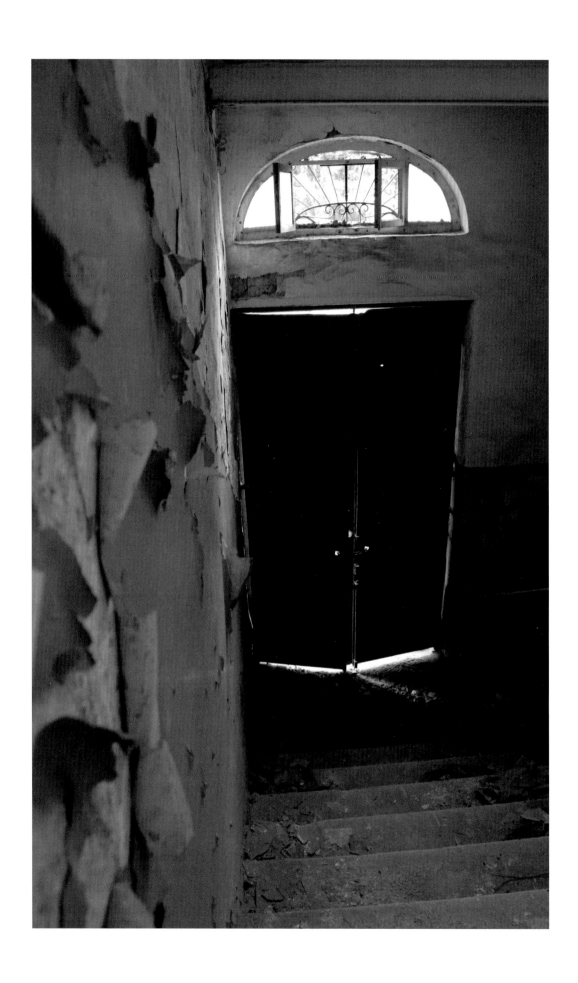

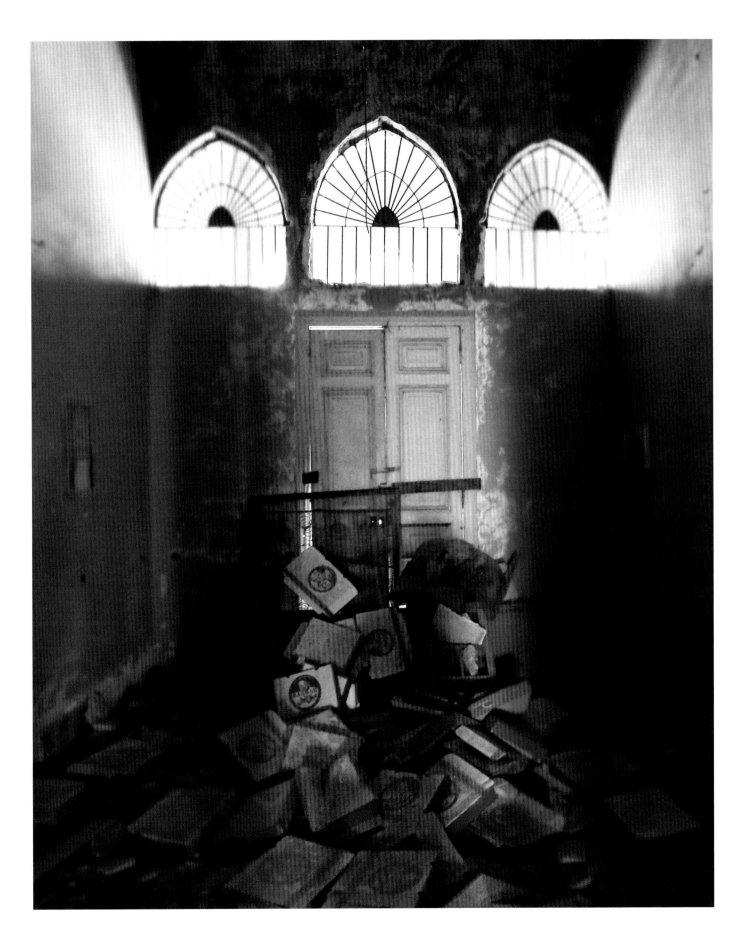

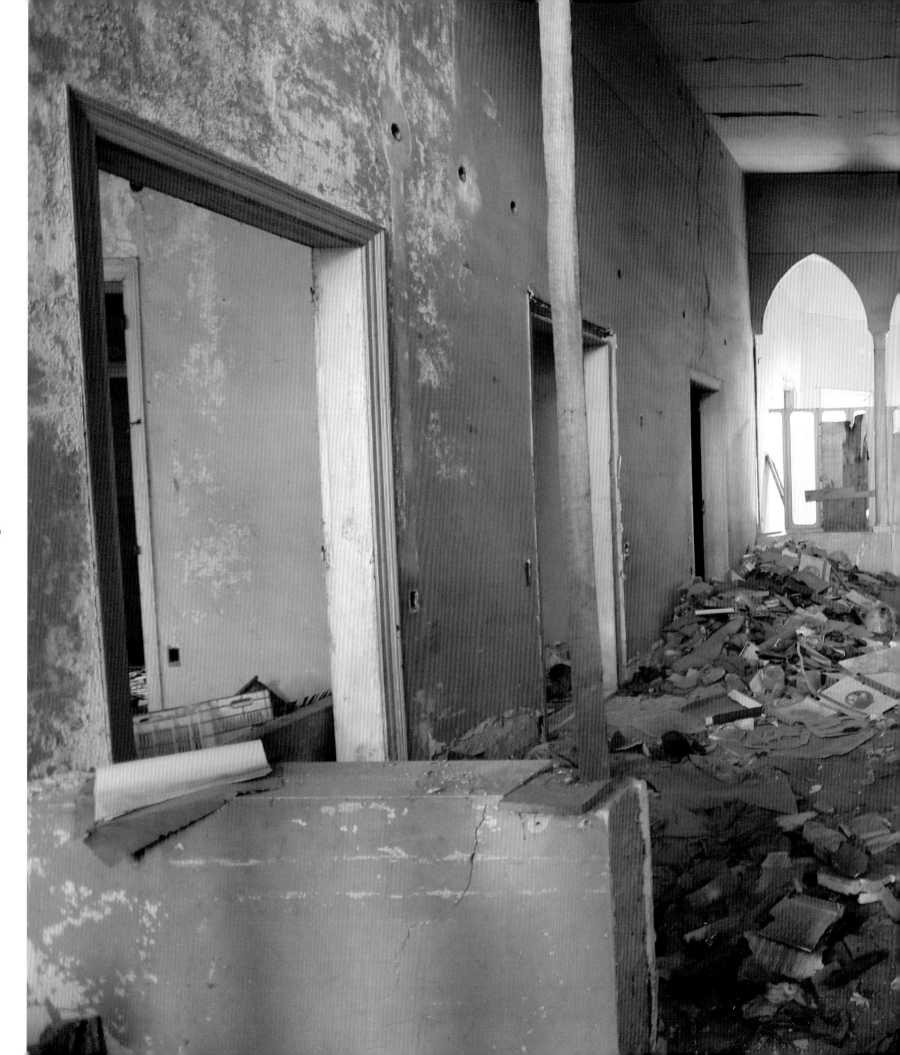

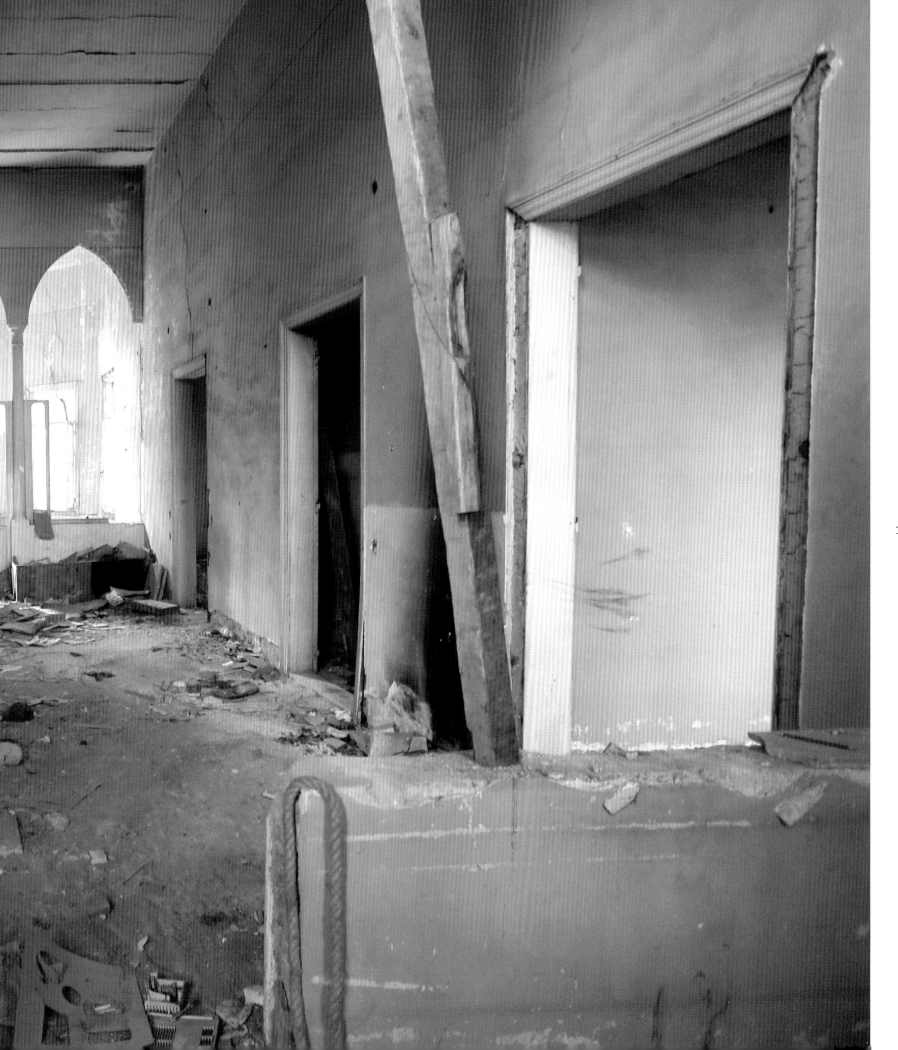

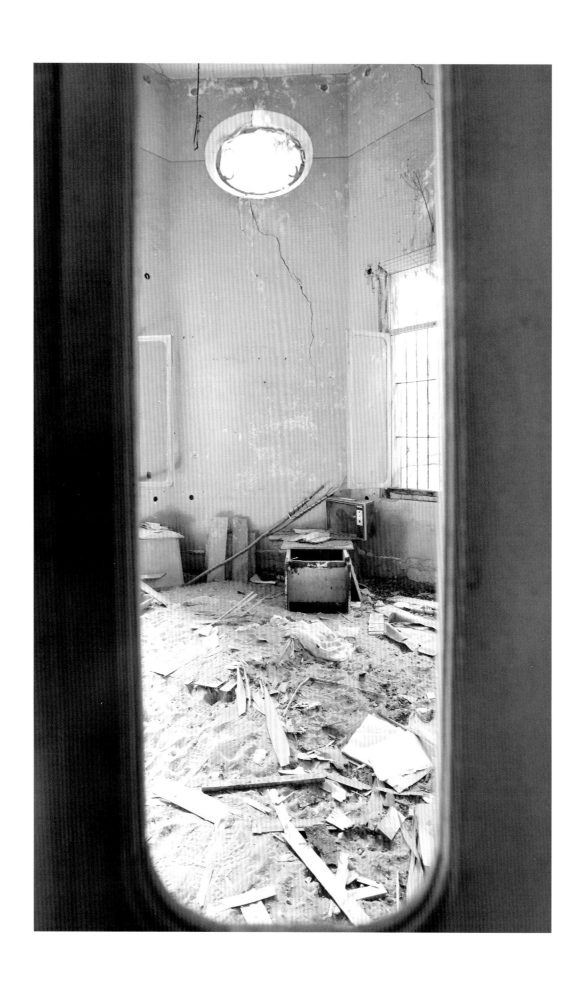

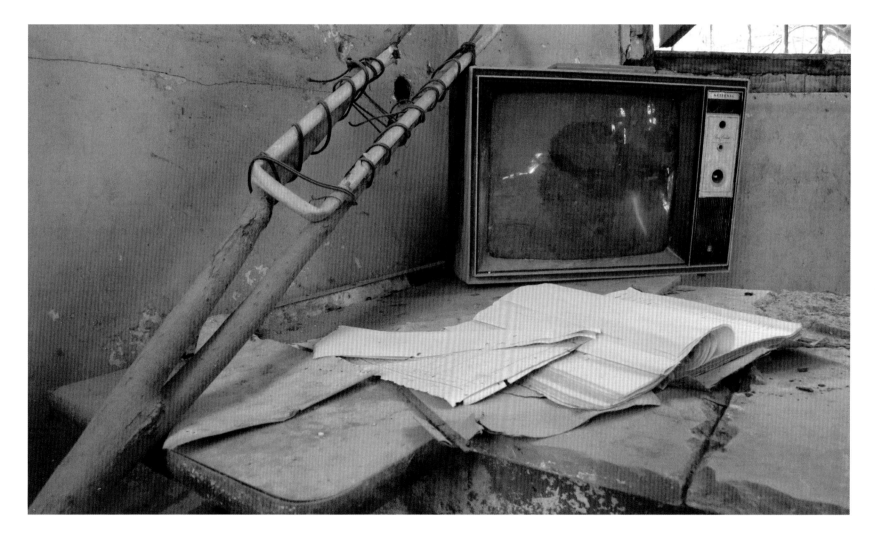

164

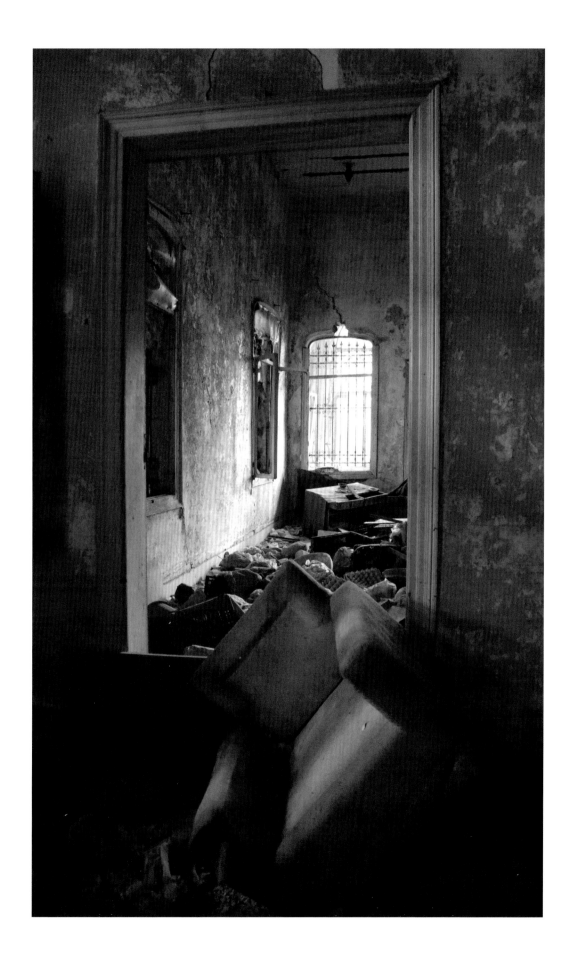

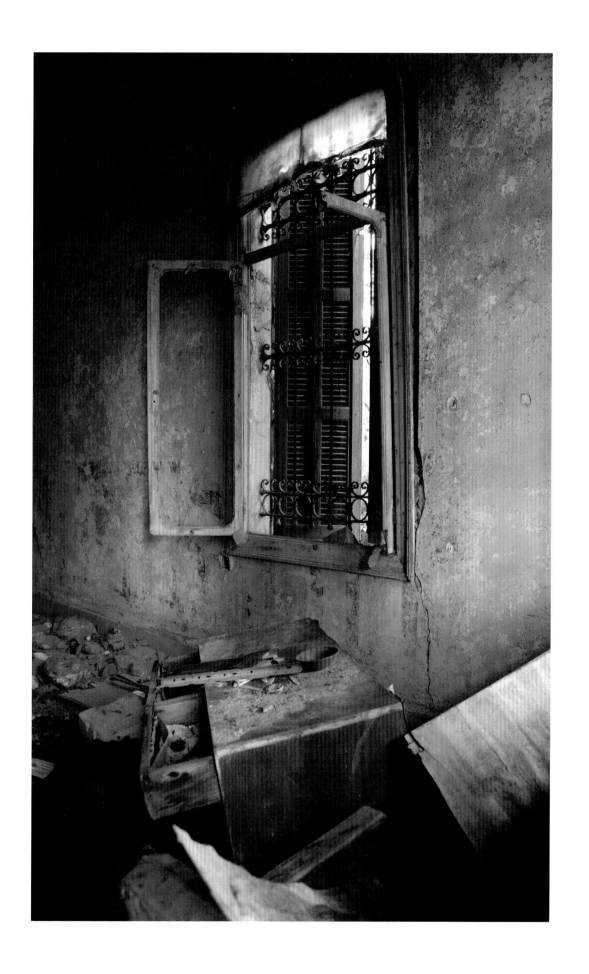

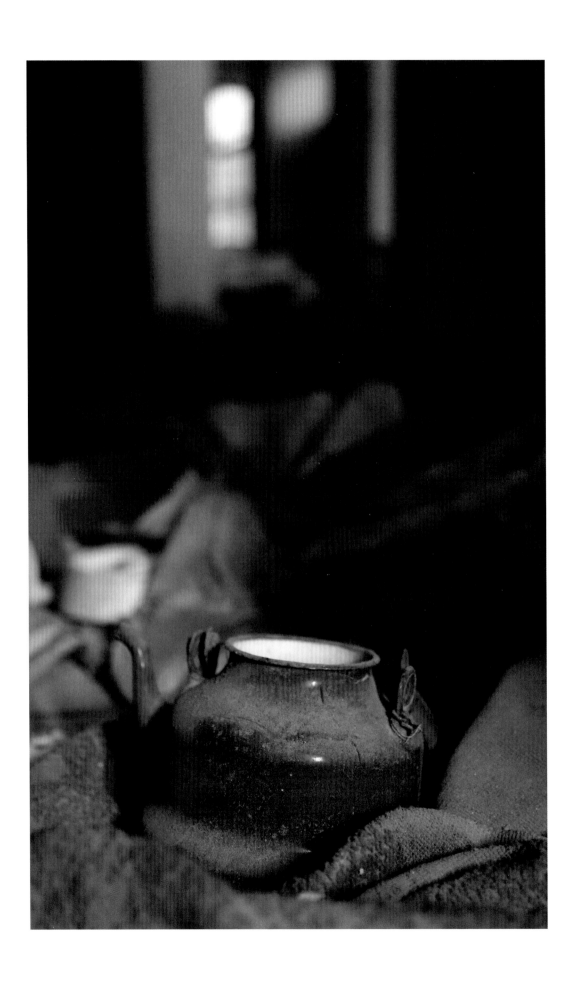

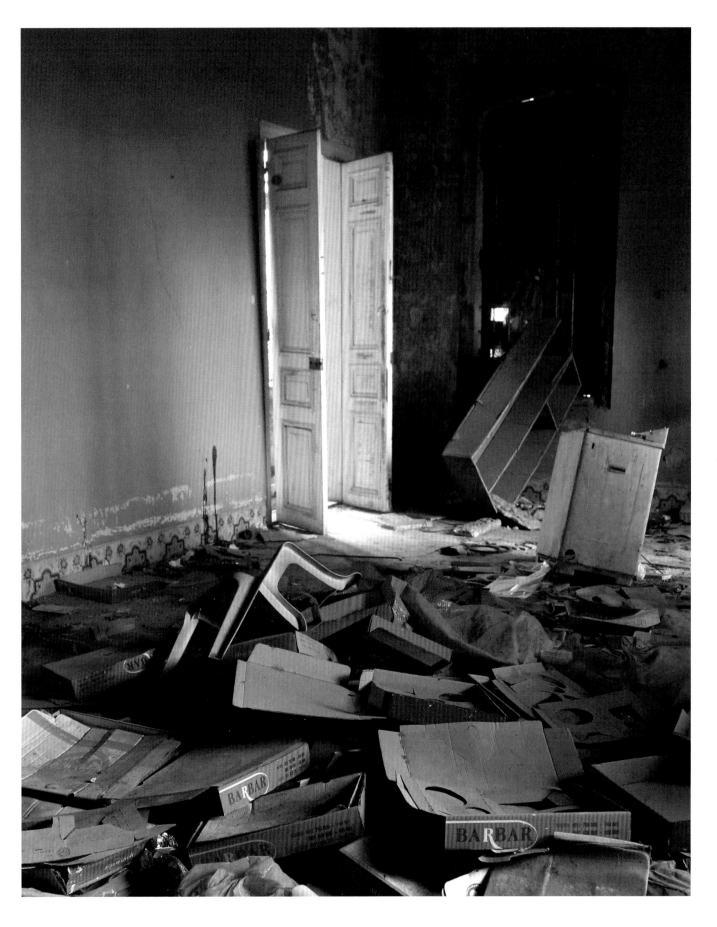

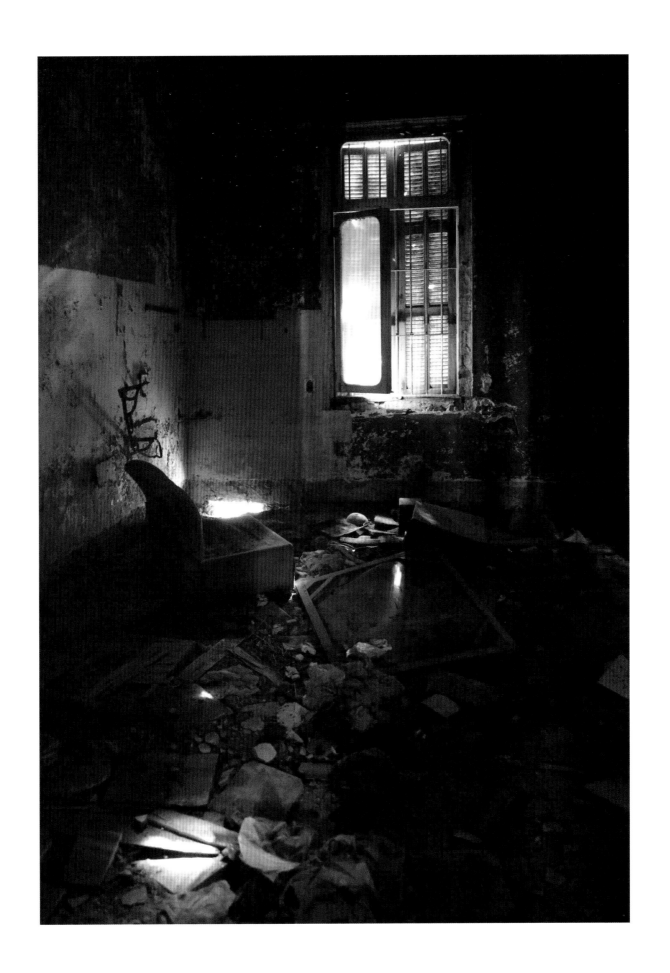

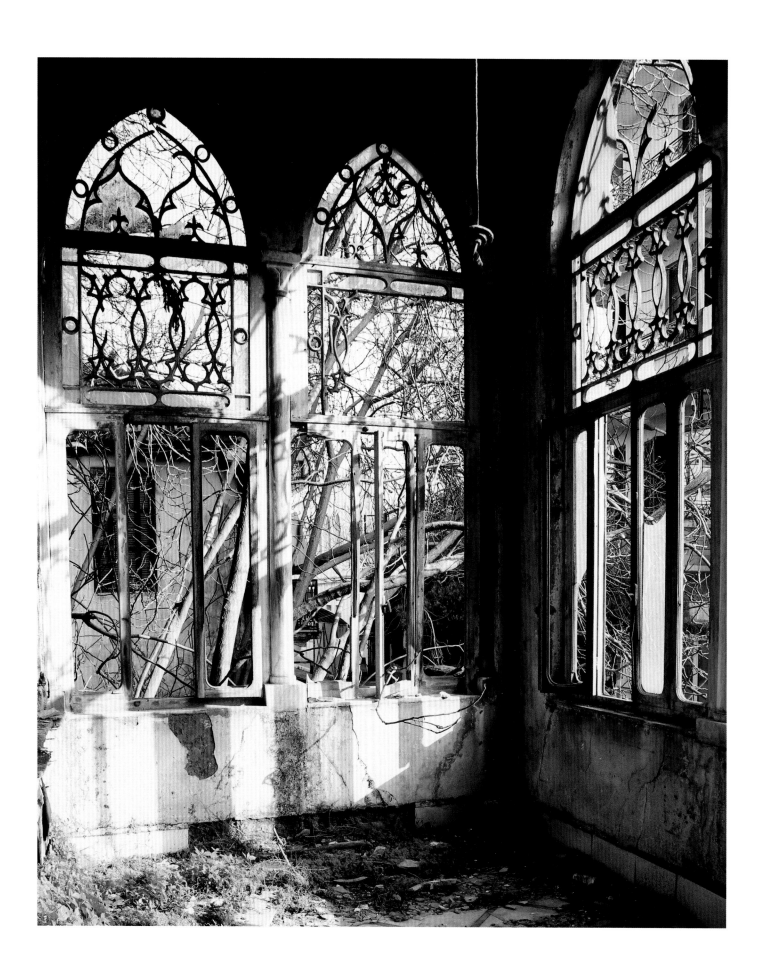

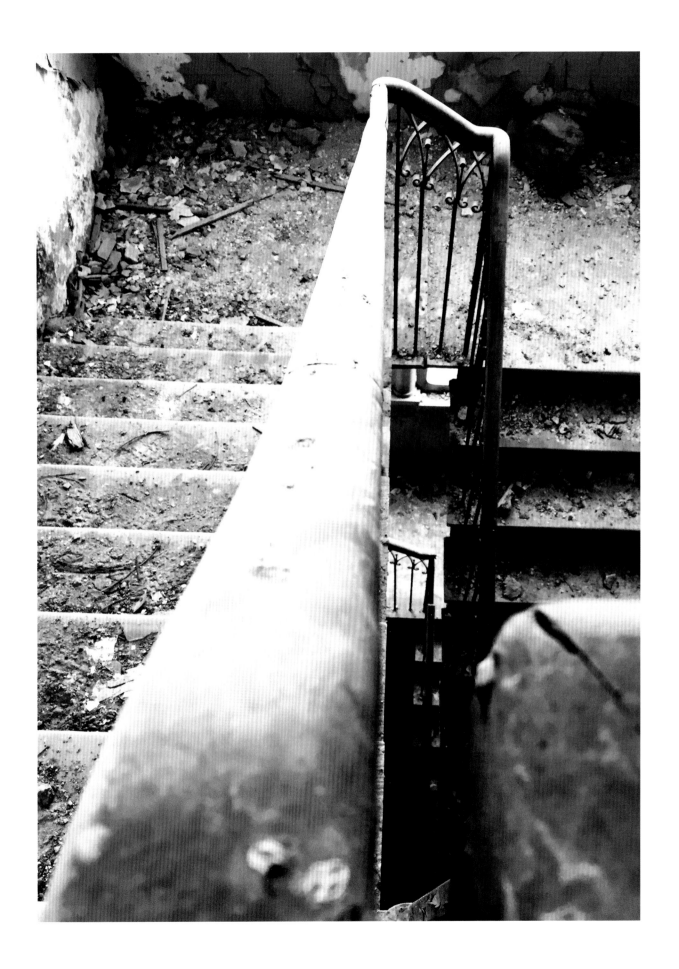

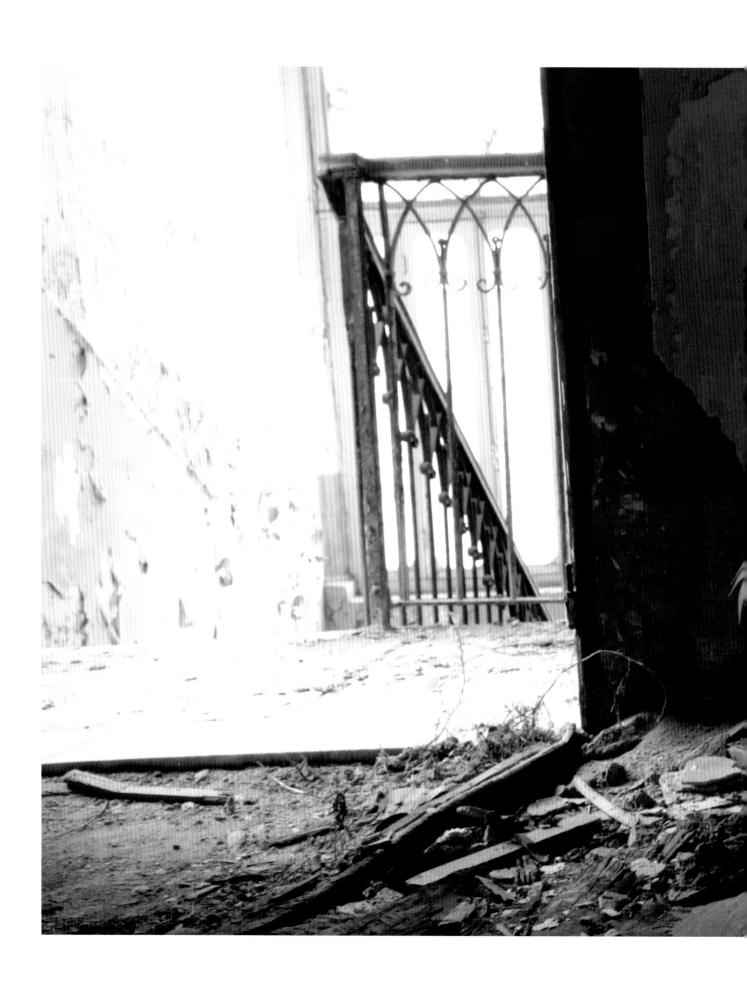

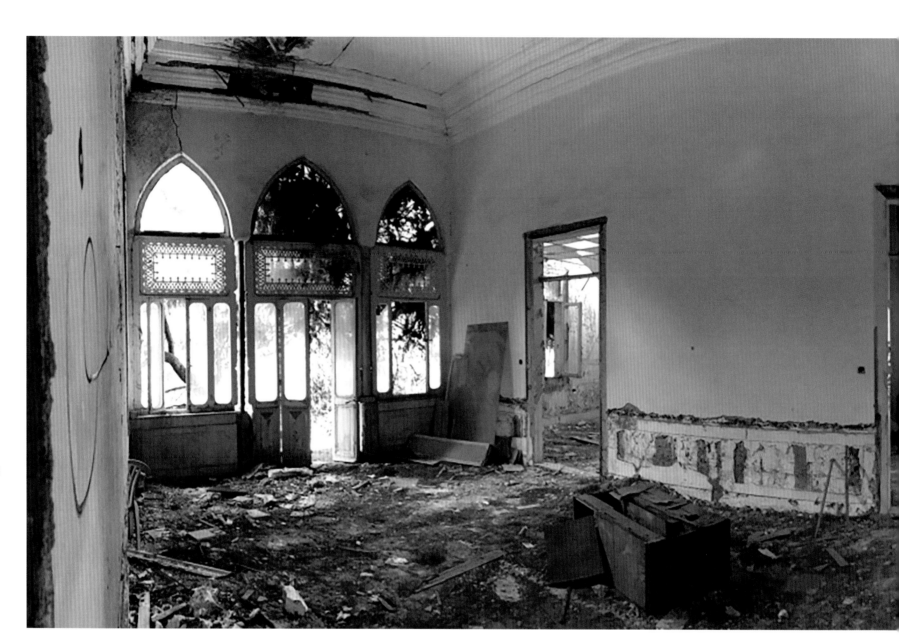

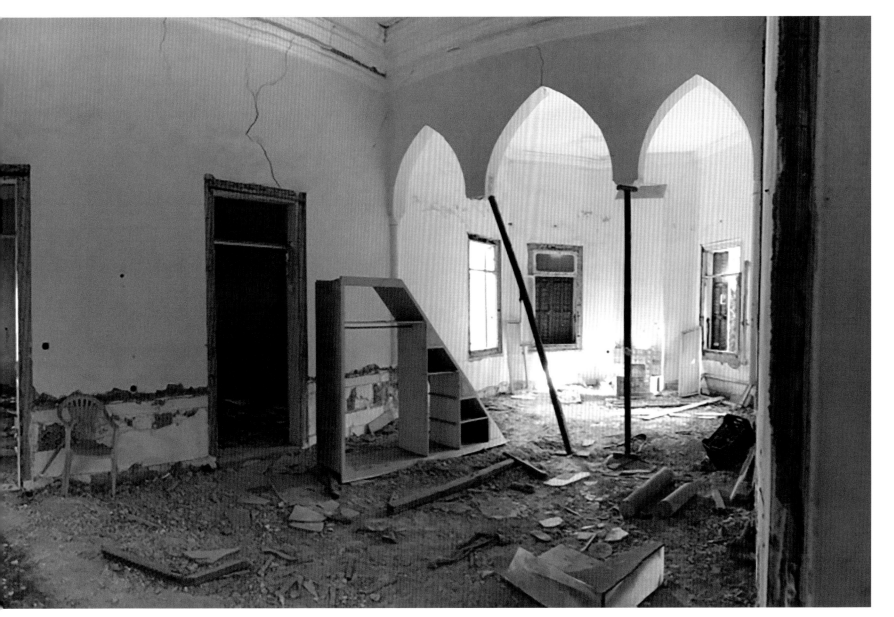

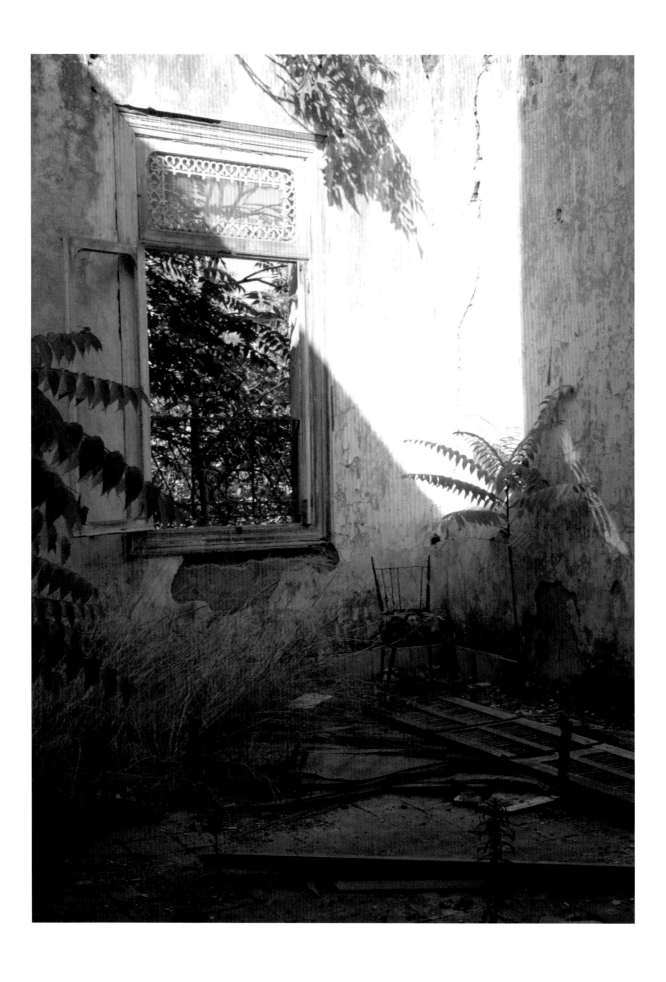

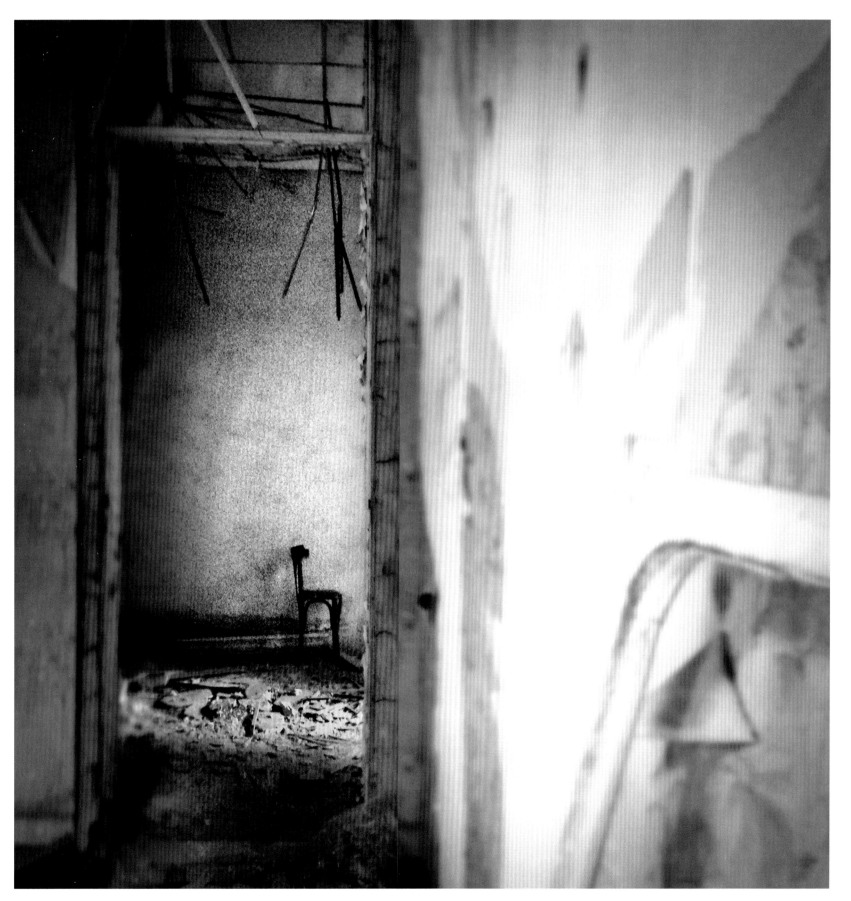

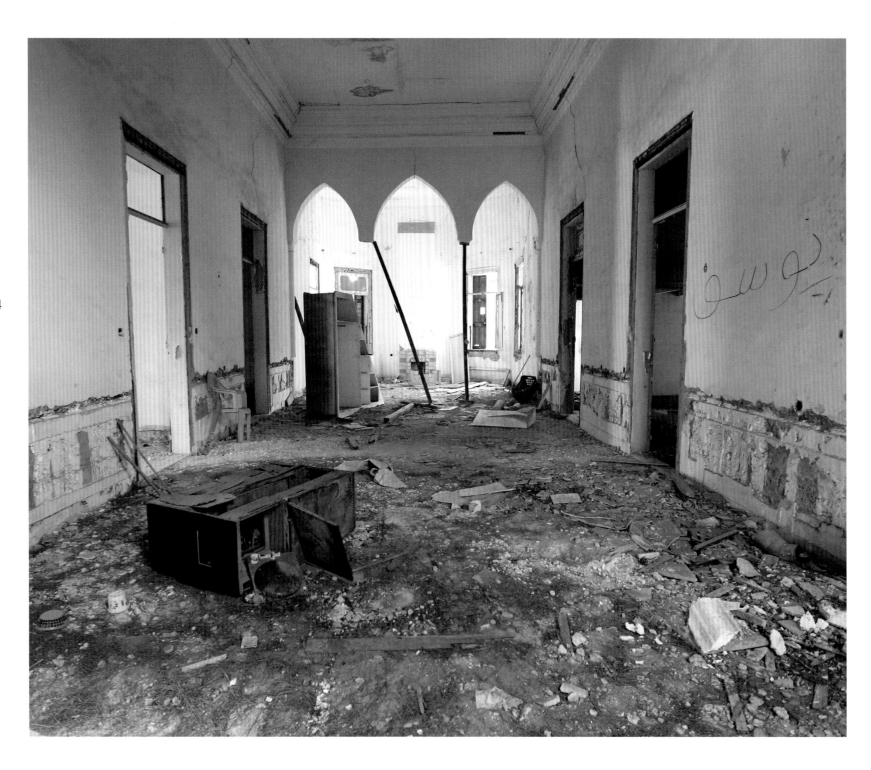

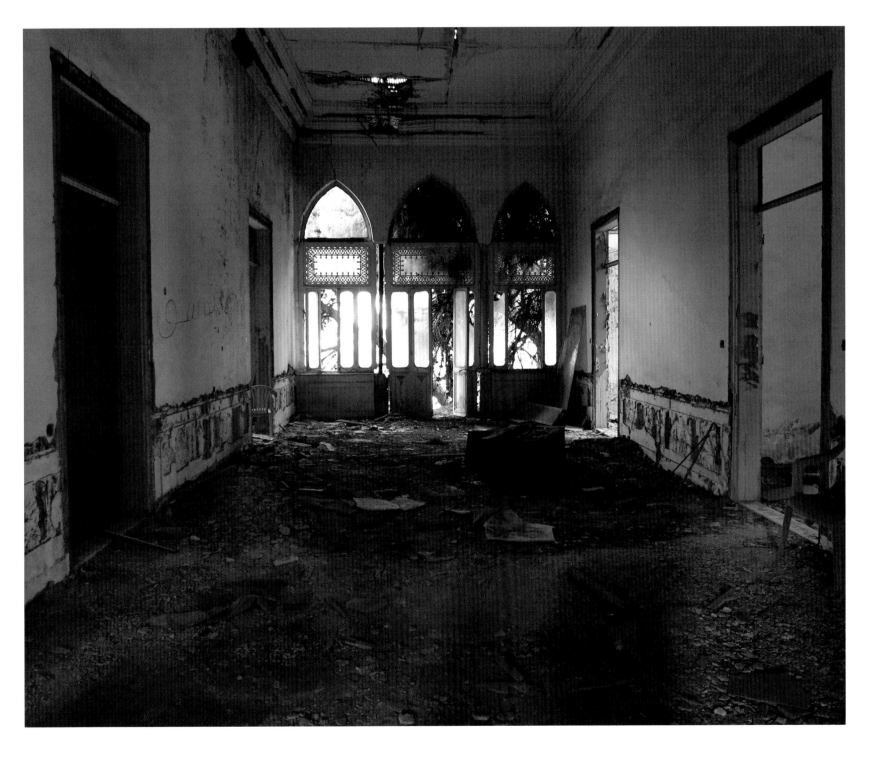

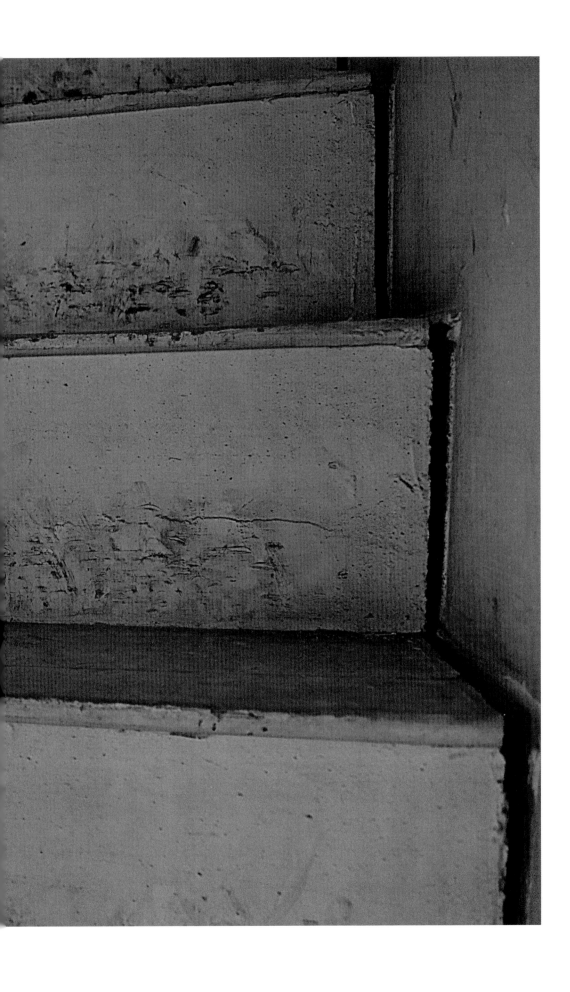

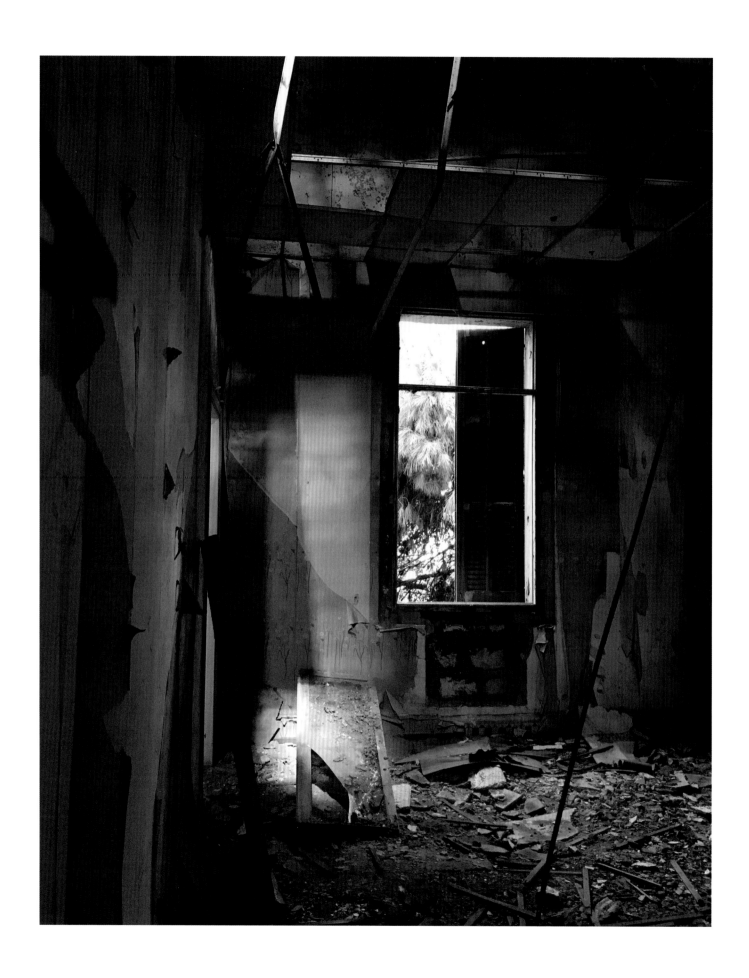

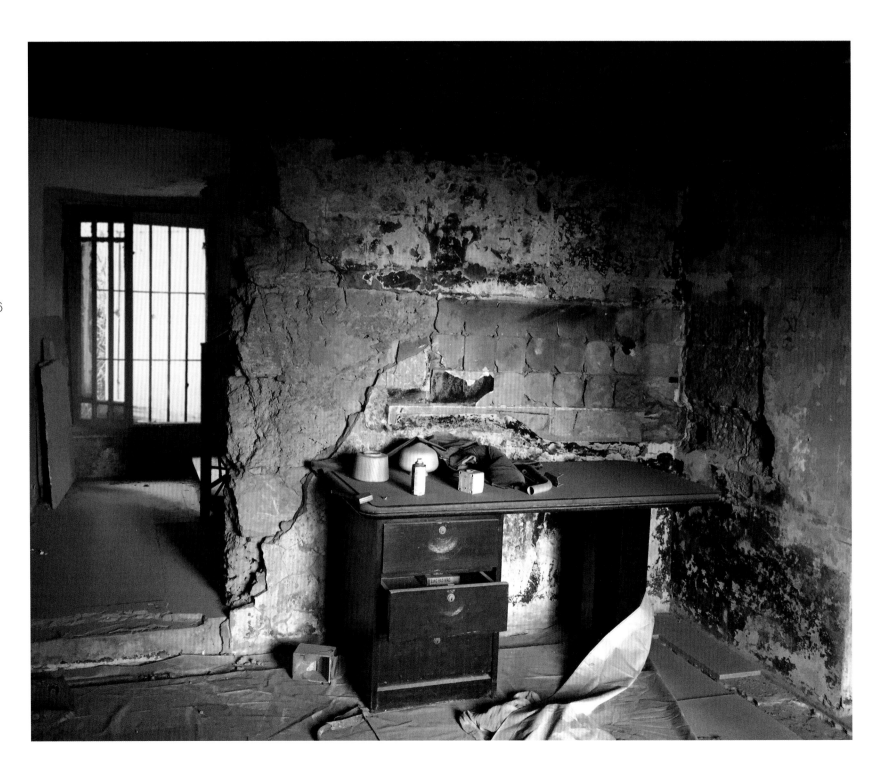

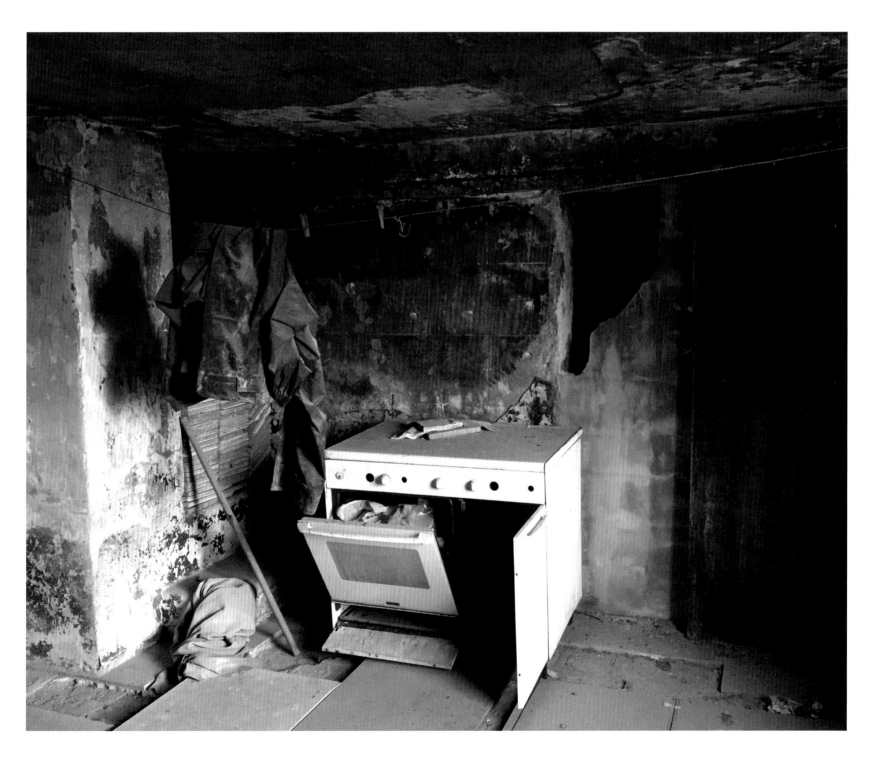

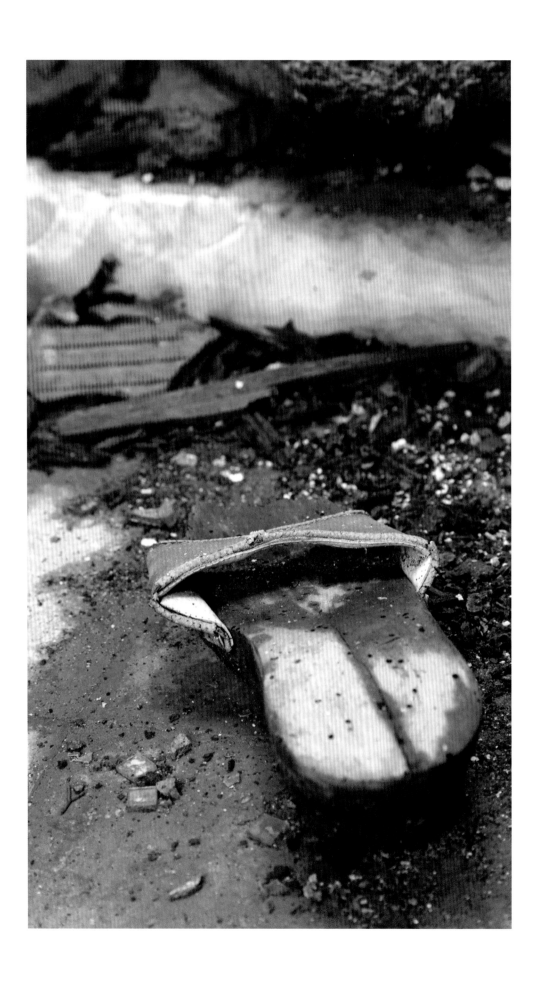

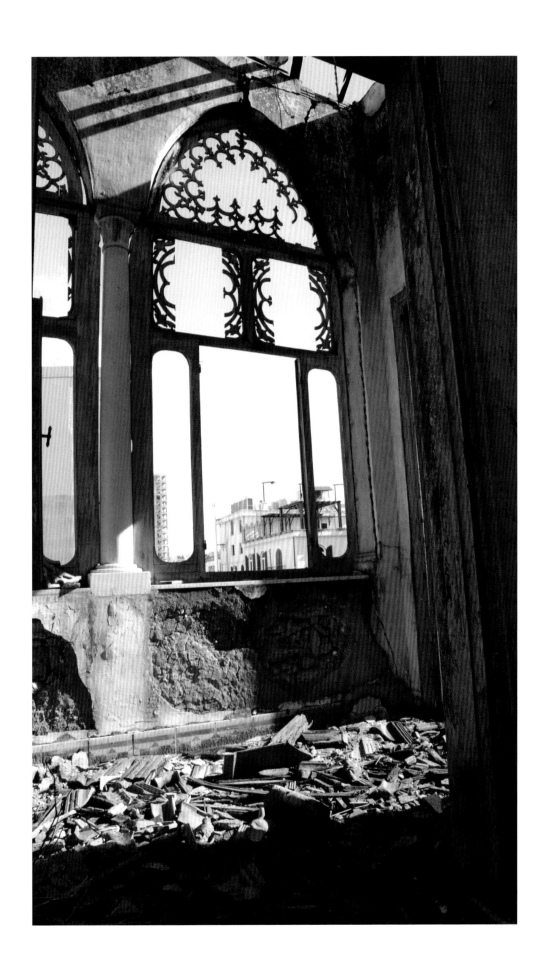

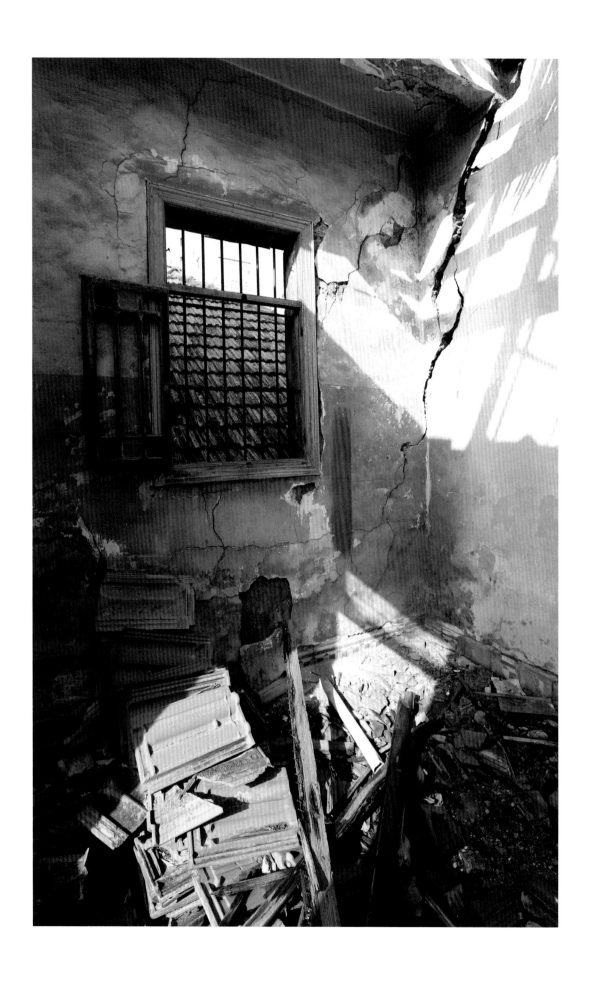

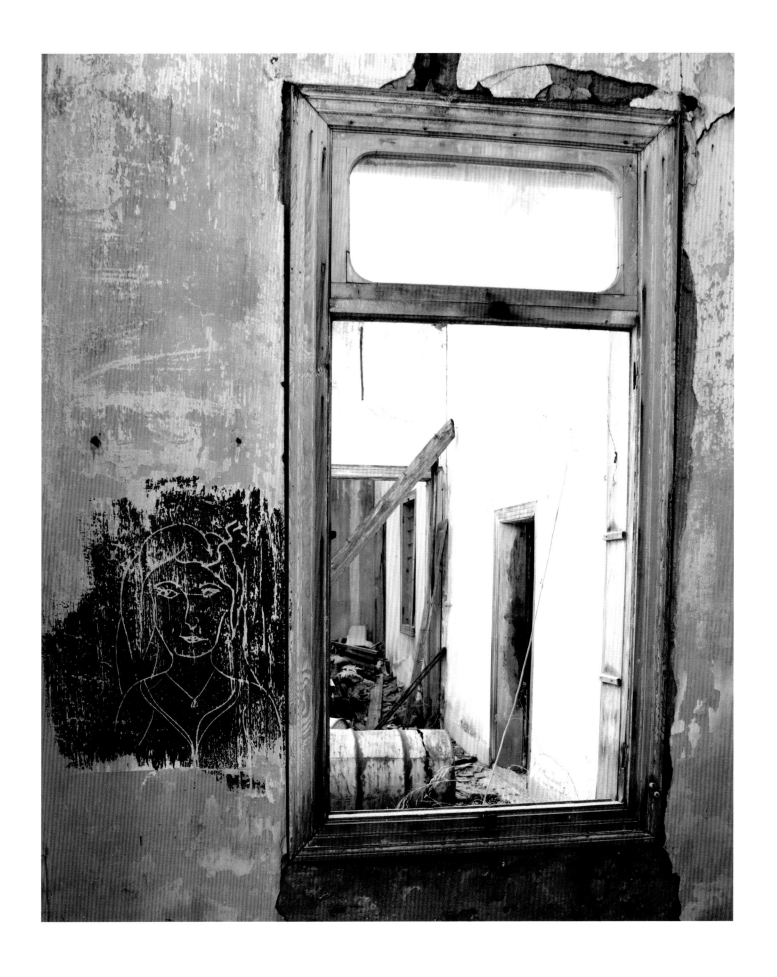

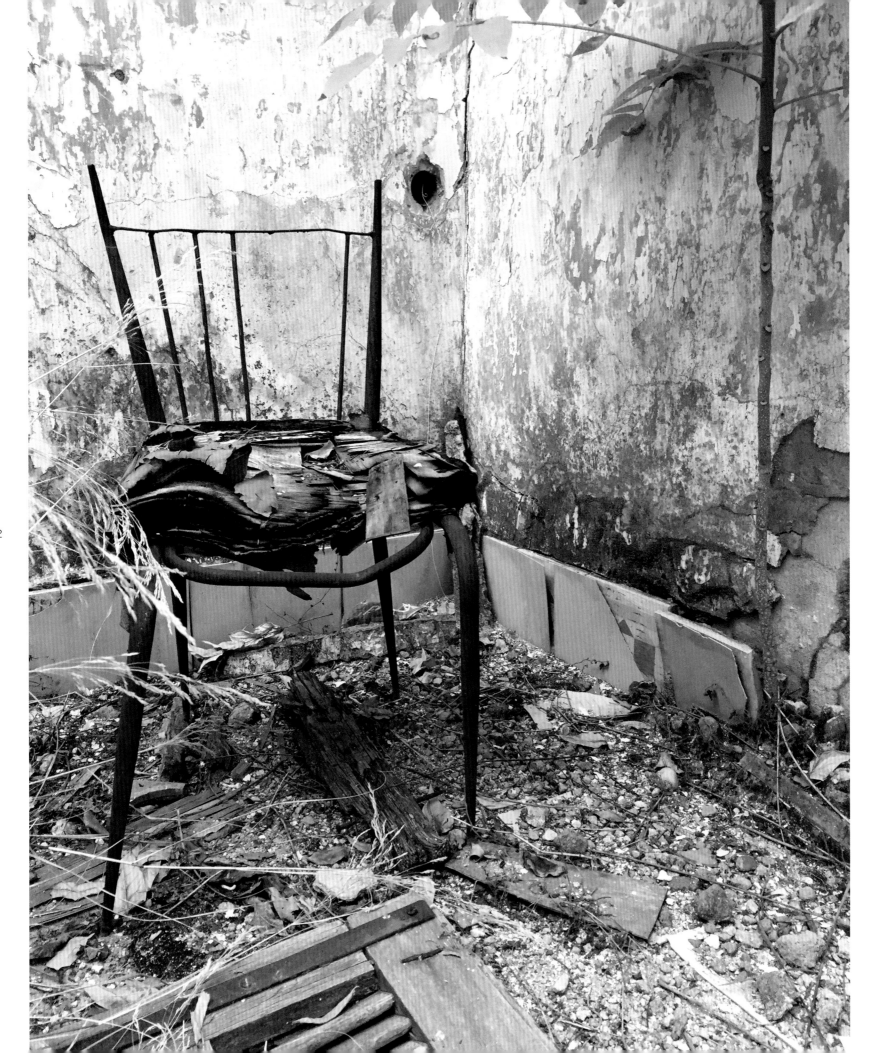

CONCLUSION

The future of the mansion is uncertain, and it balances precariously on its slowly crumbling foundations. None of the owners want to live in it enough to invest the fortune required to renovate it. Fadwa is no longer interested in living there, since it holds painful memories as well as being far too large for an elderly lady. She just wants an end to the decades of litigation that she has endured, and to be given, as she sees it, her fair share. Abboud's wife and children have never lived in the mansion and have no emotional attachment to it. Their interest probably lies in building apartments on the land for various members of the next generations to live in. However, in the division of the inheritance, Elham, Mohammad's only child, fought for the plot of land on which the house stands. I have found her to be very elusive, despite many attempts to contact her and her daughter. Therefore I have no insight into their plans for the property, nor first-hand accounts of the time Elham spent in the house, and no photographs.

A few buyers have been found but no satisfactory agreement has ever been reached, between the owners themselves as well as with the buyers. As things stand, a buyer would have to renovate the mansion, but could probably build apartment blocks on the land surrounding it. The house sits in a very high-value real estate area and the land could probably fit in three tower blocks, but let us hope it will not come to that. The house remains in limbo for now, with the owners still negotiating over it. Meanwhile strangers take advantage of the situation to live in it illegally, store belongings illegally, and destroy it a bit more along the way.

The battle to hold on to our heritage embodied in old buildings is raging. They are being replaced by modern skyscrapers, which are devouring the small city, blocking views, natural light and suffocating its inhabitants. Is this progress? And yet the majority of people do not seem to mind, or perhaps feel helpless at the haphazard and chaotic way in which the city is sprouting concrete blocks, invariably with no rhyme or reason from one building to another.

The story of the mansion correlates to broader events in the country's history, a microcosm amidst the macrocosm of geopolitical developments. These include the decline of the Ottoman Empire; the establishment of the new world order after World War I and colonialism; the great depression and famine; prosperity and independence; the golden age, with its glamour and intellectual centre, attracting the jet set to its half-Mediterranean, half-Middle Eastern capital; civil war and the involvement of world powers shifting geopolitical allegiances.

The four main families connected to the mansion intersect at various points in the hundred or so years of the timeline, namely the Naamanis, Ammouns, Abdel Razzaks and el-Solhs, and their paths have crossed in the political and social spheres from the early 1900s. An interesting early example of this was Riad el-Solh's plan to unite Christians and Muslims in Lebanon, thus lessening the Christian reliance on the French for protection, preferring a closer association to Syria and Faisal I. With the help of two of his closest friends, Aref Naamani and Amin Arslan (both members, like himself, of the General Syrian Congress), Riad made secret contact with several members of the Administrative Council and, without

alerting pro-French loyalists like Daoud Ammoun, persuaded seven of them to 'defect' from the French to Faisal. The seven defectors would declare their allegiance to Faisal, then attend the Paris Peace Conference, where they would reject the French mandate. The French were tipped off and many of the participants were arrested and sent into exile. The house is a reflection of our times and even that of our forefathers who helped to build the country, drawn into politics through patriotism and passion.

Christians and Muslim families co-existed in the country as well as in the same building, the Ammoun family occupying the ground floor and the al Abboud/Abdel Razzaks residing on the first floor. As well as being neighbours, Charles Ammoun also founded the French-language newspaper *Le Jour* with Mohammad al Abboud in 1934. The paper was sold to Michel Chiha in 1937, merging with *L'Orient* newspaper in 1970 when it was sold again, to become *L'Orient-Le Jour,* which remains in circulation to this day.

Mohammad al Abboud was the finance minister in Riad el-Solh's government in 1947 and in 1957 Takieddine el-Solh married Mohammad's widow, Fadwa al Barazi. Fadwa moved into the mansion as a young bride in 1947 and provided the thread that binds the story together. She married her first husband Mohammad al Abboud, from a rich landowning family in north Lebanon, who converted their wealth and influence into political power. He was tragically assassinated in 1953, after which Fadwa battled to remain in the house, relying on her defiant spirit in a patriarchal society, refusing to be pushed down and subdued into irrelevance

and succumb to being a victim of circumstance. She had to employ her considerable charm to persuade her second husband, Takieddine el-Solh, whom she married in 1957, to reside in the mansion of another man. Fadwa goes against the notion of a powerless Muslim Middle Eastern woman, the source of her strength being an unconquerable spirit and unbridled determination, combined with a calculated charm, very aware of being watched and desired. The mansion has been a symbol of her resistance, a tangible part of her existence.

The families crossed paths in the mansion for decades, before the wars came to ravage its walls and replace the glamour of the Beirut heyday with the wretched lives of refugees and squatters. As looters gutted the palatial mansion, stealing everything from the ancient tiles to the precious chandeliers, the various heirs keep haggling over its ownership and its future, in a tragic reflection of the miserable state of our nation's destiny.

CONTEMPLATIONS

The house pulls me ever closer with each visit, silent, patient, watchful. There it sits, scarred, decapitated, ignored by the congested streets on the other side of the wall and the mutilated garden that surround it. Stripped to its skeleton, it harbours amputations, bearing the scars of battle of external and internal damage inflicted upon it by human destruction compounded by the elements, its entrails ripped out.

The walls have inhaled and exhaled along with its numerous human companions, riddled with emotional and physical scars. The building stands as a large open wound of times gone by, current neglect and human absence. It has borne witness to the tissue of daily life, with the tentacles of love, life, loss and grief oozing out of each crack in its crumbling walls.

Will the mansion be yet another victim of Beirut's unbridled development, assigned to memories and history? Or is there the slimmest of chances that it may be resuscitated and once again be a beating heart, pumping life inside its walls, regurgitating a new tapestry of stories?

The city is a juxtaposition of broken dreams perhaps for the older generations, on the one hand, but full of hope and excitement for the youngsters who remain in the country, an outlook they need if they are to survive, though the dire economic situation has shaken even that fragile hope. The cataclysmic port explosion has scarred the coastline and buildings, but the deeper wound is the collective trauma unleashed on the Lebanese population. Behind every shattered window are shattered lives. The greatest crime that the post-Civil War Lebanese leaders have inflicted on their own people is not the corruption, incompetence and callousness, not even the endemic nepotism, nor the widespread abuse of power, but it is the robbing of each person of hope and the extinction of the possibility of a sustainable future.

As the call of death comes ever closer, and plucks my loved ones one by one, my outlook on life becomes ever simpler and my priorities shift in turn to a more basic existence, with an appreciation of the past: to a reminder of our mortality and ageing, in a society which thrives on a denial of both inevitabilities.

205

Finally, I dedicate this book to my English mother Désirée, who, I realise, was one of the strongest people I have known. Her adventurous spirit and love led her to Lebanon in 1964, where we lived until 1978, when we were forced to leave for London after enduring a few years of the Civil War. As a child I mistook her compromising for weakness but in later years I realised that it takes great strength to compromise, to give of yourself unconditionally to others. She was my best friend as well as my mother, who tried her hardest to envelop my brother and me in love and protect us without suffocating and stunting our growth. With her passing, she left a gaping hole in my soul, but also great admiration for the woman she was, flaws and all. My heart is forever scarred by her loss, but I carry my wound proudly as testament of my boundless love for a wonderful woman, greatly missed.

Contributors

Fadwa el-Solh
Amira el-Solh
Bouchra Naamani
Lyne Lohéac Ammoun
Arab Abdel Razzak and
 Family
Maha Nasrallah
Hassan Naamani
Khaldoun el-Solh
Nayla Razzouk

Thanks to

Rick Whiteman
Christine Morgan
Hannah (el-Solh)
 Hashisho
Nadine Hajjar
Donna Williams
Lara Hassan
Sana el-Solh
May (Naamani)
 Makhzoumi
Dina Debbas
Rose Issa
Sylvie Briand
Hala Audi Beydoun
Wissam Beydoun
Cyba Audi
Balkis Yassine
Samar Yanni
Assafir newspaper
 (Rabiaa Salman)
AUB library
Omar Zein
Nicolas Rahbani
Leila (Hashisho)
 Abu Alfa
Lama Sablini
Rania Stephan
Fouad Elkoury
Malak Hassan
Camillia Fawzi el-Solh
Roland Kemp
Marianne van Abbe
Paule Chiha
Laila Arafeh
Rowina Bouhard
Katya Maddison
Lina el Barazi

Soad Mufti
May Abiakl
David Melville
 Edwards
June Greenway
Lindsay Gardiner
Hazel Lindfield
Pippa Lusby
Jane Bartley
Irene Carvellera
Sandy Chatterjee
Elizabeth Conway
Max Baker
Tania Mordaunt
Maya Hawie
Tom Miller
Ajay Kidambi
Lina (el-Solh) and
 Andrew Mortimer
Karen Winget
Alex Brooks
Sarah Bond
Bérengère McLoughlin
Adrian Blanaru
Marion Gallasch
Kate Hands
Sally Holmes
Gill Waite
Cathy Reid Dick
Thierry Van Biesen

Credits

Nayla el-Solh Cover, 6-7, 9, 10. 28 (x3), 29, 34, 35 (x3), 36, 38, 39 (x2), 48 (x3), 49 (x3), 74, 101, 141, 142-143, 145 (x3), 146-147, 150-151, 153, 154, 156, 159, 160-161, 162, 163, 165, 167, 168, 169, 171, 172, 175, 176-177, 178-179, 180, 183, 184, 185, 186, 188-189, 190, 192, 193, 195, 195, 196, 197, 198, 199, 200, 201, 202

Roland Kemp Portrait of Nayla 3

An-Nahar **newspaper** 12, 13

Assafir **newspaper** 14-15, 117, 127 (x2), 128, 129, 132-133, 134, 135 (x2), 136-137, 138, 139

P. Elie Korkomaz 19

Nadine Hajjar 20-21, 106-107

Maha Nasrallah 22, 23, 40, 45, 46 *(Scanning and Colour Correction by PlanBey)*

Online Resources 24-25, 41, 42, 43, 49 (x2), 54 (x2)

Lama Siblini 30-31, 32-33

Ammoun/Lohéac private collection 26-27, 34, 37, 60-61, 62, 63 (x2), 64, 65, 67, 68 (x2), 69 (x2), 70, 71 (x2), 72 (x2), 73 (x2)

Nayla Razzouk 44

Naamani private collection 51, 52, 53, 54, 55, 57, 58, 59

Dalati & Nohra *(Official photographers of the Lebanese Government)* 72, 117

Fadwa el-Solh private collection 16, 78-79, 82, 83, 84, 85, 86 (x2), 87 (x2), 88 (x2)

Abdel Razzak private collection 80, 81

el-Solh private collection 95, 97, 99, 100, 102 (x2), 103 (x2), 104, 105, 109, 110 (x2), 111 (x2), 112 (x2), 113 (x2), 114 (x2), 115 (x2), 116 (x4), 117 (x2), 119, 120 (x2), 121 (x2), 122 (x2), 123, 124 (x2), 125 (x2), 126

Daily Star **newspaper** 91 (x2), 92, 93

syrianhistory.com 109

Fouad Elkoury 130-131

206

References

Lords of the Lebanese Marches – Violence and Narrative in an Arab Society
Michael Gilsenan

The Struggle for Arab Independence Patrick Seale

Architecture in Lebanon Friedrich Ragette

Lebanon and Arabism – National Identity and State Formation
Raghid el-Solh

Beirut Samir Kassir

Takieddine el-Solh Omar Zein

Daoud Ammoun et la Création de l'Etat Libanais Lyne Lohéac Ammoun

Abandoned Dwellings Gregory Buckakjian, PhD Thesis

Links to Historical Events and Personalities

The Paris Peace Conference 66
https://en.wikipedia.org/wiki/Paris_Peace_Conference_(1919%E2%80%931920)

Balfour Declaration 108
https://www.britannica.com/event/Balfour-Declaration

Sykes Pico Agreement 75, 108
https://www.britannica.com/event/Sykes-Picot-Agreement

General Catroux 117
http://www.famousdaily.com/history/lebanese-independence-day.html

General Gouraud 60-61 *(caption on p.62)*, 75
*https://commons.wikimedia.org/wiki/File:Proclamation_
of_the_state_of_Greater_Lebanon.jpg*

King Faisal I 55, 98, 108, 109, 203
https://www.britannica.com/biography/Faysal-I

Abdel Kader 98, 102
https://www.britannica.com/biography/Abdelkader
https://en.wikipedia.org/wiki/Emir_Abdelkader

Al Waleed bin Talal 107, 110 *(caption on p.111)*
https://en.wikipedia.org/wiki/Al-Waleed_bin_Talal
https://www.britannica.com/biography/al-Waleed-bin-Talal

Heneine Palace 24-25, 38, 40, 41
https://www.wmf.org/project/heneine-palace

El-Solh
http://el-solh.com

207